P9-DHP-897

CHRIS GORE'S
ULTIMATE FILM FESTIVAL
SURVIVAL GUIDE
FOURTH EDITION

CHRIS GORE'S ULTIMATE FILM FESTIVAL SURVIVAL GUIDE

FOURTH EDITION

The Essential Companion for Filmmakers and Festival-Goers

CHRIS GORE

WATSON-GUPTILL PUBLICATIONS / NEW YORK

Copyright © 2009 by Chris Gore

All rights reserved.
Published in the United States by Watson-Guptill, an imprint of the Crown Publishing Group,
a division of Random House, Inc., New York.
www.crownpublishing.com

WATSON-GUPTILL is a registered trademark and the WG and Horse designs are trademarks
of Random House, Inc.

Library of Congress Control Number: 2009928925
ISBN 978-0-8230-9971-9

Printed in the United States of America

Design by Nicole LaRoche

10 9 8 7 6 5 4 3 2 1

Fourth Edition

CONTENTS

SECTION 2

BUILD BUZZ: SECRETS OF INDIE MOVIE MARKETING

SECTION 4

FROM THE FRONT LINES OF FILMMAKING

I'd like to dedicate this book to those aspiring filmmakers who forge ahead in spite of insurmountable obstacles.

You may be confronted with looming deadlines, lack of sleep, little money, waning light, and a cranky crew . . . yet you do it anyway. Your reward is the indescribable high that comes from seeing an appreciative audience moved to laughter, tears, and applause . . . by your movie. Without your struggle to make uncompromising films, there wouldn't be any festivals. Thank you for your stories—the ones you share with us through film and those behind-the-scenes battles that inspire us.

To those filmmakers, enjoy the journey, but always remember . . . be realistic about your dreams, and never quit.

SPECIAL THANKS

Thanks to the various film festival staffs for their assistance—you made this book possible. I wish there were space here to name you all. I certainly owe you each a drink, even if it's at the cash bar and I have to open my wallet.

A special thanks to all of the interview subjects for their candor and allowing their stories to serve as case studies for the filmmakers of the future. You've done a great service to the film community by being so honest and sharing information so freely. I hope this starts a trend.

Thanks to all the hardworking folks at Watson-Guptill and Random House: Victoria Craven, Bob Nirkind, Gary Sunshine, Amy Vinchesi, and so many others who have gone above and beyond to make this the best possible edition of the book.

The dedicated writers at FilmThreat.com have my endless gratitude for their passionate coverage of festivals and for championing movies that take risks. To the readers of Film Threat, thank you for your support and for understanding that a healthy moviegoers' diet should consist of more than what's being served at the multiplex . . . so please keep reading and feeding your minds.

And finally, I'd especially like to thank my friend Mark Bell, who deserves a standing ovation. He spent countless hours collecting festival database information as well as offering advice and support. I cannot thank Mark enough, not only for working so tirelessly but for being a once-in-a-lifetime friend.

Thanks to you all . . . you will always have my respect, my gratitude, and my love.

RE-INTRODUCTION

"First things first: You have to really want this. No one who's on the fence about being a filmmaker ever succeeds."

—HEIDI VAN LIER,
writer/director of *Monday*

INDEPENDENT FILM
TRANSCENDS THE TRENDS

"Independent film is dead." You might have heard this. It's kind of the trendy thing to say now.

The imminent demise of indies has been declared by movie reviewers, argued by experts on film festival panels, and even been announced as cleverly written obituaries by bloggers. The folks who loudly make this bleak diagnosis always seem to forget one very important thing: People are still making movies, and they are making a lot of them. Whether new movies are uploaded to the Web, screened at festivals, or find distribution elsewhere, this death notice has yet to reach all the filmmakers too consumed in their projects to worry about what the so-called experts say. In fact, a record 8,700 films were submitted to the 2009 Sundance Film Festival. Clearly there are new voices out there waiting to be discovered, and nothing is standing in their way.

Hard economic times may affect films released through traditional distribution outlets, but when have indies ever had it easy? Woeful economic realities have always gone hand-in-hand with independent film. I can't pinpoint a moment in film history when money was not a dilemma facing indie filmmakers who hoped to get their projects off the ground. Fortunately, technology has made it possible to deliver a slick, skillfully made movie for, well, really cheap. A smart filmmaker, when asked about the budget he requires, will often respond with, "How much do you have?"

Main Street in Park City, Utah, during Sundance

There is no correlation between dollars spent and quality. I've seen indies made for $10 million or $10,000 and the only thing that mattered was how effectively the filmmaker engaged the audience with his vision. Money is irrelevant in the realm of creativity. Individuals committed to telling their stories by any means necessary will always find a way. Ultimately, independent filmmakers are immune to a struggling economy since they are always struggling anyway.

Those new to the business realize fast that the film industry has an insatiable appetite for speculation, especially the kind of information that pinpoints and predicts trends. I've written about many trends myself, and some of my recent favorites include: *Teens prefer to watch movies on their computers, rather than go to the movies.* It's true, according to some. *The audience that goes to the movies is shrinking.* It's a fact. *Digital downloads will replace DVDs as the way people watch movies in their homes.* That is likely to happen. Certainly downloaded movies are being viewed by a growing audience. At their height in the 1960s, there were 4,000 drive-in movie theaters across America; now there are just 200. Sure, habits change, but the death of the drive-in theater *did not* result in the death of the movies, just a shift in how people viewed them.

The author with Sundance founder Robert Redford

Thanks to the tremendous growth of film festivals (about 400% over the last decade), a whole new audience of moviegoers exists. These film festival fans have discovered a taste for the kind of renegade cinema that can only be served up by independents. And they enjoy being challenged as much as they like to be entertained. A festival-goer quickly learns to love the surprise that comes with experiencing a movie that has not been tainted by oversaturated marketing or trailers that give away the entire story. A sold-out premiere followed by a lively festival question-and-answer session along with a wild post-screening party will bring that festival-goer back next year. Once festival virgins have seen a movie at a decent fest, they always come back. With their eyes opened to a whole new world of movies,

those festival converts develop a passion that can be satisfied with indies on DVD, cable, or downloads while they plan their escape to the next fest.

Now, I don't see how it's possible that independent film could be on the wane while festivals continue to expand and their audiences grow. And there clearly is no shortage of filmmakers struggling to make movies to present to that audience. These visionaries do not make sacrifices to fill a slot in a studio's schedule or to make a blockbuster summer movie or a franchise sequel or even to make money—they sacrifice because they have to. Fueling their efforts is the need to communicate free of financial concerns something important about the human experience to an appreciative audience.

Independent film is not dead, but it will always evolve.

So damn the trends and make your film.

One final word: This is the first edition of the *Ultimate Film Festival Survival Guide* that does not include listings of film festivals. However, by purchasing this book, you have gained an all-access pass to listings available in the digital realm through this exclusive online database, www.UltimateFilmFest.com. With the book in an easy-to-carry, old-school paper format combined with the most current listing data delivered digitally, the result is the perfect combination of tools to map out a winning festival tour. In addition, www.UltimateFilmFest.com will expand upon what you read within these pages through extended filmmaker interviews, templates to create marketing materials, useful contact information and support from a vast online community, plus plenty of other filmmaking tools to help you along the way.

It's been ten years since the first edition was published, and I've always looked for ways to improve each update. I like to think of this book project as the text version of a documentary series. I deliver what I feel to be the best advice, but you must remain aware that my suggested approach may be *contradicted* by one of the interview subjects in the "From the Front Lines of Filmmaking" section. Or a new filmmaker may burst onto the scene with something brilliant that no one could have dreamt up and rewrite the rules altogether. That seems to happen every few years, which is really exciting. I specifically include the broadest range of voices to impress upon you that there are many correct paths to success . . . and

even more ways to fail. Your challenge is to choose what works for you. And those choices are as individual as the movies themselves. Think of your festival journey as one of those "choose your own adventure" books; the adventure you pick will help determine the path of your film career. So make your selection wisely.

I'll see you and your movie at the next fest.

WELCOME TO MY FESTIVAL PARTY

"Hope."
—Robert Redford, when asked to describe Sundance
in a word.

I check my Sundance party list and realize that it's impossible to hit twenty events in three hours. I've conveniently color coded each invite as I examine my handy party pocket spreadsheet—green means I've RSVP'd and received confirmation that I'm definitely on the list. The other colors note the level of difficulty involved in getting through the front door to the hottest parties in Park City, Utah, during what is the biggest festival in January. It sounds like fun, but any film fest veteran will tell you that attending social gatherings is not only work but also a key element of working the festival circuit, where networking can lead to numerous business opportunities.

What is most striking walking down Main Street in this snow-filled resort town is not just the tremendous amount of people, but the ones dressed to truly party. While I remain smartly bundled up in layers with a ski jacket and scarf in the sub-freezing cold, club wear dominates the Sundance scene as I observe men wearing garishly colored fake fur coats and women sporting open-toed heels. Open-toed heels? These shoes actually dominate the female footwear on a Saturday night in the bitter cold. I follow my rule of not waiting more than ten minutes to get into any party but quickly discover that getting to the front of the line takes more time than that, and I move on. As I try to shake off the frustration, Sundance's new mantra

comes to mind: Focus on Film. After nearly two hours of walking up Main Street without squeezing into even one event, I realize that it's just not that fun anymore ... or perhaps that seeing films should really be the goal after all.

Here's how some other important voices view the ever-evolving role of film festivals for independents.

THE STATE OF THE FEST

As a festival vet who made his career with the debut of his doc *Super Size Me* at the 2004 Sundance Film Festival, Morgan Spurlock has observed and experienced

WHEN IN SUNDANCE, USE MASS TRANSIT

Parking is a bitch, and your car is just going to get stuck in the snow anyway, so take the bus. The convenience of having a car will quickly turn into a burden when you spend more than twenty minutes searching for parking and paying the inevitable tickets you'll get. Using mass transit has the added bonus of making new festival friends. It's good advice to use mass transit at whatever festival you attend.

the growth of festivals firsthand. "I think there are a few reasons, from the explosion of independent film in the marketplace to the ability of anyone with a camera, computer, and good idea to make a movie, to the growth of cable and satellite television, to the realization of many cities that festivals bring big, big money to their towns." Spurlock's recent doc, *Where in the World Is Osama Bin Laden?*, premiered at Sundance in January 2008 and wasn't the only one to reap the benefit of the exposure. "I heard the economic impact on the area exceeded $60 million [in 2009]. For a small town to get an influx of capital like that is huge."

Money is clearly a factor in the formula for the widespread growth of festivals, but it all comes down to content. Matt Dentler, former festival producer for the biggest film event in Austin, Texas, SXSW, and currently with Cinetic Media, points to other reasons for the expansion. "I think technology is the biggest factor, both on the filmmaking side and the exhibition side," Dentler explains. "It's become increasingly accessible for artists to make their work, as well as easier for people to set up screenings in almost any kind of venue. So, more films are looking for exposure and now more communities can provide that exposure, no matter how

THE ULTIMATE FILM FESTIVAL SURVIVAL GUIDE ··□

big or small. But, like any revolution, there's an upside and a downside. There are more great festivals than ever before but also more lackluster festivals than ever before."

Producer Jeremy Coon's *Napoleon Dynamite* hit numerous festivals during 2004, and he's since traveled the festival circuit with two other features seeking love from audiences and the industry. "Honestly, I think people are just looking for another excuse to party with celebrities," Coon relates. "There are just a lot more films being made due to the advent of less expensive, digital filmmaking options. All of those films need a place to exhibit, so as long as more films are being made than can be released by distributors, there will be plenty of films to fuel that festival growth. Economics and social status are also fueling this growth. Cities are realizing that a good film festival not only brings in additional revenue (hotels, restaurants, etc.) during its run, but it also raises the awareness and cachet of a city."

There's no shortage of passionate people determined to start a film festival, fueled by little money but a healthy amount of enthusiasm and volunteers. Christian Gaines, former director of festivals for AFI, currently at Without a Box, explains: "It's no secret that there's been an explosion in the number of film festivals over the last decade, which is good because now my mom's friends know what I do for a living," said Gaines. "But, while film festivals will always put out a press release when they're launching, rarely will they do so if they're closing up shop. You hear about the new festivals, but it takes tenacity, hard work, and a commitment to long-term institutionalization to first survive and then chart real year-to-year progress."

Filmmaker Michael Blieden attended fifteen festivals in 2003 with his indie favorite, *Melvin Goes to Dinner*, and he relishes the experience. "It's a training ground, an informal bit of market research, a chance to form some very collegial relationships with other filmmakers, and if you're single you're going to try to get laid," he reveals. "Plenty of the filmmakers I met that year now have graduated to real professional showbiz jobs, and not even necessarily as a direct result of their festival films," Blieden says. "I think making a festival movie is just much more of a stepping stone for anyone who wants to be a writer/director. In many ways the festival

movie has replaced the thesis film for the savvy and inspired filmmaker who isn't interested in too much theory."

While promoting a city as a vacation destination is certainly the intent for some festivals, there are loftier goals for others. Christen McCardle, the former director of the Ann Arbor Film Festival who took on local censors, sees greater value for audiences. "The cultural value that film festivals play to their local community is becoming increasingly evident," McCardle points out, "as is the larger role that festivals have in the film industry's quest to find quality content. Film festivals are havens for unique and innovative films and are a breath of fresh air for communities."

NEW FESTIVALS ON THE RISE

The growth in the sheer number of festivals has resulted in exciting new events as well as what some might characterize as unique experiments in presenting fresh films to moviegoers. These new festivals seem to crop up weekly, each addressing the needs of a specific audience segment that may have been previously ignored. CineKink, based in New York, is a festival dedicated to screening work of an erotic nature and calls itself the "really alternative film festival." In fact, the films shown to enthusiastic and often leather- and vinyl-clad audiences, according to the festival, "explore and celebrate a wide diversity of sexuality." The four-year-old event recently teamed up with the Los Angeles Erotica Film Fest to share submissions, proving the concept succeeds on both coasts.

The newly formed Phuket Film Festival in Thailand may be the perfect escape for those who wish to enjoy international films as well as the resort destination. The event is also focused on spotlighting Phuket as a potential locale for Hollywood production.

Film festivals have always been about discovery, and for those who work the festival circuit regularly, that involves finding new and exciting fests as well. "I attended the Midnight Sun Film Festival in Sodankyla, Finland," notes Without a Box's Gaines. "Films play twenty-four hours a day, and because it's June and inside the Arctic Circle, it never gets dark. The programming was eclectic, thorough, and thoughtful, and festival guests got very well acquainted with Finnish culture."

Morgan Spurlock has a few recommendations of his own. "My two favorite festivals are the San Sebastian Film Festival in Spain and the West Virginia Film Festival—one is all about the Spanish coast, good food, and delicious wine, and the other is all about the green mountains, good people, and cold beer. But at the end of the day, both are about great movies, and that's what I really love."

McCardle points to a lesser-known and far less commercial event that she admires. "I like FreeWaves in Los Angeles. It's a festival of installations, located all around Hollywood. The installations are interactive and experiential films that are projected on landscapes of our own community."

Both Michael Blieden and Jeremy Coon cite the Waterfront Film Festival as a favorite among filmmakers and a must-stop on their respective festival tours. "Waterfront takes place in the small, beautiful lake town of Saugatuck, Michigan," says Coon. "The people who run it are great, the atmosphere is totally laid-back and fun, the parties are crazy, and the films are consistently good."

"I didn't win any awards," says Blieden, "but my screenings at Waterfront were totally packed, and there were no technical snafus, which says an awful lot. Also, I'm pretty sure I was propositioned by a married couple to join them in the motel Jacuzzi for a three-way. I'll never know for sure, though."

If there is one trend that could be observed from the recent wave of new festivals, it's the popularity of the horror or genre film festival. While sci-fi and horror films are a solid staple of Sundance's midnight program, they make up the entirety of the programming at many new festivals, including Shriekfest, Screamfest Horror Film Festival, and the New York City Independent Horror Film Festival, as well as horror festivals in Sacramento, Chicago, Portland, Rhode Island, and too many more to list. Denise Gossett is the founder and co-director of Shriekfest Horror and sees this trend as serving a growing demand. "I think audiences are hungry for new stuff," she says. "We all know we can go see the big-budget films at the theaters, but it starts to feel like cookie-cutter copies, so that is why we long to see the independent films. Genre fans are everywhere, and they are very supportive of independent filmmakers and are willing to attend genre fests to show their support."

THE EVOLVING FESTIVAL CIRCUIT

While there seems to be a never-ending list of new and sometimes strange film festivals, survival is a reality each new organization must face. "So many film festivals in the last decade have transitioned from being a simple celebration of film culture," says Without a Box's Gaines, "to having to provide essential outcomes for the many constituents who converge on the scene: filmmakers, audiences, the film industry, the media, and corporate sponsors, among others. These different groups often desire very different outcomes from the festival experience. So festival programs and infrastructure have become more sophisticated, more complex, and tailored specifically to satisfy the needs of these groups. The communal warmth and simple pleasure of getting together to watch a film and celebrate the filmmakers has transitioned into something that's more loaded and more fraught with expectation than it was a decade ago."

The festival world as a whole has seen a lot of change in the last decade as the audience hungering for films outside of its standard studio movie diet grows to super proportions.

"There are even more movies being made now than ever, but are there better films being made?" Morgan Spurlock asks. "I don't think so. But what you see is someone who never would have been able to make a film ten years ago getting the chance to follow his or her voice and dreams and making a film that breaks out from nowhere. That's inspiring."

Spurlock reflects on his recent critical support for his new doc, *Where in the World Is Osama Bin Laden?* "I was amazed in Park City this year. When I was there in 2004 with *Super Size Me*, they said 35,000 attended the fest. This year that number topped 50,000. Fifteen thousand more people in four years! Why? The biggest reason is the paparazzi factor—it's become as much about the scene at many of these big festivals (Toronto, Cannes, Sundance) as it is about the movies."

The real secret to the success of film festivals rests in that focus on film.

Marquee on the theater at Ebertfest

"Audiences can now see honest-to-goodness fresh talent that's just happy to be there," Blieden explains. "In my opinion, film festivals are like music festivals. The 'festival' part of the whole thing has really come to the fore."

Festivals are clearly big business, but Spurlock points out the benefits that lesser-known festivals provide. "There are still the smaller fests that can show movies and be intimate and cater to filmmakers," he says. "But at the end of the day, the festivals that most producers and directors want to attend are the ones where they have the best chance of getting distribution. So, I think the power of the industry has really helped push and shape the directions of festivals in both positive and negative directions."

10 DIRTY SECRETS OF INDEPENDENT FILM

If one is going to enter the sometimes brutal world of independent film, it helps to be armed with the knowledge of all the harsh realities. So to save you from having to experience them all firsthand, let me just spell this all out for you now—even if it is painful, you need to know.

1. Corporate independents rule. Deal with it.

Every major studio has an independent film division, or what might be called a "low-budget studio division." Basically, these churn out dramas in which the actors are paid scale. Corporate indies have co-opted the independent spirit and turned it into a section in the video store. You can look on this as a good or a bad thing, but that's the way it is. So learn to live with it.

2. It's a business of relationships.

Yes, it really *is* who you know. There are those who say that the film world is all "politics." So, get good at politics. Get to know the acquisitions executives at the major distributors who still buy movies and get these people to your screening—no matter what it takes.

3. Casting counts.

Unfortunately. The first question any acquisitions executive—or moviegoer, for that matter—is going to ask is, "Who's in it?" So, put together a cast that will get your film noticed. Actors are always on the lookout for good material, so get it to them any way you can. Director Rod Lurie played poker weekly with actor Kevin Pollack and ended up directing his independent feature debut *Deterrence* by casting his card-playing pal. Cultivating relationships with recognizable talent is valuable; pursue these assets by building a friendship first and not by shoving a script in an actor's face.

WORTH MORE THAN MONEY

A thank-you is worth more than money. Acknowledgment in film credits and public acknowledgment go a long way toward building strong relationships. Be sure not only to be humble but also to thank those who helped you along the way. In independent film, money is always scarce, but thanks should never be.

4. Be original. But don't be too original.

As much as film executives say they want something original, they really don't. What they mean by "original" is simply "old wine in a new bottle." They want a familiar genre, story, or tried-and-true formula told in a completely original way. For example, a rock-and-roll musical (familiar) about a man with a botched sex-change operation (very original) called *Hedwig and the Angry Inch*. That works.

Adam Goldberg and Giovanni Ribisi at the Toronto International Film Festival

5. Want to get into a film festival? Get to know the "phantom programmers."

Sure, everyone knows that Geoffrey Gilmore is best known as the longtime gatekeeper at the Sundance Film Festival, and that he recently made the move to the East Coast, becoming the creative director of the Tribeca Film Festival. And there is no chance he is going to return the call of an unknown emerging indie filmmaker.

That's why it is critical to get to know the "phantom programmers." These are the trusted friends of festival programmers—people they rely on to offer advice about how to fill a programming slot. To get into the festival of your choice, it's key to look for the people the main programmer respects and enlist their support.

6. Get a good review from Roger Ebert.

There are seven "Roger Eberts" that can be found in the phone book in the Los Angeles area alone, and one of them is bound to love your movie. (You do know I'm kidding, right?) Seriously, there are more outlets covering film today than there are films released in a year. No joke. If you can't get a decent review in a recognizable media outlet, there are plenty of lesser-known media outlets on the Web just salivating over the prospect of being quoted on your movie poster. Just ask the major movie studios—they use this technique all the time.

7. Awards are meaningless.

Unless, of course, you are the one receiving the award. Be sure to tout any kind of award you receive no matter how cheesy or meaningless it seems to you. The graphic of those two laurels with the words "Award Winner" in the center will make a perfect piece of marketing to use on the poster or video sleeve.

8. Don't be an orphan.

There are thousands of "cine-orphans" out there—movies without distribution. It's important not to end up as one. After all of the large and small distributors have passed on your film, don't concern yourself with making back your money. At this point, it's all about your career, so it's critical to get the film into the commercial marketplace, even if you have to self-distribute it on DVD. And DVDs make great giveaways at meetings about your next project.

9. Get a look.

Yes, as irrelevant as it seems, fashion sense is important, and a distinct look does count for something. If fame matters in moving up the indie film career ladder, then it's important to be recognizable in a crowd, or at least in photos that appear in the trades. Picture the writer and director of such films as *Spanking the Monkey, Three Kings,* and *Nailed.* You can't. That's because writer/director David O. Russell is about as nondescript as they come. He's an average guy, and there's no crime in that. Now picture the writer and director of such films as *Welcome to the Dollhouse, Happiness,* and *Storytelling.* Yes, Todd Solondz is that dork with the goofy hair and big glasses. His unique "look" gets him recognized at festivals, events, and parties—and *that* will get his geeky mug in the trendy sections of magazines. Fame does help.

10. The truth.

The reality is that the indie film world is a freelance business in which most rarely get paid and fewer get paid well. Success is garnering good press, or winning an award at a festival, or receiving rave reviews, or the simple pleasure of getting distribution and seeing your film open on the big screen. All of this perceived "success" still won't pay the bills, so it's important to take that tried-and-true parental advice and have a fallback plan to actually make money. Otherwise, you'll be racking up credit card debt and filing for bankruptcy before your first feature even hits the festival circuit. Sad, but true.

Of course, once you reach that "perceived success status," your job will now be to lie to everyone about how great life is in the business and continue to perpetuate the myths about the entertainment industry. No one likes reality.

SECTION 1:
GETTING INTO FILM FESTIVALS

"Like the lottery, you can't win if you don't play. Sundance is the mother of all film festivals—you must apply."

—JOAL RYAN,
filmmaker, *Former Child Star*

10 STUPID THINGS INDIE FILMMAKERS DO TO MESS UP THEIR MOVIES

There are countless books that explain how to make movies. And while that is not the subject of this book, I do feel the need to chime in with some kernels of advice every once in a while.

One fact many people have a tough time swallowing is that, percentage-wise, there are more *bad* independent films than there are bad Hollywood movies. Here are the common mistakes to avoid if you wish to make a successful independent film that rises above the pack and solidifies your career as a filmmaker. Meaning, you get paid to make films instead of paying to make them.

1. Weak script

Here is where more indie films fail than in any other area. If the running time is around seventy minutes, the feature script was probably thin to begin with. But one only has to look at Kevin Smith's *Clerks* to learn why the script is the most important element. *Clerks* is perhaps the most technically inept film ever to get a theatrical release. Almost any decent student film looks better than *Clerks*. But today's audiences are not as concerned with the technical quality of a film. Content is king for indies, and this is where *Clerks* succeeds brilliantly. We don't care about the gritty look (actually, that look contributes overall to the mood)—the characters engage us, the story is well paced, and we laugh our asses off at the snappy dialogue. Kevin's amazing script rose above the limitations under which he made the movie, resulting in what is now an indie film classic. They say that paper is cheaper than film, so buy some paper. And keep buying it until you write a great screenplay (then, other people will buy it for you).

2. Casting non-film actors

Most first-time filmmakers think that to hire actors, they must go to the theater. I can spot a theater actor in an indie film on a 13-inch black-and-white TV running a VHS screener from across the room. Theater actors are used to "projecting" their performance to the back of the playhouse, which often leads to over-the-top performances on camera. Bring it down a notch. Or maybe ten notches. Actors' performances are magnified onscreen, so if you use non-actors or actors with little film experience, you'll often spend time asking them to tone it down. Other than policing non- and less-than-experienced actors, casting is perhaps the most important decision you'll face as a filmmaker. In fact, some say half of directing is casting, so choose actors who will elevate your material, not butcher it. Talent from the Screen Actors Guild is of a higher caliber and worth the extra money. SAG has several contracts geared toward helping independents get their films made. Some even allow you to defer an actor's pay entirely, but there are strings attached, so examine all the paperwork carefully. You can get info at www.SAGindie.com.

3. Sacrificing quality to meet a deadline

Okay, you're going to hear this one more than once in this book, but you *cannot* sacrifice the quality of your film to make the deadline for a festival. You are not only cheating yourself, but you are betraying everyone on the crew (who worked so hard to do their jobs) as well as your investors (who trusted you with their money). So many filmmakers rush to meet a deadline for a major festival like Sundance and they end up with a film that is less than it could have been. And then they are surprised when the film is rejected. Take the time. It's one of the only luxuries that comes with making an independent film. Take the time to edit, to get feedback through a focus group, and to be sure you have made the best film possible. Only then will you be ready to submit to a festival.

4. Wearing too many hats

So, you're the writer/director/producer/editor and you star in your movie. Great. We all understand that making an indie film requires

you to do, well, everything. But taking credit for everything makes you look naïve. Inexperienced. The opposite of humble. Consider delegating a few of those hats, along with the responsibilities that come with them, to talented people in their respective fields.

5. Clearances

The number one stumbling block to getting a distribution deal has to be legal clearances. Have your legal house in order so that when you go to sell your movie, all your paperwork is clean. This goes for everything from actor contracts, to clearing locations, to clearing any names or items and music. Get an attorney to look at the script for any legal stumbling blocks *before* you shoot. Do not, I repeat, *do not* simply get "festival clearance" for the music in your film, hoping to get full clearance later. Yeah, I know, you love that Chemical Brothers song and it's perfect and no other song will do—but that doesn't help you, because you will have to get the song fully cleared before you can sell the movie. Craig Brewer, who made the digital indie *The Poor & Hungry*, approached Icehouse Records in his hometown of Memphis, Tennessee. They provided a box full of CDs by local bands and from those recordings Craig put together a soundtrack for his film, with *fully cleared* music. Do whatever it takes to clear everything, otherwise you'll be stuck having to fix it later, which can be very costly. In fact, it can cost you a deal.

6. Bad sound

If it's a choice between sound and picture, put the cash into the sound. Nothing ruins a film experience more than being unable to follow a story because the dialogue is inaudible or so badly mixed that it's become incoherent. While film is a visual medium, filmmakers often forget that sound is 50 percent of the experience.

7. No money for marketing

There should be a line item in your budget for money to be spent on promotion and festival travel. Getting the film made is only half the battle—now it must be sold. Without money for posters,

publicity, travel, etc., the odds of selling your movie will be stacked against you.

8. No festival strategy

If you plan to attend a festival as a filmmaker, be sure to visit that festival as a film-goer first to learn the ins and outs. Get to know the staff and anyone who might help you get the film programmed. Have a Plan B. Just because you didn't get into Sundance, Seattle, Telluride, or Toronto is no reason to give up and no reflection on the film itself. There are plenty of stops on the festival circuit that can result in awards, good reviews, useful contacts, attention, and a distribution deal, so include those fests in your plan.

9. Serious documentary = PBS. Funny documentary = sale

Documentaries that explore a serious topic tempered by humor are more commercially viable than those that don't. And if you've made a doc about the world of porn, swingers—hell, anything involving nudity—that will almost guarantee a sale. It's a sad truth, but isn't that what docs are supposed to explore? Naked reality?.

10. There's no *I* in team

Don't try to do it all yourself. If you try to do it all, you will fail. Learn to delegate. Build a strong team to support you at the festival—otherwise, you'll be the one hanging up posters. Thank all those who helped you along the way. In the independent film world, genuine thanks and appreciation go even further than money.

D.I.C.—DO IT CHEAP

In all things related to your film—whether it be casting, production, postproduction, marketing, promotion, anything—you will face one seemingly impossible barrier to getting what you want: money.

Money is an obstacle filmmakers face at every level, whether producing a $100 million Hollywood extravaganza or a $900 digital indie feature. Those filmmakers who are able to master the art of Taming the Triangle will get what they want without compromising their vision.

The "Triangle" represents the way a filmmaker wants everything done all the time: fast/good/cheap. In any task related to a film, you almost always have the luxury of choosing only *two* of these elements to achieve your goal. As an example, let's say you need an explosion for your film. The big budget Hollywood movie producer may choose to do a giant special-effects-laden explosion. Hollywood can do it fast and good, but it will definitely *not* be cheap. The no-budget digital movie producer may choose to do an explosion but will select the path of fast and cheap; the resulting shot will *not* be good. The no-budget producer may choose good and cheap, but it will *not* be fast. That producer will encounter time as an enemy.

THE TRIANGLE

In the making of your film, you will come up against the Triangle and the fast/good/cheap decision many times. For most indies, the logical choice will be good and cheap as time is usually the one thing you have available. But as you've already read once and will read again throughout this book, if you rush to meet a festival deadline and wind up compromising the quality of your film, you will only hurt your chances for success.

Take a look at the choices on the Triangle and choose the path that best supports your final vision. You don't think filmmakers at all levels face the same dilemma? Even George Lucas, one of the most successful independent filmmakers of all time, let over fifteen years pass before he revisited the *Star Wars* universe—he was waiting for the quality of digital filmmaking effects and technology to improve while becoming cost-effective. Live by the Triangle, and as a filmmaker, evaluate every decision toward making the best *finished* film possible.

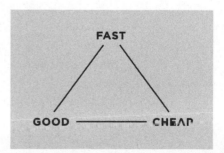

IN FILM, *POLITICS* IS NOT A DIRTY WORD

In the film industry, politics means meeting the right people, rallying them to your cause (your film), and enlisting them in your mission to get your movie made and seen by as many people as possible.

Unfortunately, the question is not always, "Who is the best filmmaker?" More often, it comes down to the question, "Who excels at the political

Robert DeNiro at the Tribeca Film Festival

game that is the film industry?" You must learn to become astute in politics if you intend to be a successful (i.e., working and solvent) filmmaker. Let me clue you in on a little secret—you already know how to do this. You may not be aware of it, and you might not have done it on purpose, but you have used politics to your advantage every moment you have been working on your film.

- You raised the money you needed for your film from somewhere.
- You secured the perfect location—for free!
- You begged the lab to go the extra mile—and they did.
- You fought to have that scene kept and shot your way.
- You convinced the rental house to give you a break on your equipment.
- You kept spirits up when disaster struck and rain ruined a day of shooting.
- You inspired the cinematographer to come up with a solution for that troublesome setup—and it turned out beautifully.
- You talked the entire crew into working through the night.
- Your sense of humor saved the first AD's life when the entire crew wanted to kill him.

- You even persuaded your actor to do that embarrassing nude scene. (Full frontal. You rock!)
- You assembled a group of people to create a film and see your vision through to completion, and you smiled through it all (even though you know you could have made a better film under more ideal circumstances).

So you see, you are a political animal; you just never thought of it that way before. Now, you must take these Svengali-like abilities and translate them into selling your movie. (Pay attention and commit the next sentence to memory. It's a run-on and completely grammatically incorrect. I already know that, and I've beaten my editor over the head to keep it just the way it is; basically, it is the crux of the entire book.) All you have to do is use these very same skills to apply to festivals, lobby the festival staff, convince them your film must be seen, get into the festival; hire a publicist, a lawyer, a producer's rep, and an agent; travel to the festival—don't forget to make a killer poster, an EPK, a trailer, and a website; get some press, create great buzz for your movie, pack the screening with a real audience along with press, friends, celebrities, and acquisitions executives; be humble, engaging, and funny at the post-screening Q&A session, get some good

SXSW theater marquee

reviews, create more good buzz, get "the call," make the distribution deal, negotiate tough to get the best deal, read the trades to look for your name and the announcement, travel the world showing your film at other festivals, support the release of the film by doing interview after interview—and during this whole process get into as many parties and have as much fun as possible while exhibiting your ability to remain witty after far too many drinks. That's it. That's all you have to do.

The rest of this book explains how all of that can be achieved. It's important to point out that no two filmmakers realize success by following the same path. Each one "makes it" differently, and your experience will be completely different and totally your own.

WHAT MAKES A GREAT FESTIVAL

FOR TRAVELERS: LEARN TO LOVE WAITING IN LINE
You're going to wait in line. A lot. So learn to love it. Here are some things you can do:
1. Read a book (or read a script, if you want to get people's attention).
2. Play movie trivia games. A great way to test your knowledge and make new friends.
3. Make cell phone calls back home and tell your pals that you are at the Sundance Film Festival and they are not. That's the most fun!
4. Text or Twitter your opinions on movies you've seen.

I have been attending film festivals since I was a kid, so I've had my share of good and bad experiences. I rate a film festival as "great" based on a very specific set of criteria. I try not to judge a festival by a few technical mistakes, because those can plague even the largest and most respected festivals. As a festival-goer, there are three key elements that make a festival enjoyable for me: great films, solid organization, and fun parties.

10 STUPID THINGS PROGRAMMERS DO TO MESS UP THEIR FESTIVALS

When I was given the opportunity to program Cinema Epicuria: The Sonoma Valley Film Festival, I was determined not to make the same mistakes I had seen at other festivals. I figured, hell, if I wrote a book about film festivals, I better damn well know how to put one on. Having traveled to more than one hundred festivals worldwide, I've seen the best and the worst, but I always see the same problems over and over again. While the following ten gaffes are geared toward festival staffs, this list should help filmmakers get an inside perspective on how a festival works. As the program director for two years, I learned a lot from my experiences, so I now present you with the top ten things to avoid when programming a festival:

1. Screening bad movies

The main reason that an avid film-goer travels to a festival is to see good movies. But somehow plenty of awful films get play—films so bad that you wouldn't watch them if they were airing for free on network television. So, why do really terrible movies constantly turn up on the festival circuit? A lot of reasons. Sometimes the director is "friends" with the programmer, or a programmer is pushing some kind of personal agenda, or another movie pulls out at the last minute and a suitable replacement must be found quickly. Whatever the reason, the programmer must be responsive to the needs of the local community. Personal tastes will always vary, but don't screen a documentary about punk rock in the 1970s at a festival whose local demographic consists chiefly of senior citizens. Asking other programmers for help is key or, heck, ask me—I see decent indies all the time and I am happy to hand out a recommendation. You must be discriminating. For Sonoma, I personally screened two hundred films sent to us through our call for entries and saw another six hundred films at other festivals and through tapes sent to me by filmmakers—all this to get down the fifty films that ended up in our program.

2. Poor organization

When the program guide contains incorrect information, when screenings are running thirty minutes late, when the screening begins with five minutes of apology from the program director about the delays, when the audience sits in the dark while a damaged print is repaired, when the post-screening Q&A begins with nervous silence—then you've got serious organizational problems. Addressing these effectively with experienced theater managers and well-trained volunteer team leaders can help solve these simple problems quickly. There will always be some amount of chaos behind the scenes—that's normal—but as long as it remains invisible to the festival-going public, those problems never happened. Good organization is often worth paying for, because a smoothly run festival is generally a profitable one.

3. Giving sponsors control

Bending over backward for sponsors can be very fruitful for both parties. The festival circuit would not exist without the generous support of sponsors committed to independent film, but that doesn't mean the program should be a slave to their agendas. Be wary of how a sponsor's influence may creep into the festival itself. If you alter the name of the festival (nothing sounds more lame than something like "The Citibank Blah-Blah Film Festival"), or if you include programming "suggested" by the sponsor, you may be bending over a little too far. And I mean bending over "forward."

4. Bad press relations

The press can be your best friend . . . or your worst enemy. Make them feel special by being generous with badges and extra tickets to events, give them goodie bags, and don't forget to invite them to all the parties. Yes, kiss their asses. Good press can make a festival, and bad press can kill it. It's never too early to cultivate press relationships, even as far as a year before the festival. Hand-feed stories, in the form of bold press releases sent to journalists willing to report on your festival's progress. Arrange for some of your filmmakers or celebrities to do advance interviews before they arrive at the festival so those stories can appear during the event. Get select members of the press into a screening room or get them video screeners of some of your strongest films so advance reviews can appear in the local media. At Sonoma, we had cover stories in two local papers the week of our event, which highlighted our best movies, and those films sold out, requiring us to schedule extra screenings. Not a bad problem to have.

5. No local support

Securing local support at all levels can ensure a successful event. Contact the local government, schools, and business leaders. Approach newspapers as well as television and radio stations and rally their support for the cause of the festival. Then engage them at all levels. At Sonoma, we had each event sponsored by a different

local business, which helped us gather more sponsors than ever and gave them a special spotlight each night.

6. Boring panels without purpose

Panels at film festivals should be two things: informative and entertaining. So, I'm constantly miffed when esoteric film professors are often given the task of moderating (what often turn out to be) deadly dull panel discussions. With all due respect to those in academia, most people don't come to the festival for an education. They just want to see movies and be entertained. Useful, concrete information about filmmaking should absolutely be disseminated during the course of a panel, but I often find film professors the least qualified to accomplish this task. I try to make panels fun. Once, I wanted to put on a panel of directors, but I also wanted to make it interesting. So I titled the panel "How to Shoot Nude Scenes." The panel explored how directors work with actors to persuade performers to become emotionally "naked" on camera. It was no surprise that this panel discussion was packed to capacity with a standing-room-only crowd and the discussion was raucous and informative. Mission accomplished.

7. Trying to be the "Sundance of ___"

I hear many festivals describe themselves as the "Sundance of the West Coast" or the "Sundance of the East Coast" or the "Sundance of the Lower Southside Main Street." Here's a message we all should have learned in preschool: Be yourself. It's better to be a festival with its own distinct identity than a Sundance wannabe. I get the feeling a lot of festivals simply lack vision. At Sonoma, which takes place in the wine country just outside of San Francisco, we realized that we could not compete with any of the international or gay and lesbian film festivals in the city. So we didn't try. Considering that the local community primarily consisted of baby boomer families and seniors, we made a conscious decision to program "life-affirming" movies. I went after heartfelt dramas and "moving" pictures, if you will. While a lot of the movies may not have appealed to my personal taste, the local community embraced this

new direction. Attendance tripled as a result, and Sonoma received its best feedback ever on our programming choices.

8. Uncomfortable Q&As

There's nothing more uncomfortable than a deadly silent post-screening question-and-answer session with the filmmaker in which the audience simply does not know what to ask. For Sonoma, I personally trained a volunteer group of people who were comfortable speaking in front of audiences and created a cheat sheet of basic questions to ask and advice on leading a discussion. Each Q&A kicked off with the volunteer initiating applause, thanking the filmmaker, and asking that first question. With the ice broken, the audience began to step up and ask questions of their own. Each filmmaker walked away feeling good about the experience, which I know will translate into good word of mouth to other filmmakers. It's really worth taking the time to do this process right.

9. Celebrity factor

Raising the profile of any festival is easy if you invite some big-name celebrities affiliated with some of the chosen films. However, ask yourself: Is the person you're flying in first class, putting up at a four-star hotel, and granting twenty-four-hour use of a limo, plus a generous goodie basket and per diem, *really* a celebrity? Is he worth it? If you have to explain, "You know that guy? On that one TV show? Back in the 1990s? Remember that guy? He's starring in a movie at our festival!" your enthusiasm for "that guy" may not be enough to convince sponsors and audiences that you have a genuine celebrity in attendance. Limit yourself to a certain number of VIPs—just be sure they are genuinely "VI," because they get expensive very fast.

10. Cash bar

The cash bar is perhaps a partygoer's greatest fear and a guaranteed buzzkill at a festival bash. It's bound to end in poor press and leave a bad taste in the mouths of festival-goers. Remember this

old saying: "If you serve free drinks, they will come." At Sonoma, well, being in wine country made it easy to serve top-quality wines at every screening and party. Lining up a liquor sponsor is critical for official events. It's the top priority on my list.

EVERY FILMMAKER-FRIENDLY FESTIVAL MUST AVOID THESE

1. Inflated entry fees

Keep the entry fee as low as possible—you'll get more submissions as a result.

2. Unnecessarily long entry forms

Keep the forms simple for entries. You can always send a follow-up form for more information once a filmmaker is accepted.

3. Poor travel deals

Filmmakers make choices about traveling to a festival based on cost. If it's a choice between a festival covering hotel only versus a festival covering airfare, hotel, and throwing in per diem, there's no choice to make. The festival offering the better travel deal will be the one that always wins.

4. Failure to send rejection letters

Send a rejection letter to every film that does not get in. It's tough, yes, but necessary. Here's the one that I sent out when I was at Sonoma:

Dear [Filmmaker's Name]:

I really hate having to send letters like this. It is my unfortunate duty to inform you that we were unable to program your film for this year's Sonoma Valley Film Festival. The final schedule will be up on the festival website in the next week, should you wish to peruse our offerings.

*Please do not take this rejection as a reflection of the film itself.
I really wish we could accept more films—but due to schedule and
timeslot restrictions, we were limited this year, but hope to expand in
the coming years. In many cases, it was not a matter of rejecting films
that were not worthy, more that we received so many quality films that
our choices proved incredibly difficult.*

*I encourage you to send your future projects our way. Thanks again
for considering us in your festival plans.*

If you have any further questions, please contact me.

Thanks,
Chris Gore

5. Technical mistakes

Be sure to hire the right people to handle your tech and print
traffic so that each film is seen in the best possible way—the way
the filmmaker intended. Nothing is worse than seeing a stressed-
out filmmaker pacing the lobby because his or her movie is being
shown in the wrong aspect ratio or the sound is garbled. Make
technical excellence a top priority (and not number five, like it is
on this list).

APPLY YOURSELF

AIMING FOR THE BEST FESTIVALS FOR YOU

So, you've worked hard, had the wrap party, you're close to finishing your
film, and it's now time to begin to send in that festival application and
travel the world showing your masterpiece. Having finished a film, you
certainly have the right to be on a creative high, but don't let that sway
you from reality; it's time to get serious.

Aimlessly filling out applications and writing checks is generally how
most filmmakers go about submitting to festivals. That method usually

results in paying a cool forty bucks for each rejection letter—a total waste of cash. You can do better than that. You need a submission plan.

First, you need to get to know the festivals. (Which is why we've given you access to the all-inclusive festival website, www.UltimateFilmFest.com.) Choose a group of festivals that best fit the profile of your film. There are many factors to consider when choosing festivals that are right for you.

> **PACKAGE CORRECTLY**
>
> When you send out tapes, don't use those ones packed with paper fiberfill. When they are ripped open, they can damage your tape. Some festivals will not accept films sent in these packages. Always mail your tapes in plastic bubble wrap-padded envelopes. And there's no need to include things like T-shirts or promo items—they usually just get thrown in the trash. A simple press kit with entry form is plenty.

10 IMPORTANT FACTORS TO CONSIDER WHEN APPLYING TO FESTIVALS

As the filmmaker (writer, director, producer, or combination of the three), your job is to act as the ambassador of your film. When you travel to a festival, you represent everyone who worked on the movie and the movie itself. Make no mistake: Selecting the festivals to submit your film to is an important decision. You will be throwing away vast amounts of time and money if you do not consider these ten important factors before submitting to any festival. In order of importance, they are:

1. Prestige

Submitting your film to a prestige festival will give your movie its best chance to be sold to a distributor, receive loads of press coverage, get your next film deal, and (cross your fingers) launch your brilliant career as a filmmaker. Also, even being *accepted* into a prestige festival can make a great quote on DVD packaging—something as simple as "Official Selection, Sundance Film Festival." I'll bet you've

> **MEET THE MARKETING FOLKS**
>
> Get to know the players in distribution who are interested in your film. Especially the marketing people. They are the ones who will be selling your film to the public, so make sure they "get it." You only have to make one distribution deal—make the right one. Deals are made with people, so get to know and trust them.

noticed that on more than a few films. Prestige counts for a lot. Being accepted into one of the top ten festivals is an honor, so keep that in mind.

2. Distributors

Is this fest considered a "discovery" film festival that distributors attend? If the ultimate goal is to sell the film, this must be of paramount concern to you. Make sure to ask the festival staff which acquisitions executives will be attending.

3. Reviews and press coverage

Getting exposure in newspapers like the *Los Angeles Times* and the *New York Times*, magazines like *Entertainment Weekly, American*

X-Dance Film Festival marquee

Cinematographer, and *Filmmaker,* Web outlets like Film Threat and indieWire, as well as trades like the *Hollywood Reporter* and *Variety* is another important factor to consider. Your chances of being covered and/ or reviewed by these outlets increases when they actually attend the festival. But it's also your job to be sure that they see a screening of your film. Ask the festival office to provide a list of the journalists attending the festival. If the festival has only attracted local press, it may not be worth your time. Unless, of course, that local press is in one of the top ten markets in the United States.

4. Prizes and awards

From sizable cash awards to film equipment to lab deals, prizes should play a role in your decision to submit. The winner of the Grand Prize for Dramatic Feature at the Heartland Film Festival gets $50,000—that's a damn good prize! Cash awards are always a nice dividend. Be sure to research the prizes awarded and take them into consideration when submitting. Inquire about audience awards, judges awards, etc. Any type of award that your film receives

will only serve to increase its overall value. While it's an honor to receive a jury award, audience awards hold a lot of clout since they are the true gauge for whether moviegoers respond to your film. Winning an audience award will get you attention and will increase the interest of other people (hopefully, well-funded people), who will now want to see your film.

5. Location

Could this film festival be a well-earned holiday as well as a chance to schmooze with the big shots of the movie world? If it's a choice between the Hawaii Film Festival and a festival in Ohio, the choice is clear. Surf's up! Hawaii!

6. Perks

How does the festival treat you? Is the flight paid for? Are you put up for free? For example, the Florida Film Festival treats filmmakers like royalty, even offering passes to Disney World and Universal Studios Theme Park while the filmmakers are in town. Be sure to inquire about paid expenses and other perks. Travel costs can add up fast, so research what expenses festivals will cover. Almost all festivals cover lodging, fewer cover airfare, and a small few will give filmmakers per diem. Get the facts before you submit.

Florida Film Festival marquee

7. Application fee

Festival application fees can be really steep. Upwards of fifty dollars for some. At that price, enter twenty fests and you've spent a thousand bucks. With over a thousand festivals worldwide, those application fees can add up. You could end up spending enough in application fees to finance your next film!

Be sure to ask if a festival is willing to waive the fee. It's always worth a try, and some of them might actually grant your request. If your film has no chance of being accepted anyway, why bother

writing the check and submitting the film? Do your homework. Don't submit your talky, twenty-something, angst-ridden, Kevin Smith–like *Clerks* wannabe to the Asian Children's Film Festival.

8. Research and recommendations

You should do your own research and contact others who have either attended or had their films shown at that particular festival, if at all possible.

9. Contacts

It's vitally important to make useful contacts for investors in future films, distributors, acquisitions executives, agents, lawyers, and especially other filmmakers who can help you along in your career. Or simply to make friends in the industry. You never know how these contacts can pay off later. For many, a festival can be an opportunity to meet their heroes in a social setting. I know a filmmaker who attended a small film festival for one reason only—Martin Scorsese was going to be there, and he wanted to meet him. Nothing is more fun than slugging down beers and talking film until all hours of the night with a longtime film hero. You'd be shocked at what John Waters will tell you when he's feelin' loose at a party. (God, I love that guy.)

If you decide to go the route of self-distribution, making contacts will be a major factor in your submission plan. You'll need to find others in the industry willing to champion your film.

BUILD A TEAM
A combination of publicist, manager, producer's rep, agent, and lawyer is not always possible. Just be sure you have one point person to represent the business interests of the film. Members of your team should be as passionate about your film as you are.

10. Fun

Yes, fun. If it's going to be miserable, why bother? Working the festival circuit, plugging a film day in and day out, can be grueling after the fiftieth post-screening Q&A session. Select festivals in places you'd like to visit—that way, if the festival is a bore, at least

you'll have the opportunity to explore the nightlife in a new city. Ohio may not have the beach, but there are some great bars and even better people.

Basically, you need to think of your film as an investment. The value of your film (and yourself as a filmmaker) increases as you receive good press, awards of any kind, and acceptance into prestige film festivals.

SEEKING ACCEPTANCE

AVOIDING MISTAKES ON THE ALL-IMPORTANT FESTIVAL APPLICATION

All you have to do is fill out the application, write a check, enclose a DVD, mail it off, and you're in, right? *Wrong!* Filmmakers who follow this path are only fooling themselves. There are some very simple things you can do to make the lives of the people running the festival a little easier and increase your chances of acceptance. Follow this advice and avoid the mistakes that turn many festival entries into recycled DVDs.

1. Follow instructions.
The first thing you can do to leave your film teetering on the fence of rejection is fail to follow the directions on the application. This only serves to upset busy festival workers. If you have any questions or extenuating circumstances regarding your film, be sure to call the festival.

2. Label correctly.
A package sent to a festival generally includes the check, application, your film on DVD, the sleeve and press kit, press materials, photos, etc. Be sure to label every single one of these things and include your contact information on everything. If you send the DVD, the contact info should be on the packaging *and* the DVD itself.

3. Inquire about a festival's prescreening process.

Most festivals won't admit this, but many submissions are first viewed on DVD by volunteers from a screening committee and not the festival programmers. Sometimes only the first five to ten minutes are actually viewed. This is an unfortunate reality. However, when you consider that festivals generally receive a thousand films, resulting in close over fifteen hundred hours of viewing time (that's about two straight months with no sleep in front of a TV—hey, you try that!), you can't blame them for rushing through the screening process. If you pay the application fee, I believe you have a right to inquire about who will see your movie. A volunteer from the selection committee is nice, but ideally you'll want your film to be seen in its entirety by the festival's key programmers. A friendly call asking about this is recommended, but be sure to respectful of each festivals' screening process—which means you'll smile no matter what.

4. Research the number of submissions accepted.

Your chances may be better at a smaller festival with fewer submissions.

5. Save your premiere for the right festival.

It's something you'll hear more than once in this book: Your premiere should be protected as if it is your film's virginity (and you can only give it up once). When submitting to a festival, full disclosure is necessary, so be honest. Lying on the application is never a good idea, since the festival staff will eventually find out the truth. If the film has screened elsewhere, you must include this information. One way to get around premiering too soon is to screen at a festival as a work-in-progress—out of competition—and be sure you are not listed in the program guide. This means you can still officially premiere at a bigger festival sometime in the future. Don't hesitate to ask a festival whether playing at another will exclude you from acceptance. Playing Toronto in September will not exclude you from playing Sundance in January, but if you play the AFI Fest in November, your chances for playing Sundance will be over.

6. *Do not* include a long apologetic letter pointing out your film's faults.

"The sound is a pre-mix . . . this is a rough assembly . . . we plan to take out another twenty minutes . . . we're still doing some reshoots . . . " Dailies are for *you* to examine, not the film festival. Send as close to a finished film as possible.

Your cover letter should include all the basic details and should be no more than one page. If the film is a rough cut, certainly point that out, but don't dwell on it or go into exhausting detail.

7. Make a personal connection.

Any kind of connection you can make in your cover letter or follow-up phone call to the festival is helpful. Attaching a voice to a name makes you human and not just another applicant. But don't be bothersome by constantly sending letters asking, "Are we in yet?" In the case of festivals, the squeaky wheel gets annoying really fast, so be understanding and respectful of festival staffers' time. There are hundreds of other filmmakers also waiting for a response.

8. *Do not* include promotional junk.

T-shirts, stickers, pens, and other promotional giveaways will often make their way into the garbage. You'll need this stuff later to promote your film—*after* it has been accepted. Don't include it in your package.

9. Have a story.

I mean your own personal story. There is a reason that you made your film, and your struggle to get it onscreen can be as compelling as the film itself. It makes a great story in a festival program and will set you apart from the pack. Is the film autobiographical? Why is your film so important that people would pay to see it? What hardships were endured to tell your tale? The viewers of your film will look differently at it if they know you had to sell blood to get it made.

If you don't have any story at all, be creative. The Slamdance Film Festival program book features information about each filmmaker,

BE UNIQUE, JUST LIKE EVERYBODY ELSE
Even an independent film without name actors has a chance, especially when the movie has a clever hook. Look for ways to capitalize on your film's marketability.

including a short bio. I still remember reading "Eric Kripke is a millionaire playboy director who solves baffling crimes in his spare time." His short film *Truly Committed* was hilarious and went on to win the Audience Award at Slamdance.

10. Submit on time.

Submitting late will only give the festival staff an easy excuse to reject your film. It also means that most screening slots have already been filled and that your film will most likely not be viewed in its entirety. By now, the bloodshot eyes of the screening committee in the festival are highly trained to spot films they don't like. If they are not hooked in the first five to ten minutes, your film becomes a reject.

WRITE A POWERFUL FILM SYNOPSIS

I cringe when I read poorly written descriptions of movies that appear in festival program guides. Sometimes the descriptions are so pretentious or vague that it's impossible to even tell what the movie is about. These short descriptive paragraphs are an essential piece of movie marketing and often the only tool a festival-goer has to make choices about what film to see. Many times the film description sent in by the filmmaker is the one that is used in the program guide, so as the filmmaker, it's worth spending time writing a synopsis of your film in various word lengths.

WHAT SELLS
Talk to people about the marketplace. What kinds of films sell? What doesn't sell? What are the realistic expectations for my movie?

Remember, the synopsis is made to *sell* the film. If the synopsis is poorly written, it will reflect on the film itself. Also, avoid being esoteric or pretentious like this synopsis from a rejected submission from the Atlanta Film & Video Festival:

"Put simply, this film is a romantic fable. However, as a film, it is a composition of auditory and visual components. Please keep in mind, the same person both photographed and scored this

film thereby creating a structure of audio-visual counterpoint. Using an original, yet light archetypal story, the filmmaker has sought to compose a film that 'works' not only as an intensive audio-visual approach, but also as a carefree ride right into a big fat smile!"

Uh, yeah.

This handy writing primer can be used by both filmmakers and festival programmers to write eye-catching copy that will fill festival seats.

Getting Started

First and foremost, a description of a movie written for a festival program guide is *not* a review—let's face it, it's advertising. You want to get audiences so excited that they'll be afraid they may miss something. You'll need to hone your writing skills by using your thesaurus. A lot. But if you're like most broke filmmakers or festivals, you'll look for a *free* one on the Web; try www.thesaurus.com. Be sure to bookmark that site as it will come in very handy. Begin by sprinkling your description with "emotional" words, like *compelling, touching, moving, milestone, life-affirming, sexy, romantic, groundbreaking,* or *heartfelt.* Adjectives like these work, so use them liberally. Yes, it's hype, and it can be very successful.

Sound Bite

Consider starting with a large quote underneath the title, which serves to grab the reader's attention. With only a glance, a reader can get a quick idea of what the movie is about and whom it's for.

Synopsis

A compelling description of the story should run about one hundred to five hundred words. The most important thing to remember is to be specific. Believe it or not, some of the worst festival program guide descriptions come from Sundance, where you can read five hundred words about a movie and still not know what it's about. Don't go that

route—tell the story, but *never* give away the ending or too much of the narrative. The story description should act as a *tease* and make people want to know what happens.

And don't forget to address this in the copy somehow: *Why* is this story important? *Why* should audiences pay attention? *What* about this film may change the lives of audiences taking the time to see it? *Why* is this film so compelling? *Why* is this film unique? The "why?" is important to include since it's a chance to point out the unique nature of this film and what makes it a "must see." Every film playing at the fest is a "must see" but each has unique attributes. Point out what your film's attributes are.

Review Quotes

If you have them, include very positive quotes from prominent critics/reviewers or other sources woven into the copy. A quote needn't be a complete sentence—a phrase or even a word or two will do, as long as the credible source is cited. If you're a filmmaker, get your movie reviewed somewhere. Anywhere. Then quote from it. Or consider getting a quote from a champion of the film, someone recognizable who gives you permission to quote him or her.

Extra Info

Be sure to include additional information with the film description, such as the movie's official website. Note any actors or filmmakers that may be present at the screening, as well as the premiere status of the film. (And you know, a *local premiere* is still a *premiere*!)

And don't forget to have fun with this! You're not writing a serious film "essay"—this is marketing copy to get audiences (you know, regular moviegoers) excited about your movie. Make it sound like a movie that *you* yourself would want to see. So pour on the hype!

Here's an example:

MELVIN GOES TO DINNER

"They discuss marital infidelity, religion, schizophrenia, ghosts, stewardesses, self-pleasure. . . ."

Starring Michael Blieden, Matt Price, Stephanie Courtney, and Annabelle Gurwitch, with cameos by Maura Tierney, Bob Odenkirk, David Cross, and Jack Black

Directed by Bob Odenkirk, 80 min.
www.melvingoestodinner.com

WEST COAST PREMIERE! Have you ever gone to a dinner that changed your life? Melvin (Michael Blieden) reluctantly attends a dinner with three almost complete strangers. They discuss marital infidelity, religion, a guy in heaven wearing a Wizard's jersey, fetishes, cigarettes and schizophrenia, ghosts, stewardesses, self-pleasure, and how it's all going to get a lot worse before it gets better.

Directed by Bob Odenkirk, *Melvin Goes to Dinner* is vastly different than *Mr. Show*, his groundbreaking HBO sketch comedy series. No worries, though. Melvin has a crude sense of humor that can be linked with Odenkirk's past work, and there are also laugh-out-loud cameos by David Cross and Jack Black.

GETTING A "THUMBS UP" FROM THE GATEKEEPER

*Behind the Scenes with Geoff Gilmore, Former
Director of the Sundance Film Festival and current
Creative Director of the Tribeca Film Festival*

The Sundance Film Festival is the leading festival in the United States, if not the world. It is where indie films are picked up for distribution,

where new talent is discovered, and where people from all over the world travel to make deals. All festivals have gatekeepers—screening committees that often make group decisions about what films to accept. For years, Sundance's chief gatekeeper was Geoff Gilmore. While the festival has a trusted group of programmers, including John Cooper, Caroline Libresco, and Trevor Groth, Gilmore was the primary person responsible for programming at Sundance. He is considered by many to be the leading tastemaker for the next big thing in independent film. Gilmore's recent appointment as creative director of the Tribeca Film Festival promises to take the East Coast festival to new heights and lead to exciting new discoveries.

Geoff Gilmore introduces
a film at Sundance.

Sundance sets the tone for a lot of the smaller film festivals. Many of those festival directors attend Sundance to see what's hot and then try their best to program those films at their festivals. What do you think of that?

That's partially true, although in recent years, Sundance has really gone out of its way to offer another thirty or forty films to those festival directors to say, "Hey, guys, you didn't see this at Sundance, but look! This wasn't ready for us when we had to make our decision, or, we just couldn't include this one. Why don't you take a look at this?" For a number of different festivals (SXSW, Los Angeles Film Festival, and others), we make recommendations about work that we think they might be interested in.

This also gives the filmmaker another chance. There's a real need to support a range of different independent filmmakers. Theatrical distribution is very hard to get right now, and many independent filmmakers tend to see Sundance as an all-or-nothing goal. If they attain it, they've achieved victory, and if they don't, then they've lost. I very strongly want to make the point that this is not true and that good

films do surface. Good films will find a way out, and they'll find a way out through a number of different paths.

But playing at Sundance goes a long way toward helping a filmmaker secure distribution, doesn't it?

I don't think Sundance should be seen as only a market; that's too narrow. There are films at Sundance that people *don't* get to see, that *don't* become the buzz films, and therefore people don't understand that those are also very much part of the independent world. But one of the things Sundance is really interested in trying to do is continue to expand the sense of what the aesthetic possibilities are. Festivals were once aesthetic enterprises for critics who went and talked about the movies and talked about the nature of the film and they talked about whether it was exciting or not. It was amazing—you could go to the Berlin Festival and not hear any talk about business whatsoever. Business was just not a big part of the film festival culture.

> I think probably the nicest thing you can do for young filmmakers is to get them out of debt and get their films sold.

Now you go to these festivals and the topic of conversation is acquisition deals, or whether new films could have been found. That's unfortunate, because it really overloads and categorizes only one aspect of a festival's function. I think there is a range of functions. That said, I never apologize for the fact that Sundance has become a market. I think probably the nicest thing you can do for young filmmakers is to get them out of debt and get their films sold.

Often I don't care whether a film was successful at the box office—I want to know whether it was successful creatively.

It becomes a horse race; number one is the only position that matters. They report whether something is the number one grosser of the weekend; that's ridiculous, because independent release distribution patterns are now similar to studio patterns. It's so much harder to keep a film in a marketplace and watch it actually find an audience.

The generation of filmmakers currently very much involved in producing independent films strikes me as being similar to the '90s professional athlete—very interested in what's in it for them, in making money, having their own position and their own status, but not necessarily winning championships. A lot of guys have huge contracts without ever winning a playoff game. And in some ways that seems to be what's going on with independent filmmakers. They don't really care about making films that will be memorable, films people will talk about ten years from now. They care desperately about making a film that can get them into the industry so they can recoup some of the investment they've put into the film. More than that, they want to go on to a career that's lucrative and glamorous. I meet more and more filmmakers who are extremely knowledgeable about the business side of the industry and don't really know anything about film. They have a better understanding of who's who and who is influential in the business of film than they do an appreciation for the craft.

I don't hear anyone justifying their festival by saying, "The films we showed at our festival were great." They justify themselves by saying, "We had as many films picked up as they did!" Or, "We have as many acquisitions coming out of it as they do." That should not be the justification for a festival. You have to look at your program and say, "I like this program. This is a strong program. This is what we should be showing. These are the choices we made because these are the films that have value on a number of different levels."

Hasn't Sundance become a part of this emphasis on the business side of the film industry?

You really have to have a degree of balance. I would hope that to some degree that balance comes from the filmmaker—that they have not chosen filmmaking as a career because they like the accoutrements that go with being a movie director, but because they actually have some passion and a kind of creative vision and a voice they need to express. I don't know if I see that as much. You can ask a lot of filmmakers questions about any of those filmmakers in their fifties, or about guys who are dead—and they don't know them; they haven't seen them. When they do,

it really shows. It comes out in their work, which doesn't always make it the most commercial, but makes it interesting. And this fails to be lauded enough by critics and by journalists, who used to be part of that mechanism that helped support the aesthetic dimensions of independent film.

How does Sundance actually select the films?

When you look at about eight hundred independent fictional features and another couple of hundred documentaries and another three or four hundred films in other categories, you really just don't have time to go through them all yourself. So the primary staff is responsible for viewing that work. Sundance has a support staff, and no film is seen by fewer than at least a couple of people. I screened a lot of films cold, off the shelf. In recent years, that percentage dropped a bit. Instead of picking up 50 percent of those old films and taking them home, maybe the number was down to 25 percent or so. That means that there are a number of other major staff members who see material cold. Sundance has screeners as well, and they are there to make sure the films get dealt with in a very professional way.

One thing I always gave my staff credit for is that they are very thoughtful. They really take a lot of time to consider work. They argue it passionately and persuasively—often fighting over different films. You are not looking for five of six people to sit there and agree. You are looking for people to support the work and you are trying to think about what they are saying. You are trying to be a professional programmer who is able to pick a film out and say, "This film should be shown. It's not necessarily my taste or a film I would buy if I were an acquisitions person, but it is a film that should be shown." You make that decision as a professional because you have reasons for this film to be shown as part of what's out there in the independent world. That's the goal for your staff and for yourself. That's what you strive for.

The competition is fierce now, and it continues to grow.

Prints and advertising (P&A) costs have tripled in recent years. Any film you buy has to gross theatrically at a certain level to make it profitable.

You can't release a film with less than $2 million of P&A. You are going to be in that situation regardless of what the film cost to make in the first place. So, you have these acquisitions executives looking around and asking themselves which are the films worth investing the huge amount of P&A required to make them profitable? Those are the questions that I don't think people think through clearly enough.

Are there common mistakes that you see filmmakers make over and over again?

Rushing. I keep saying, "Don't rush." Don't create a situation where everything is dependent on a schedule only to get into X or Y festival. You know, you spend an awful lot of time putting this project together. Make it good; take the extra time to not only shoot that extra take but to really think about quality. Try to take a step back. Have naysayers around you. Don't just let people say, "Great, great, great!" Have someone who really gives you a critical eye. You don't want a whole bunch of people arguing with you; what you really want is someone you can trust to help support your vision and not rush it.

For many years, we have attacked the industry as making formulaic work and pushed the independent film as the realm in which creative vision flourished. Yet, we have now moved into an era in which the independent world has become a derivative mess. Some of the initial perspective that motivated the independent world has been lost: the capital Q quirky comedy that reflects only a series of quirky comedies that have come before; the generic Tarantino–wannabe work; the coming-of-age angst story that really isn't fresh or doesn't

FOCUS TEST YOUR FILM
Paper is cheaper than film. Write. Rewrite. Get more feedback. Rewrite and repeat. Shoot some test scenes on video. Get more feedback and keep rewriting until the script is perfect. Ask yourself, "Why am I making this film?" Be willing to take helpful advice from others. When you have a copy of the film to screen, show it to a real audience. Friends and family are too polite, so recruit real moviegoers, but be prepared for brutal comments. It takes a thick skin to handle it, so be ready for a painful but ultimately worthwhile experience.

have the depth to make it profound but is simply another version of the same tale.

Without being too harsh, you want to say those films aren't going to make it anymore. You really need to find something or think about something that runs with freshness and originality. People hear these words and then go and do something straight out of a primetime network sitcom.

The thing that irks me is when I hear a filmmaker brag that they wrote the film in a week.

Isn't it amazing that they do that? They say things like, "This film was done on first draft." You want to tell them, "*It shows.*"

Many times filmmakers get so wrapped up in everything film that they tend to lose a sense of real-life experience. Do you agree that some of the better films come from filmmakers with actual life experience?

You aren't going to find creative inspiration just by watching movies. You can learn a lot, you can find a great deal to think about in terms of your craft, but in terms of your stories, you really need to find those elsewhere.

What makes a good professional in this field is a real eclecticism. Being narrow or critical in your taste is a real deficit. We have tried to support a lot of different things and have managed to avoid a narrow agenda. We understand mainstream filmmaking and filmmakers and traditional aesthetics; we are supportive of those but we try to see the world more inclusively. Filmmakers of color, gay and lesbian filmmakers, different points of view, and different voices all became part of the definition of the Sundance festival.

Diversity has always been a key definition of what Sundance is about. Though to me that diversity isn't simply a position of the color of the skin. It's a diversity of aesthetics, a diversity of points of view—and that sometimes has to do with the creator's experience, but it also comes from a creative mind.

*If you could sit down with some of these independent
filmmakers before they started writing their screenplays
and give them some advice, what would you tell them?*

Don't just go out and make a film; make a great film. It's so hard to make films, and I have so much respect for people who do it. So often, we have people filled with righteous indignation at being rejected. We have people who think that because it is so hard to make films, that just having made a film is a significant enough accomplishment in itself. It's just not enough to spend a couple of years of your life making a movie, finally finish it, think, "Oh, my goodness, I've made a movie!" and pat yourself on the back. You really have to look at what you made and say, "Is this successful? Does this convey the kind of energy and inspiration and storytelling and excitement? Does it work the way I want it to work?"

They read these stories in the paper about this guy making a film or that girl making a film. They feel they have to get their film made and they go out and make it—and too often it is just not good enough. It isn't cast well or it doesn't have any visual style, or it doesn't necessarily have the kind of creativity to it that really makes it stand apart. So you have to say to yourself—if you are a filmmaker and you have to spend all these resources and all this time—why not shoot for the top? Not enough people do.

Filmmakers need to be encouraged to really take their time. Sometimes that means you won't make it this year and that you need to work on your script. People don't like hearing that their third draft wasn't good enough, that they need to go into a fourth draft. They don't want to do that; they want to say, "Let's make it!" That sort of thinking will ultimately create something without any kind of effect, and people won't care about it.

I don't believe that this generation doesn't work hard. I feel that the twenty-something generation right now is almost Protestant in its work ethic. Film students feel they should have no other life outside of their film schools. They don't even see movies because they're working so hard in school. When I was in film school, we used to say, "Are you going to go to the Nuart and watch this film?" Because it was presumed that was what you were going to do. Now, though, people are saying, "No, I've got to finish my project," or "I've got to work on my script or do my essay."

The goal should be to go see those films. My advice is, seek that inspiration, seek that knowledge, broaden yourself, and take the time for your project to really get it right. Or else I fear we are not going to have a generation of filmmakers that will be considered memorable.

What so many of these young filmmakers forget is that you find a lot of major filmmakers doing great work in their late thirties and their forties and their fifties, rather than in their twenties. You need life experience, and you just don't get it when you are twenty.

It's interesting how many of the filmmakers who have made really low-budget films have become the filmmakers of note for this generation. Maybe the creative ingenuity you need when you are working with a low budget really marks them. I wonder if there isn't something to be said for that sort of initiation. I wonder if really struggling and making those really small $100,000 budget films forces them to overcome obstacles and marks them as filmmakers with ingenuity and promise for the future.

I've heard this many times, primarily from filmmakers who have been rejected from your festival, that getting into Sundance is very "political." Some say it's "who you know." How do you respond to that kind of criticism?

That's a "I hear you've stopped beating your wife" remark. If you tell anyone what the reality of the situation is, no one believes you. I've heard a lot of people try to take credit for getting films in Sundance. They want to claim credit for getting films in based on the calls they make. I still have to smile and say, "Guys, it just isn't true." It's very hard to get inside Sundance's doors.

I've heard some say that there are too many festivals. I disagree. What do you think?

The functions of film festivals are now so numerous that you have festivals being created for regional tourist bureaus only to raise the media profile of a small resort, rather than to fill any function in the national scheme of things.

But is that necessarily a bad thing? The way I see it, these festivals are providing alternative distribution outlets for indies, and more people will see them on the festival circuit than after they get picked up by a distributor. It's as if the "festival tour" itself is really the thing filmmakers should focus on, rather than trying to get distribution. These films are, in a sense, already being distributed to an audience passionate about indie film.

Well, I agree with you. I think the film festival circuit is a little bit like the cinematheque circuit in the '60s. Except the cinematheque circuit failed because they didn't have the marketing dollars. I do think that there are audiences for this. There's very much a payoff for filmmakers and audiences that are able to see work that is not simply what the major multiplex world and major mainstream sources would have us see. So, in some ways, it is a substitute for some kinds of theatrical distribution. In the meantime, film festivals continue to broaden the possibilities and the opportunities for filmmakers as well as audiences, for which I am grateful.

10 MYSTERIES OF THE FILM FESTIVAL CIRCUIT REVEALED

In my travels on the film festival circuit I hear a load of gossip. I hardly pay attention, but so many disturbing rumors and pieces of pure fiction seem to get thrown around as "fact" that I thought it was time to set the record straight. Here I attempt to squash the rumors and separate the reality from the bull.

1. **Why do so many quality films never get distribution?**
 My film had no stars! My film isn't commercial enough! They just don't get it! I hear a lot of complaints from filmmakers about why their films went unsold. There are many reasons that excellent indie films get passed up for distribution, but perhaps the most common is not so obvious. Typically, movies made by novice producers fail

to sell for legal reasons. Having a clean chain of title and legal clearance for all the music and copyrighted material is critical. To actually sell your film, you must have legal paper on everything. And I mean everything—not just the cast and crew, but that box of Kellogg's Corn Flakes in the background. It's always best to err on the side of, well, paranoia, when shooting. So before you even yell "action," have an attorney check your script for legal red flags and go about obtaining the clearances you need before you even get on the set. I can't tell you how many films I know about that did not sell because to do so the filmmakers would actually have to spend more money to get those

YOUR LIFE IS NOT OVER
When you pick up the trades and read that this film or that film sold for a million bucks, don't let it get you down when yours does not sell. The cold truth is that the entertainment business moves at a glacial pace. Things happen very, very slowly, so you must have patience. You may not close a distribution deal for your film, but you'll have made many new friends and useful contacts that will help you along on your eighteen-month-plus journey in getting your work seen in front of appreciative festival audiences.

clearances. In fact, closing that coveted distribution deal can end up costing filmmakers so much money, the movie is better left unsold than getting into deeper debt. (Depressing thought, huh?) Get your legal papers in order so that when it comes time to sell, you're covered. And don't forget to ask that attorney about E&O insurance (errors and omissions). Trust me, your lawyer will be able to explain it a lot better than I will.

2. Why does Sundance only show big independent films with Hollywood stars?

Sundance has somehow gotten this bad rap (mainly from rejected or bitter filmmakers), that they only show celebrity-filled independent films from major studios. The truth is that Sundance does not only show big Hollywood independents. You see, the media, and audiences for that matter, are lazy. They tend to only focus on the celebrity-driven films that screen in Park City during Sundance. The reality is that close to 120 features screen at Sundance. Probably twenty-plus are films with stars—the remaining hundred

include docs, world cinema, experimental work, and the Native Forum. Truth be told, for narrative features, there are about thirty or so slots open for films that are discovered from submissions. So before jumping to the cliché conclusion most often arrived at by those rejected filmmakers, do your homework, study that Sundance schedule, and take note of the other films screening. In fact, heck, take a count. I'm a documentary fan and it's a genre where I almost never see a celebrity, but I would defend any festival's efforts to bring in celebrity-driven projects. It's great for publicity, the media, and the movie-going public (who love celebs). Best of all, it can help draw much-needed attention to those docs, experimental films, and features starring unknowns.

3. Why do some films win Jury awards while other great films go home winless?

There's one very simple reason: Juries tend to award the film most in need of help (in terms of attention or securing distribution), rather than the superior work. It happens all the time. How do I know this? I've been on countless juries, and the mind-set is always the same—give the prize to the movie that needs the push, rather than the best film. So, if you lose that jury prize, don't take it personally. And if you win, scream about it to everyone in the industry.

Salma Hayek addresses guests at a party in Park City.

4. Do I have to go to the major festivals like Cannes, Toronto, or Sundance?

The short answer is no. There's a small elite within the indie film community who seem to think only the big fests matter. This is simply not true anymore. Independent films are finding media attention, adoring audiences, and even distribution in the most unlikely festivals. So don't completely ignore the invite to that small, out-of-the-way film festival, because you never know what contacts you may make or what might happen.

5. Is it absolutely necessary to have a publicist, lawyer, agent, manager, producer's rep, and image consultant?

No. Some of the worst filmmakers I've encountered had an entire team in place. It still won't guarantee a thing. It is absolutely essential first to have an outstanding film. That will attract the agent, manager, publicist, etc. . . . and they usually come around right when you need them.

6. How can I get away with submitting to a festival late?

In reality, you can't get away with submitting past a festival deadline. But there are ways to gain yourself a few extra weeks to work on your film. One way is to be completely honest and simply call the festival to explain your situation. Their written and spoken policy will always explain that they adhere strictly to their deadlines, so it's time to beg. And sometimes this does work. Some understanding festivals will make you send in the fee, the completed entry form, and a blank DVD as a placeholder so your film is in their system. Then once they pull that DVD off the shelf, they'll call you, and that is the time you absolutely must be ready to turn in the final work.

Now, I didn't tell you about this last one, but you can try it. All you have to do is submit on time, but send in a blank or defective DVD. By the time the festival screeners discover your defective tape (hopefully weeks later) you'll have a completed version that you can send in right away.

7. Can I buy my way into a film festival?

No, not into a reputable one. But there are some festivals that proudly allow filmmakers to buy themselves a slot in their program. So, please listen to my warning—if you are entering a festival that calls

SCREENING TIMES MATTER

Unless your film is opening or closing night (generally taken up by studio indies anyway), the best screening slot is usually a Friday or Saturday at 7 or 9 P.M. Check to be sure your screening does not conflict with any parties or major events. Usually you can count on getting at least one lousy time slot, like 11 A.M. on a weekday, but this should be countered by an evening screening. Be sure to ask your screening times, and if there is time to make a change, ask for at least one good slot.

you up and informs you that their entry fee is more than $100 and it's not Telluride, you are being taken. In fact, there is a very important-sounding New York–based "film festival" that spends its time preying on naïve filmmakers by calling them to say that they have been accepted into their prestigious-sounding event. The phone call then devolves into a sales pitch involving paying more "fees," like $300 for entering, then selling services like trailers, a website, and ads in their program guide. I know filmmakers who have been taken for more than $5,000 by these scumbags, who actually tried to sue me once for telling filmmakers about their unsavory tactics. This is a scam. Do your research and do not under any circumstance give a cent to any organization like this one.

8. The art of the sale.

Sorry to have to break this to you, but most filmmakers will not close a distribution deal in Park City during Sundance. In fact, many of the deals "announced" in the trades were closed and negotiated weeks *before* the festival even began—they are simply "announced" at Sundance because of the added media attention. The truth is that Sundance and the alternative festivals in Park City are really backdoor markets for independent films. You'll find festival directors from all over the world, as well as distributors (both large and small), seeking films just like yours. For most, the process of getting distribution may take only a year after the movie has played ten or more festivals, received a few awards, and gotten great reviews from key critics.

9. What and who are "phantom programmers"?

Okay, I have to admit something: I'm a phantom programmer. I actually assist in programming many film festivals, yet I am not officially involved in any of them. I'm not even on an advisory board! Because I see a lot of indie films through my website, www.FilmThreat.com, before they hit the circuit, I am often asked by festival programmers looking to fill a slot, "Hey, see anything cool lately?" I always have a recommendation or two. And I'm not the only one. So consider getting your film to a festival programmer

by way of a recommendation, which tends to get more attention than the usual entry form enclosed with a check.

10. What is the one thing I must know when going to a film festival?

Be nice. The indie film world is a fluid one. The assistant this year may be the festival director next year, so it's important to be cool. Just like Fonzie.

SECTION 2:
BUILD BUZZ: SECRETS OF INDIE MOVIE MARKETING

The best advice I can give anyone about creating hype is do not limit yourself in any way. It is very, very hard work, and if you do not feel completely exhausted, then there is probably a lot more you can do.

—PAUL RACHMAN,
filmmaker

INTRODUCTION TO
GUERRILLA MARKETING

What do I mean by guerrilla marketing? Basically, it means "be different." (I would also add that it means you intend to market inexpensively.) You must think beyond simply slapping the logo for your movie onto a baseball cap or a T-shirt. I know it's a cliché, but you have to think "outside the box." And since everyone else is thinking "outside the box," you have to take a sledgehammer, a bazooka, and a flamethrower to the box! Get creative when it comes to getting your film the attention it deserves from festival attendees, press, and especially distributors.

Take Morgan Spurlock, whose documentary *Super Size Me* played the 2004 Sundance Film Festival and walked away with an award and distribution. He had cheap buttons with the McDonald's logo on it and the word "Obesity." Within a few days, everyone was wearing them. One well-attended Sundance party found loads of people wearing the "Obesity" button. It was cool because it was mysterious—and because it wasn't a T-shirt.

Morgan went even further and created unique items like *Super Size Me* skullcaps, french fry change purses, and even Fat Ronald dolls. The *Super Size Me* posters and postcards (with screening times stickered on the back) were found everywhere. (For more on the story, see his interview on page 150.)

T-shirts may be cliché, but they can be an effective way to gain attention.

Morgan Spurlock's film had huge buzz with all of his screenings sold out because he was able to think outside the box. He didn't spend a lot of money and yet he produced unexpected attention-getters and presented his film in

a creative and unexpected way. This doesn't mean that you should be passing out buttons yourself, but it certainly means you should consider something other than T-shirts, which are very typical and often boring and uncreative. (Uh, that doesn't mean you shouldn't give me a T-shirt if you see me at a festival; I always keep the cool ones.)

STAND OUT
Some might advise against doing something outrageous to promote your film, but I encourage it. If you're one of the many filmmakers without distribution or Brad Pitt in your movie, you'll need some kind of extra push. Be creative.

"OUTSIDE THE BOX" QUICK MARKETING IDEAS

Here is a list that should get your creative juices flowing so you can come up with your own inventions. The ideas are really clever, and I think they're great—but they've been done, so use them to inspire your own wacky concepts.

- Create a flyer for your film and make it look like a parking ticket. Put it on all the cars at the festival and in the festival parking lots.
- Make a flyer that looks like a twenty-dollar bill. On the other side is info about your screening. Spread them all over town. NOTE: The Feds don't like this one, so be careful. Counterfeiting is illegal, so make sure to replace Abraham Lincoln's photo on the five-dollar bill with your own, or do something else to make it obvious that the money is fake. Many copy stores will not make copies of money, as they already know these laws.
- T-shirts are easy, but depending on the local environment, you can come up with better items of clothing, like earmuffs, sweatshirts, ski caps, boxer shorts, or G-strings. (Hey, that'll get my attention!)
- Create a cereal box (the single-serving, tiny kind) with the poster of your film on the front and back. Screening info is printed on the sides where the ingredients should be.

- Give View-Master viewers to the press with still images of your film printed on the still frames in the viewer. The frames on a View-Master are made from 16mm film, and custom View-Master sleeves could be made cheaply. This one would be really cool, but likely expensive.

There are plenty of ideas to come up with on your own; the point is to do something unique so people will talk about it and ultimately attend your screening.

CREATE YOUR OWN MARKETING MATERIALS Demonstrate to others how your film might best be sold to a paying audience in theaters. Your own early marketing materials (poster, trailer, website) along with the hype those generate in the form of publicity (articles in magazines and newspapers, on television, and the Web) will show a distributor that there is a market for your movies.

FIND A CHAMPION FOR YOUR FILM

The single most important thing a filmmaker can do to get attention for your film on the festival circuit is to find a champion. A champion can be a film critic or reviewer, a well-known filmmaker, or someone who speaks with some kind of credibility when it comes to the content of the film. A champion provides a quote or endorsement touting the virtues of the movie that can ultimately be used to help secure a sale. For indie films with no stars, finding the right champion just may be the difference between getting a distribution deal and ending up as one of the thousands of cine-orphans.

One young Michigan filmmaker brought his low-budget horror film to the Cannes Film Market in the early 1980s. After failing to attract attention for his gruesome movie, he happened to run into horror novelist Stephen King. The wide-eyed young filmmaker begged King to attend a screening of his little independent movie. King agreed and liked it so much that he provided a quote, which was used on the poster. The quote read:

> *"The most ferociously original horror movie of the year."*
>
> —STEPHEN KING,
> author of *Carrie* and *The Shining*

REMEMBER: IT'S A CAREER, NOT A GET-RICH-QUICK SCHEME
Have realistic expectations. You're not likely to get rich and your lifestyle is not likely to change even if you beat the odds and sell your film. Look ahead to your next film project and keep your eye on the real prize. The sale of the film is not the prize. Making the film itself was probably the best part, you just didn't know it then.

That famous quote was used on all the marketing and posters at the time. Just those few words from King put this little indie movie on the map. Michigan filmmaker Sam Raimi credits the quote King provided for *Evil Dead* for helping to launch his career.

The secret is to come up with a champion who breaks convention and will get audiences (or distributors) interested in seeing the film. Securing a "thumbs up" from a prominent film critic (a dying breed in movie marketing anyway) is a long shot at best. Being creative about exactly whom to approach is critical.

The Last Game is a documentary about the story of a high school football coach who participates in the game of his career, which pits him in a regional playoff game against his own son. Producer's rep Jeff Dowd felt that a quote from a prominent director of sports movies would give the movie a leg up. Here's the result:

"I remember when I directed Hoosiers, *the* Los Angeles Times *said, 'You don't have to be a man or a basketball fan to love this movie.' You don't have to be a man or football fan to enjoy* The Last Game. *It has a wonderful and inspirational true story with great characters and exciting real life drama that the best Hollywood screenwriters could only dream of inventing. And if you are a football player, coach, athlete or fan, it's a must see!"—David Anspaugh, Director* (Hoosiers, Rudy)

This David Anspaugh quote has been used in all the marketing for the film, including the DVD release. The film racked up positive reviews from critics and gained the attention of audiences.

My own company, Film Threat, was in need of a champion for our first DVD release. The feature-length documentary *Starwoids*, about a bunch of *Star Wars* fans waiting in line for the *Episode I* premiere, already had a great sales angle—*Star Wars*. More than a few people have heard of that film. But asking DVD consumers to watch an entertaining documentary can be like asking a kid to eat

vegetables. We had to get creative. We knew we needed someone to endorse the film and give it even more credibility. Someone who could elevate an already great doc and make it a must-see. We settled on independent director Kevin Smith. He perfectly represents the *Star Wars* generation to fans. Smith liked the film enough to record some voice-over narration and even provided a ten-minute interview about *Star Wars'* influence on his own films, which became an extra on the DVD. Selling *Starwoids* with Kevin Smith's endorsement became a lot easier. (And damn if I'm not grateful to him for it.) His affiliation gave us the credibility to get the film into retail chains, and filmmaker Dennis Przywara actually made a healthy profit from his indie doc.

Now, most might think that a movie reviewer could make a good champion. And they often do. But sometimes an endorsement from an unlikely source will provide a much better way to get attention. Just ask my pal Silent Bob.

A POWERFUL PRESS KIT

All effective marketing begins with a press kit. It contains all the information a media person will require to do a story about your film. A large festival will be attended by hundreds, sometimes thousands, of members of the media from newspapers, magazines, television, radio, the Internet, the wire services, all types of local and international media—you name it, they're here. They're all going to need a press kit in some form—whether it is contained in a folder printed on paper, on a CD-ROM or DVD, or in a special press area of your website on the Internet, *everyone* will need one. Many times the press kit will act as your only communication and sales tool to convince journalists to write a story about your movie. The writing should be smart and witty, as well as completely accurate. A little humor is okay, exaggeration is fine, but outright lying will end up losing you all your credibility—it's always best to stick to the facts. I often find that the stories behind many indie movies are better than the movies themselves. Tell me that story and get me excited by it. An interesting story about how your film got made can

QUICK TIP
If you get some really nice stickers printed, they can also be placed on anything, turning that item instantly into an inexpensive promotional piece of merchandise. A baseball bat, a candy bar, a pen, a lunchbox, a backpack, a shoe horn, a bag of microwave popcorn, a jar of olives, a lampshade—anything can be instantly transformed into a cool promo giveaway simply by slapping on an "official" sticker.

prove just as helpful toward getting press as the movie itself.

Most festivals require that you provide them with a certain number of kits to give out to the media. Be prepared with a master press kit and enough extra materials so that you can turn around several hundred kits on a moment's notice. Get your film's logo professionally printed on some slick stickers. (You can also print really nice stickers using your home computer and laser printer; it depends on how high you want the quality to be.) The stickers can be placed on the front of a folder that will hold all your materials.

THE SEVEN ITEMS THAT MUST BE IN A PRESS KIT

1. Cover sheet

The cover sheet to your press kit should include the logo for the film, the contact info for your publicist, and your own contact info. Be sure to include a local contact number for the particular festival—perhaps on business cards with your name, contact number, and description of the basic plot of your film. Having a cell phone number printed on this page is essential because you need to be available at every moment.

2. Synopsis

You need to have three versions of your synopsis:

- **The One-Liner.** A sentence, but not a run-on sentence. This one-liner version is much like the logline that you use to describe the story of your film to others. Basically this sentence determines how others will talk about your movie, so take the time to craft it and try it out on people. It will be used to sell your film as much as it will be to describe it. Think about this one carefully—it must be a grabber.

- **The Short Synopsis.** About 100 to 250 words, this should share a page with the one-liner. This gives an overall description of the movie in a longer form and might give away some details from the first and second act of your film while offering just a hint of what might happen in the climax. If well written, it will only encourage readers to dig into other parts of your kit.
- **The Long Synopsis.** From five hundred to one thousand words. This one describes the entire film and teases at what happens at the end, but it should not give away the ending. This detailed synopsis is for really lazy journalists who either skip your screening and pretend they saw your film or who fell asleep at your screening.

These three synopses work to the benefit of one another, offering deeper levels of information about your film depending on how far the reader wishes to delve. Most will only read the one-liner and the short synopsis, but having all three is helpful.

3. Details about the production

A behind-the-scenes story detailing the making of the film that includes brief interviews with the cast, anecdotes about the shoot, and the true tale of what inspired the filmmakers to make *this* movie. The best way to go about writing this is to interview the cast and crew during production and include their quotes. Journalists like numbers, so include details like how long it took to shoot, how many years you worked on the script, etc.... This document can be five hundred to a thousand words or more.

4. Bios

Include the bios of the key players in the production—the director, writer, producer, and actors, along with other key crew, like the cinematographer. Bios can run anywhere from one hundred to five hundred words generally speaking, but there is no rule here. If any of the crew or actors have their own bios, start there. The best way to write a bio is to record interviews and just say, "Tell me about yourself; how did you get into film? What is your

background and experience?" Include details about schooling and other films they may have worked on. Highlight experiences with name actors or name filmmakers who journalists might recognize. If the director began as a production assistant working with Zack Snyder, that must be mentioned and will be a great starting point for any journalist to ask questions. Personal details are always important. If the film is about working at a restaurant and the writer worked at one for five years, include that. As they relate to the film, personal details make the bio that much more interesting to read.

5. Credits

Include a list of *all* the credits that appear in your film. It's important that this is completely accurate, as anyone who writes about your film will use this document to find the correct spellings of names of the actors, characters, and anyone else associated with the picture. Also, there are reviewers who will skim those credits looking for some kind of personal connection to your film, so complete credits is a plus.

6. Other press clips

Any positive press, no matter how small, should be included. If you have done your homework, you should at least have a mention of the movie in the local newspaper where shooting took place. Any mention may help. Online press counts, so include those printouts. Also, include other reviews *only* if they are positive and *especially* if they are written by name critics or for well-known outlets. You don't want someone to decide that he should not write about your film because someone else has already reviewed it. Be careful about this, particularly before your debut. Critics like to think that they "discovered" your movie and that by supporting it they are somehow sharing in the success of the films since, hey, they saw it first. All I can say is, whatever gets them excited is fine and should be exploited. After your premiere, include as many positive reviews as will fit in the folder.

7. Photos

You should have at least one good photo that best represents the film. Be careful about this photo—it's likely the one used all throughout your festival run, so choose the very best you have. Include caption information identifying the actors, their characters, what is depicted in the photo, and any other pertinent info. Captions might say something like *Jack Jones as Dick Starkiller, a video store clerk in* Revenge of the Clerks, *an independent feature film written and directed by Keith Jones.* Don't forget to include a photo credit and copyright information. You should have three different formats for photos: black-and-white stills, color slides, and digital stills on a CD-ROM. Different outlets have different needs—generally newspapers want black-and-white stills, magazines want color (they'll also probably ask for some kind of exclusive picture, so be prepared for that), and websites will want their photos in a digital format (on a CD-ROM or DVD, or they may download them from your website—more on that later). If you're sending out press kits in advance, ask the contact what kind of photos they require rather than wasting pictures on an outlet that may not use them.

POSTER THE TOWN

Most film festival movie posters just plain suck. But don't worry, plenty of successful films have had bad posters as well. Weak tag lines are commonplace even in mainstream movies. Consider Orson Welles's *Citizen Kane,* whose "memorable" tag line was: "It's Terrific!" Wow. Or George Lucas's *Star Wars,* whose original tag line read: "It's about a boy, a girl and a galaxy." Yikes. That sounds like *crap!*

Most posters seen at film festivals have an amateur look that, well, represents the film in a bad light. The festival is like a job interview, and here you are in jeans and a grubby T-shirt. You need a poster that feels like a smooth Armani suit, not a stinky T-shirt.

Posters on Main Street
in Park City

The first piece of advice for any filmmaker wishing to create an eye-catching poster is to acknowledge that you are a filmmaker, not a poster designer. Filmmakers, especially on small productions, have a tendency to want to make the poster themselves. You made the film, now back off and allow others to do their jobs. If you tell a designer exactly what you want her to do, she will do exactly as you tell her. If you allow your designer some creative freedom, you are more likely to get some new and cool ideas. However, if your budget does not allow for a poster designer and you are forced to create your own poster, there are some basic things you should know.

Jon C. Allen designs movie posters for a living. Allen began collecting one-sheets when he was young and knew he wanted to create them professionally. He has a degree in visual design and has worked at various Hollywood advertising agencies. These days, Allen freelances and has designed movie posters for Sony, New Line, HBO, and many others. Allen's poster credits include films and TV shows like *Starship Troopers*, *The Sopranos*, *Six Feet Under*, and *American History X*, along with countless DVD sleeve designs. Now, don't blame him for some of these bad movies—the posters are all cool. However, a designer's job is also about pleasing the client, and Allen is ultimately a gun for hire.

Allen suggests asking the right questions before embarking on a design. "Is the poster positioning this film in the best possible way? Does it invoke a good reaction? Can you tell what it is as you drive by it at forty miles an hour, looking at it in a bus shelter? Really, a designer has to be aware of the issues beyond the obvious aesthetics and layout. For me, a great poster is one that manages to straddle all of the fences just mentioned: sell the film, offer the slightest hint of something new, be well balanced in layout and design—and look really cool."

For an indie to create a poster that stands out at a film festival, it's important to know your market. "There are a lot of factors—film markets, for example. Some foreign markets lean toward more action-oriented posters (and movies)," says Allen. "As far as the U.S. film market goes, I would take advantage of the fact that you aren't in the studio system and avoid some of the clichés that tend to creep into those type of projects. You don't have to do the overused and over-abused 'Two Big Heads Floating in the Sky' look that so many studios rely on. The best

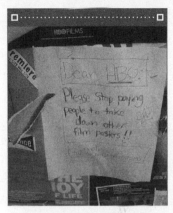

Having posters can get competitive in Park City.

piece of advice I can give you for your poster look (whether on your own or hiring a designer to do it for you) is to *keep it simple.*

"Whenever we work on a smaller film, we always make it simple to make the movie feel *bigger.* Less really is more, in this case. So often smaller indie projects with low advertising budgets fall into the 'kitchen sink design trap'—let's show everything this movie offers so they know how hard we worked on it. Granted, in some cases, a distributor wants you to show all kinds of action, explosions, sex, etc. in your poster. But sometimes, it might be better to show less. Especially if you have no stars, no photography—often in those cases, we go with a simple icon, or a concept idea that captures the viewer's attention."

Allen offers a few final thoughts: "People ask me, 'Why do the majority of movie posters suck?' Well, it's all subjective, but those same people should ask, 'Why do the majority of movies suck?' Film advertising mirrors many of the same traits (good and bad) as the rest of the film industry. Whenever you have to please a significant number of people, compromises will be made. Sometimes this will improve something—often it will not. 'Design by committee' just like 'Filmmaking by committee' doesn't always work. I encourage someone working on your own one-sheet to make the film poster your own vision. Please yourself first, everyone else second. Hopefully, those same rules applied when you made your movie."

Jon C. Allen can be reached via his website: www.onesheetdesign.com.

10 ELEMENTS OF GREAT MOVIE POSTER DESIGN

Include these simple elements and you are on your way to a memorable one-sheet.

1. **Invoke feelings**
 Create some sort of emotion. This can be done through color, image, etc. A great poster sparks interest and makes people stop on the street or in a theater lobby. For example, a poster for a comedy should make you laugh.

2. **Well thought-out typography**
 Type should complement the image, yet not attract undue attention to itself, and it should work with the imagery as a unit.

3. **Second read**
 In other words, something you don't notice the first time you look at it. For example, take a look at the FedEx logo. Have you ever noticed the hidden arrow inside the type?

4. **Good photography**
 Head strips of stars' heads on doubles' bodies sometimes work, but it's always nice to have an idea for a photo shoot, have that star shot the way you envisioned, and use the resulting photography to make your design work.

5. **Great copy**
 Always important, especially for comedies. "Four Score and Seven Beers Ago . . . " made my *Senior Trip* poster work.

6. **Logo**
 A logo that stands on its own. A great logo complements the poster and works well in its own context, because it will often be used on its own in other mediums, such as trailers. The logo should actually complement the poster, instead of "floating" out in front of the poster and not acting as part of the artwork.

7. Translatable

Translates well to other formats. Some things may look great at 27 x 41 inches on a one-sheet, but how will it look on billboards, bus sides, websites, or in black and white in a newspaper?

8. Relevant to the film's story/plot

Sometimes a poster has nothing to do with anything that happens in a film—for example, an idea that services the marketing but is completely removed from the film itself.

9. Something new

This is always a tricky issue. Movie posters mirror the movies themselves—it's rare that something new is tried as opposed to giving them what they've seen before.

> **PROMOTE, BUT DON'T ANNOY**
> Yes, it's important to have those promotional postcards with your screening times printed on them, in every pocket at the ready. But at some point, you just have to stop promoting and actually talk to people about something other than your film and its screening time. You'd be surprised what you learn if you listen and engage in conversation rather than being in constant "promotion mode." Give it a rest.

10. Hits the target

It should please the intended audience. Know your demographic and be sure the poster appeals to this group. Studios not only hold focus groups for movies but for the poster ideas themselves.

10 MOST COMMON MISTAKES OF POSTER DESIGN

These mistakes result in amateurish posters and poor design.

1. "Kitchen sink" design

2. Failure to think conceptually

3. "It looks cool" is the design's only redeeming quality

4. Thinking of it as art instead of commercial art

It's about marketing, not just what looks good.

5. Not positioning the film well

6. Not designing everything to work together
For example, the typography doesn't work with the imagery.

7. Unwillingness to compromise for the best overall design
Sure, there are compromises left and right, some of which will drive
the designer crazy. Every movie poster designer has had the client
change/alter their "vision" and felt it was a fatal mistake. But that's the
nature of the business—you're trying to market a movie. Being able
to play within those limits and boundaries and produce something
worthwhile is part of the challenge.

8. Not using all the available elements to produce good work
Typography, layout, color, imagery, concept.

9. Bad finishing skills
Sure, you have a brilliant idea that will make you the next Saul Bass,
but the fact that it looks like crap because you aren't comfortable in
Adobe PhotoShop will hinder your idea.

10. Again, not pleasing the client
Sure, it's easy to dismiss them if you don't agree with their views/
opinions, but since they are *paying you* to market *their movie*, you
should work with them, not against them.

MAKE AN IMPRESSION—
PRODUCE A POSTCARD

The effective poster design you create will translate to your actual
poster (of course), your website, and eventually to a postcard, which
you'll be handing out at festivals throughout your tour to advertise
your screening. There are great deals on the Internet for companies
that print up postcards and posters along with all the items necessary

to promote your film. Be sure to leave some dead space or room on the poster to include a sticker with screening information at that particular festival. You might only bring a limited number of posters, maybe fewer than fifty, and those will have to be hung at key locations, but they're no good without the basic screening info. Same goes for the postcard. When you get them printed, leave the black-and-white side blank (except for maybe your website and contact info), then get some cheap stickers printed up that include basic information about your screening—like this:

"MY BIG FAT INDEPENDENT MOVIE"

SXSW Film Festival

Work-in-Progress Screening
TUESDAY, MARCH 16th at 2 P.M.

Screens once only at the
Alamo Drafthouse, 409 Colorado St.

You'll be using the same postcard at every festival, so sticker a few hundred and bring them along to give away and leave at tables where they can be picked up by interested parties. Also, make a handy cardholder by turning one postcard on its side and stapling it. These get attention since people can grab one and get more info. Also, if you get into town early, talk to local businesses frequented by festival-goers and ask them if you can hang up your poster in their window or leave around a few postcards. *Always ask,* and ask in the nicest way possible. If you don't ask, you might as well be throwing your materials away. By getting permission (and hopefully being first) you'll make an impression with those who visit the

Alamo Drafthouse
marquee during SXSW

coffee shop with your poster hanging proudly in the window. If you really target the key locations in a city, you can almost take over a festival with just a limited number of posters and a few hundred postcards.

TEASE YOUR AUDIENCE

Posters are fine, good buzz and press always help, but nothing gets an audience more hyped to see a film than a great trailer. I love movie trailers—they're just plain cool. They're my favorite part of going to the theater, and I never miss them. The truth of the matter is that you really don't need a trailer to take a film to a festival. Creating a trailer can be a costly distraction when the real order of business should be to make the best film possible. Consider very seriously how setting time aside to make a trailer may have an impact on everything else you have to do to prepare for your festival debut. My advice is to put making a trailer at the very bottom of your "to do" list.

However, if you have the luxury of time and some extra money to invest in a trailer, it becomes yet another helpful tool to aid in selling your movie. Trailers posted on the Web get a lot of attention these days. In fact, many festivals (like SXSW and the Los Angeles Film Festival) stream trailers from their programs onto their websites. This exposes a bit of your film to tens of thousands of people, whetting their appetite before your festival premiere. In addition, the trailer can be used to get distributors in seats. While I recommend that you *never* send your film on DVD or video to a distributor, a copy of an effective trailer is yet another way to get a distributor or a producer's rep interested in attending a screening. It's hard to get them to sit still for ninety minutes, but two minutes of their time is not a lot to ask. In addition, a powerful teaser assists in spelling out your movie's selling points and explaining how exactly a distributor may market the film to a wider audience.

To learn about trailers, I spoke with one of the best in the business. Dave Parker is an award-winning, veteran trailer editor and has been toiling in the industry for the last fifteen years. Currently employed at Seismic Productions, he has worked on countless campaigns for everything

from big Hollywood movies to independent film projects, including the *Lord of the Rings* trilogy. I met with Dave, who broke down for me exactly what makes an effective movie trailer.

10 ELEMENTS OF AN EXPLOSIVELY EFFECTIVE TRAILER

1. Employ quick cuts.

If you've got some cool shots and a really simple-minded story, cut each shot down to about a third of a second and slap on some pumping driving music. The unfortunate reality is that often style wins over substance.

2. Use graphics that grab you.

Decent graphics are a plus. Be creative and make an impressive title treatment that is different from your main title.

3. Original music is important.

Be careful with the music you use. There are plenty of affordable tracks from companies that supply music specifically for trailers. Be sure to use music that is legally cleared. Of course, there *is* another way. For the purposes of the *trailer only*, if you want music that *sounds* similar to a certain movie soundtrack to capture a particular mood, have an original song or piece of music composed. The secret is this: If you want to blatantly rip off a tune, remember to change every seventh note. By changing the tune slightly, you can avoid being sued.

4. Tell the story (but don't ruin it).

If you've got a great story, don't be afraid to spell it out. It doesn't hurt to do a little handholding. A narrator can go a long way toward dramatizing the story in broad strokes. Also, don't tell the *whole* story. Leave them wanting more.

5. Use positive reviews.

If the film has gotten early positive reviews from notable critics or credible press outlets, use them. Big, bold quotes in a white typeface

against a black background look impressive when cut quickly into the trailer. Generally, these are most effectively used near the end, just before the title screen. Be sure to clear the use of these quotes from the outlets that provided them.

6. Great sound is critical.

Spend time on the sound mix. If you have a slight problem understanding what your actor said, then you can bet your ass that the guy looking at your trailer doesn't have a clue. Also, don't be afraid to record dialogue for the trailer only, to clarify the story. In *The Negotiator* trailer, Kevin Spacey says, "They're gonna have to deal with both of us!" Spacey looped that line for the trailer only and never said anything like that in the finished feature. Imagine that! Lying in advertising! Hard to believe, huh?

7. Star power goes a long way.

If your film has a recognizable star, make sure to feature your star very prominently. Even if you've got only one celebrity in a cameo, make sure those shots are used extensively in the trailer.

8. Keep it short.

The shorter, the better—about a minute or two, but absolutely make sure it is under two and a half minutes. Why? Because that is the time limit imposed by the MPAA for all theatrical trailers. The audience watching your little masterpiece has been trained like a pack of Pavlov's dogs. Anything over two and a half minutes and they're looking at their watches.

9. Start with a bang!

Open with an attention grabber. The opening of the trailer for David Lynch's *Lost Highway* features Robert Blake and Bill Pullman engaged in a creepy conversation. Man, that was cool. Opening with an explosive image or a memorable line of dialogue will keep them watching.

10. End with a bang!

Close with the best shot and/or best line. What sold *The Perfect Storm*? Was it the brooding presence of surly George Clooney? How about the clichéd dialogue mouthed by Marky Mark? C'mon, we all know it was that awesome wave!

10 MISTAKES TO AVOID IN MAKING A TRAILER

1. Do not use a feature editor.

Don't even consider hiring your feature editor to cut the trailer. A feature editor is used to letting things play out and is not as good at the short sell. A trailer is an advertisement, plain and simple. It's essentially a commercial or a music video and is a completely different animal than a feature, so get a good editor with experience cutting trailers.

2. Don't fear outtakes.

Don't be afraid to use some original scenes or outtakes that didn't make the final cut. For *My Big Fat Independent Movie*, a few key shots were done just for the trailer. These shots do not appear in the movie, but they set the mood for the trailer.

3. Don't include nudity.

Keep the trailer PG-13 or lower. Even if your film has a lot of sex, there's no reason to flaunt it. Violence, of course, is never frowned upon. But you never know who may see it or download it. Make sure the trailer is acceptable to air on network television.

4. Don't include expanded scenes.

Use sound bites only. Don't use really long expository dialogue. Make every shot concise.

> **SAVE DOLLARS FOR MARKETING EXPENSES**
> Have a poster along with other unique promo items ready to go. Be prepared to deliver a print in time for the film festival. And most important, plan to have funds available to pay for expenses at the festival. Budget for all of these costs and be ready when you get "the call."

5. Boring is bad.

Get to the point. What is your movie about? Define it in the first ten seconds.

6. Don't use uncleared music.

A distributor may assume you have the rights and you'll be shooting yourself in the foot if you use music for which you don't have the rights.

7. Don't use a bad transfer.

Make sure not to skimp on the transfer. The picture should look as good as or even better than your feature. Footage from your dailies or rough cut is not suitable for use. Transfer clean for the trailer.

8. Never use stolen shots.

Eventually, they'll see the finished film, so don't try to cut in expensive shots that are gratuitously lifted from another movie—like, say, a giant explosion or a train wreck.

9. Do not give away the ending.

Never, *ever* give away the ending. Yeah, I know that trailers for big studio movies do it all the time. Look at the acquisitions people as the big fish and your trailer as the little, convulsing worm. You want them to bite but not feel full.

10. Don't make it too long.

The most common crime committed by an amateur trailer editor is cutting one that is too long. Shorter is better. It's better to have a thirty-second trailer that leaves one wanting more than a one-minute trailer that drags.

WHY AN EPK IS ESSENTIAL

An EPK (electronic press kit) is an invaluable tool when it comes to getting press on television. While creating an EPK sounds like yet another costly distraction with all the work you already have to do to make the film, it is worth doing for several reasons.

- An EPK is incredibly helpful for television producers and makes getting press on TV much easier.
- Content from the EPK (trailer, behind-the-scenes footage, interviews) can also be used for promotion on the Web and later on as extras for the DVD release.
- The material on the EPK is an asset that will have value when it comes to negotiating a distribution deal.

Television journalists are perhaps the laziest members of the media, trust me. They often need stories spoon-fed to them. Why not make their jobs a snap by suggesting they do a little story on your movie? In addition to your printed press kit, it's to your advantage to produce an electronic press kit that will, in a way, do a little handholding to help deadline-crazed television producers fill some airtime. The more material you provide, the more chances increase that your story will go from a five-second mention in a festival round-up on local television to a full-blown review taking up a minute or more of time on the air. In addition, television producers will archive your EPK for later use, in case the need for a follow-up story presents itself. Or they might throw it in a pile—you can never tell. With this in mind, it is helpful to label it: *Please Return After Use.* But DVDs like this are rarely returned, so you shouldn't expect it. Just be grateful to get any press at all on TV.

PRODUCING THE EPK BEGINS WITH THE MOVIE

Work on the EPK should begin along with start of production. When you are shooting, you know that you should have a photographer shooting stills of key scenes such as the production at work and slick pictures of your cast. It doesn't hurt to shoot some Hi-8 or digital video footage of behind-the-scenes activities for use on the EPK. Members of the cast are often waiting around for the next setup. Don't waste this downtime—get the actors to sit in front of the camera for twenty minutes for an interview. Be sure that the actors are coached to speak in sound bites—no more than thirty seconds on any one question and preferably much shorter, like ten or fifteen seconds. The person off-camera will not be heard asking the question, so make sure the actor repeats the basic question within his answer so his comments are put into context. Ask the actor about his character in the film, and the actor should respond, "Well, my character Max Power is a blah, blah, blah." (Except, you know, make sure they say something cleverer than, "blah, blah, blah.") Prepare ten to fifteen questions, and give the actors time to formulate some clever responses. Trust me, your actors will leap at the chance to offer their own witty comments.

Here are some sample questions to ask for your EPK:

- How did you get your start in film?
- What are the differences between appearing in a big-budget Hollywood film and acting in an independent film?
- How did you get involved in this project?
- What did you think when you read the script?
- What attracted you to working on this film?
- Tell me the story.
- Tell us about your character.
- Who is your favorite character, other than your own?
- Tell us about working on the film.
- What was the most challenging scene?
- What's it like to work with [so and so]?

WHAT'S ON THE EPK DVD?

The EPK must include a legal disclaimer at the beginning of the DVD itself. Issues such as a specific time frame that the outlet may use the material can vary, so consult your lawyer. The legal disclaimer should include the following language:

> This film/video/digital footage is for publicity and promotional use only. Any use, reuse, or unauthorized assemblage of this film/video/digital footage is strictly prohibited without the prior written consent of [PRODUCTION COMPANY NAME]. All rights reserved. Property of [PRODUCTION COMPANY NAME], promotional use only. Sale, duplication, or transfer of this material is strictly prohibited. Use of material is granted for a six-month [TIME PERIOD MAY VARY] window.

The legal disclaimer is followed by the title card or logo. Then, a menu screen lists the content contained on the DVD. Indicate how long the DVD is within the text with a TRT (total running time) in parenthesis— e.g., (31:30)—and then scroll the menu and indicate the TRT for each individual section. The sections include the following elements and should appear in the order outlined below:

1. Two trailers

There should be two versions of the trailer: one that includes the complete trailer and a second version of the same trailer with the sound split into two tracks—one for dialogue and effects and another track for music. In addition, if your trailer has a narrator, the second version of the trailer should either delete or isolate the narrator onto the second track. This is so that a television commentator can add his own commentary over clips from the film. This second version is very important. Be sure to indicate the second version has *no narration* and has dialogue and effects on one track and music on a separate track. Many television producers are wary of airing anything they even suspect might be uncleared music, so even if you have done your homework and cleared

your music, be sure to leave them the option of omitting the music entirely when running clips.

2. Selected scenes

This is your opportunity to highlight the best scenes from your film. You may choose from just a few or as many as ten scenes— there is no rule—but offer a variety of scenes that accentuate your film's greatest strengths. Every scene should be under a minute— in fact, the shorter, the better. Spend some serious time thinking about what clips represent the best of your movie. TV time is very precious, and a gripping fifteen-second scene is going to deliver more of an impression than a drawn-out one-minute scene. And a shorter scene is more likely to be used in its entirety on television. (Especially in our sound-bite-driven, fast-paced modern media culture.) Be sure to introduce each clip with the title of the movie and a title, in quotes, for the scene along with a TRT for the clip; for example: *JOE INVADES PARK CITY "Joe and Bob Lose Their Car Keys" (TRT: 20 sec.).*

3. A "making of" featurette (optional)

This is totally optional, and it's not likely to be used on television, but it will come in handy when talking to a distributor who will use it for promotion and for use later as an extra on the DVD. Featurettes can run anywhere from just a few minutes to up to thirty minutes. This behind-the-scenes look at your film offers another opportunity for coverage of your movie if it has already been covered in another way. It's not necessary to have behind-the-scenes footage on the EPK, but it doesn't hurt. If your featurette has a narrator, it's also wise to put two versions on the tape with the soundtracks split so that a TV commentator can add her own spin to the footage.

4. B-roll footage with key scenes (optional)

This is yet another optional element and often just contains raw footage of the production of certain scenes.

5. **Interviews with the cast, director, writer, producer, etc. (optional)**

This should be presented in the same way that scenes are shown—with a title for the clip keeping the comments from the cast in clever sound bites under thirty seconds or less. A few comments from each crucial cast and production member are acceptable. Be sure to title each clip; for example: *JOE INVADES PARK CITY, Director Joe Jones "Joe on making a movie on a lunch-size budget" (TRT: 15 sec.).*

6. **Still frame of the title**

A still frame of the title logo is crucial because this can be used as a computer graphic and appear in the background when the TV commentator mentions your film. Don't forget to include the logo or the poster, or both separately, as a still running for thirty seconds or so on the DVD, so it can be turned into a graphic.

It's not important that your EPK contain every one of the above-mentioned elements. However, the two things you must have are the *trailer* and some *selected scenes*. The EPK can become a huge distraction, an animal as large to deal with as the movie itself. Do not go about producing an EPK if it will take time that is better spent on the film. Have an EPK with a trailer and scenes; that's really all you'll need.

GET PRESS ONLINE WITH A DIGITAL PRESS KIT

When most people refer to an EPK, they only think in terms of television press, but this amazing PR tool can also help toward getting press on the Internet as well. When it comes to online press, your EPK material can be digitized and used on your film's official website (see below).

Actor Brian Krow promotes al SXSW.

In addition, you can also take the digitized content and burn it on a CD-ROM or DVD to give to major online press outlets as the digital version of your press kit. The DVD or CD-ROM version of your EPK should be readable by both Mac and PC or any DVD player, and it must also include a decent selection of digital stills in the form of JPEGs. Stills are the most important addition to the digital press kit. It also is wise to include text from the press notes like cast and crew bios, the synopsis, and production notes.

HYPE IT ON THE WEB

The Internet is the most important promotional tool for the independent filmmaker. The website you create for your movie has the potential to reach more people than any other mass-media outlet—more than radio, magazines, or television. And the best part about it: You have total control over the content. In other sections I've discussed how to make various promotional materials like a press kit, a trailer, an EPK, and a poster. They are all valuable, but if you can choose only one of these marketing tools to put your time, money, and energy into, I would tell you to build a website.

> **QUICK TIP**
> Be sure that you use your "dot-com" name, your *www. thenameofyourfilm.com*, on everything. Your website URL should be on your poster, stickers, press kit, and on your business cards.

You absolutely must have one. Then, consider supplementing your official site with fan pages or sites on Facebook and MySpace. You may even have your director's or cast's Twitter accounts viewable to fans who wish to follow everything from the film's various festival travels, to its official theatrical release, to its DVD debut.

A website is a vital tool to build buzz in advance of your festival debut and is necessary to communicate with your greatest supporters—the moviegoing audience. In fact, promoting a movie today without a website is wasting a fantastic opportunity to increase the value of your film. Consider it this way: An effective website can help double the value of your movie. You must have a site.

CREATE A SUPREME WEBSITE

The basic steps for creating a site don't necessarily need to be done in the order listed below; in fact, it makes sense to work on many parts simultaneously. I don't have the space for all the details necessary, and there are whole books on how to build a site, so I'm just going to give you the fundamentals. Here's how to do it:

1. **Register the name.**
 It's the best investment you'll make, so be sure to reserve a URL name or a variation with the word "movie" at the end. It only takes about a few minutes—if you type really slowly. There are many places to register a name on the Web, and they even offer other services, like site hosting and e-mail. Start by checking out sites like www. register.com, www.dotster.com, or www.godaddy.com and take the time to research other places to register your name. When you have settled on a name for your film, register it as soon as possible, even if you don't plan to launch the site until much later. If the name of your film is taken, you can always do what Hollywood does and add the word "movie" to the end. I suggest registering the name of your production company as well and letting this be the home for all of your films.

2. **Create content.**
 Here is where the word *repurpose* comes into play. By creating the materials for the press kit, you have already done the hard work of putting together a synopsis, bios, credits, production details, trailer, photos, and a logo for your movie. These will be elements used to launch your site. You may want to write other material exclusive to the site by keeping a production diary, but the basics from a press kit will be the early building blocks to release the initial version of the site. More elements will be added later, but starting with these key elements is essential. Don't forget this important component: your contact info. Have this visible at the bottom of every page of the site.

3. Build a flow chart.

Here is where the site really begins to take shape. The site itself is like a collection of pages from a magazine or a book. The difference is that, unlike a reader, a Web surfer can bounce from page to page. The flow chart identifies all the pages of your site and shows how they connect. On paper or on a computer, build a flow chart that demonstrates how a reader will use the site and how every single page is linked. The easiest way to begin is to start with the home page and then spell out the most important aspect of the site—this becomes the menu bar. Make it simple, logical, and easy to navigate. The key word to keep in mind is *intuitive*. Ask yourself: Does it make sense that this page connects to that page? Can the reader get back to the home page or any other page on the site efficiently? The easiest way to go about this is to design a menu bar that contains all the sections for your site. Name those sections: Home, Movie Synopsis, Bios, News, About the Production, Trailer, Photos, etc. The best thing to do is to look at other sites and see how they did it. Spend considerable time poking around to see what works and what doesn't. Ultimately, an intuitive site will have your visitors focusing on the content instead of the flow (or the lack thereof). Check out as many other sites as you can to get a feel for what works best for you.

4. Design the site.

When I say design, I am talking about the way it looks. This is where you can get creative and have a blast. In a way, it's like decorating your room or apartment. Your site should, in some way, reflect the theme or mood of your film. Choose graphic elements that say something about the movie. It's like painting the outside of the house and deciding exactly how you want it to look. All of the filmmakers interviewed in this book have their own sites. Check them out and see what they did to create a mood. The subject matter of your movie will dictate much of the design. When designing a look for the site, make it fun, have it express other levels of your movie, and (for some this may be the hard part) be original. Make sure it does not look like any other movie site.

5. Build it.

There are so many ways to build a site, it would be like me telling you exactly what kind of film you should make. Here are just some of the options you may consider:

- **OFF-THE-SHELF SOFTWARE.** There are plenty of programs made for building sites. They vary in levels of complexity, but for under $100, you can find numerous programs made to build a site from scratch.

- **BUILD IT ON THE WEB.** Some websites offer space on their sites to build your own. These sites have software encoded in the browser that walks you through building your own simple site, but research them closely before moving forward. The advantage here is that you won't be paying for space. The disadvantage is that you may outgrow it quickly. Be sure you have the option to move the site to another server, should that happen. All of these sites require that you click on "Terms" or "Agreement" when using their sites. Check any restrictions that apply before you put in the energy. Explore all of these options fully and choose the best path for you.

- **HIRE A WEB DESIGN COMPANY.** This is a smart choice if you have the money to do it. You'll provide them with the content and design and they build it. Most charge upwards of $100 or more per page of the site, so if you plan on a large site that you'll want to grow, then this may not be the most cost-effective option.

- **GET A FRIEND.** Most high school students now know HTML and Web design better than they can spell. Get a student or a friend to do it. If you are not technically inclined, or if you are busy making the movie, delegating this responsibility is a wise choice. The only option you don't want to exercise is putting it off. It's helpful for the site to go live during preproduction. Even if it is not perfect, you can always alter it or add to it later. And don't forget to test the site for bugs. This involves looking at every page of the site using different computers and browsers with different types of Internet

access (cable modem, T1, DSL, or modems). Ask some friends to look at it for you and report any problems so they can be fixed.

INGREDIENTS OF AN AWESOME MOVIE WEBSITE

Here are the "Dos and Don'ts" you must know to make a movie website that readers will not only revisit but also tell their friends about.

1. Don't get too flashy.

Bells and whistles like Flash animation look really cool. That intro movie to your site is great to watch—but it only works once. Web design sometimes gets too caught up in trends. (Do you even remember "frames"? Does anyone use frames for their site anymore?) There is one mistake that novice Web designers make time and again, and that is over-designing a site. Just because you can add some cool new effect doesn't mean you should. To reach the maximum number of people with your site, avoid adding flashy extras. The design does not have to be compromised, but avoid jumping headlong into new technologies without weighing how that might limit the potential audience for your site.

2. Interact with your audience.

Adding production diaries, interviews, exclusive video footage, and such adds a personal touch to the site. Speak directly to your audience and have a message board so readers can offer feedback. Make it a priority to answer that feedback and make yourself accessible.

3. Keep it simple.

This one should be self-explanatory. An overly complex site will only turn off readers and they'll surf elsewhere.

4. Update the site yourself.

If you design the site yourself, this should not be a problem. Make sure that you are trained to add simple updates to the site as often as you need. Don't be a slave to some Web design firm that must be paid each time you add a minor update or news story. Don't be a slave to

the friend or student who built your site. Learn how to update the site yourself. Then, be sure to follow my next suggestion . . .

5. Update often.

I can't stress this one enough. Weekly updates are preferred and even more often if that is at all possible. The latest news about your film should be right on the front page. Attach a date to each new news item so readers know when the site was last updated. If new features are added, be sure to let others know about it as well. You are taking the readers on your journey. Tell them about all the ups and downs—the sometimes personal and real-life drama you encounter making the film can make the best stories. It will also endear the audience to your cause, which is making your movie. And when you experience triumphs, like your debut festival screening, they will share in those successes.

HIRING A PUBLICIST: WHAT YOU NEED TO KNOW

Filmmakers entering the festival game for the first time quickly learn the value of good PR. Great public relations can take an average movie and increase its value by creating hype. An average film with heat behind it is much more likely to be sold to a distributor than a great film with no heat—this is an unfortunate reality at film festivals. Really good films can get lost in the shuffle. However, with a great

Telluride Film Festival banner

press kit, an amazing website, some well-timed articles in the trades, a few positive reviews, and some friends in the media, you'll be much better positioned to achieve a sale and begin your filmmaking career.

ON THE PUBLICITY TRAIL WITH PR PRO LINDA BROWN

Linda Brown began her career at PMK Public Relations, where she worked for five years on publicity campaigns with actors such as Winona Ryder, Andie MacDowell, and Gregory Hincs; films such as Luc Besson's *La Femme Nikita* and *My Left Foot*; and television shows such as Fox's *The Simpsons*. After leaving PMK in search of some kind of life, she stopped briefly at Bragman Nyman Cafarelli, then went on to become Director of Motion Pictures Los Angeles for Rogers & Cowan, where she headed up campaigns and promotions for a countless number of films, including *The Mask* with Jim Carrey. Currently Brown heads one of the premiere public relations firms for independent filmmakers, the Los Angeles-based Indie PR. Getting press is not just a job for Brown; she passionately believes in her clients and their films. Indie PR has been in existence since 1996 and has been successful in providing promotion, marketing campaigns, parties, festival debuts, and more for indie filmmakers.

How can a publicist help a film?

A publicist does different things at different stages of a campaign for a film. For a festival, a publicist prepares the press to receive your film (in the intellectual and emotional sense). Presentation means a lot; a publicist advises you on the look of your poster, chooses the stills you will use in representing your film and your clips for electronic interviews, and will prepare that all-important press kit—which serves as a bible to the press when they write about your film.

Equally important, a publicist comes up with a strategy for presenting your film to the public. A filmmaker's idea of how a film should be presented may be entirely different from what is going to sell. That doesn't mean the filmmaker is wrong; it just means that it's only one opinion and it sometimes helps to go at it from other angles as well.

Why does a filmmaker need a publicist?

The smartest filmmaker takes on a publicist at the very onset of a project and keeps one throughout the entire process. (That can get costly, but deals can sometimes be made.)

There is so much for the press to cover during a festival, from reviewing films to covering parties to eavesdropping during breakfast for items. Unless you have someone out there vying for ink and creating a buzz about you or your movie, you run the risk of getting lost in the noise pollution. My campaigns start a month prior to the festival when I start making calls to the magazines and columnists who can put a little "pre-festival buzz" on my movie. I get the press excited about your film by letting them in on it early and in a personal way. At this point, a lot of the members of the press are friends of mine, so it is very much like my calling a friend to let them in on something they just shouldn't miss.

What do filmmakers need to know when it comes to publicity?

Publicity is less effective when it is a "one-shot deal." It is so much better to have continuity and a steady flow of information going out to the press throughout all of the stages of your film. That way, when it comes time to do the festival thing, it's a matter of instant recognition for both the press and distributors. It is also essential in getting all of the materials you will need to help sell the film—whether it be a press kit complete with clippings (to show a studio that your film can get press), or photos and an electronic press kit complete with interviews and behind-the-scenes footage.

What are the advantages and disadvantages of a filmmaker doing their own publicity?

Filmmakers can do their own publicity as easily as publicists can make their own films and do it well . . . it just isn't smart. First of all, it takes up a lot of the filmmaker's time that should be spent other ways, but mostly

because it's smarter to have those who do what they do best—actually *do* what they do best. The only advantage a filmmaker has in doing his or her own publicity is that it will save a few thousand dollars. That's it. Without the advice and careful planning of someone who lives this kind of work, an uninformed filmmaker could miss the opportunity to present his film with the perfect spin to catapult his campaign and film into the arms of a dream distributor. Without the forethought and careful planning that went into the PR campaign for *The Full Monty*, most ticket buyers would have passed it up for another film. Think of the distributor as an audience member with a checkbook. You still have to stand out and grab their attention.

What kind of advantages do filmmakers who have publicists have?

Ultimately, the more people you have talking about your film at a festival, the better your position. And who has bigger mouths and talks to more press, distributors, and festival-goers than publicists? We're with the press at breakfast, between screenings, *at* the screenings, in the bathroom, in their rooms . . . we never stop! We get 'em while they're drunk and make them commit. We're relentless, and you need that kind of energy on your side when your film is at a festival.

What sort of questions should a filmmaker ask when hiring a publicist?

When hiring a publicist, the most important question to ask is, "How many other films are you working on at the festival?" I see it all the time: Bigger agencies pile on the clients telling them that they are at an advantage in being "in the company" of other big films. This is simply not true, unless you are working with a publicist who can't get Sheila Benson on the phone *without* a bunch of big films.

There is no way you can effectively work with an exorbitant number of films—*effectively* being the key word. I don't like to work with more than four films per festival. Part of a campaign is spending time with the filmmaker at the social function (it's where most of the interviews

are set up), and if you're chained to a desk in a hotel room working on fifteen films, you just can't do that. Film festival PR is not like publicity at time of release, where you *can* chain yourself to a desk and pump out the calls. The press is out and about . . . they're at the parties, they're at the panels. You've got to have the freedom to pound the pavement and hunt them down.

What can a filmmaker expect to pay for a publicist?

Most agencies charge anywhere between $5,000 and $15,000 for a film at a festival. You should allow for expense monies as well, which should cost you another couple of hundred (depending on the festival).

How important is it to get good online press these days?

The Internet has taken over as a primary way to reach worldwide audiences with current information. The key word here being *current*.

As publicists and promotions people, we used to rely on magazines or shows like *Entertainment Tonight* to get the word out. Most magazines require a three- to four-month leadtime, and entertainment shows give you three- to four-minute spots and that's that. With the Internet, it's happening right now. And the cyber-sky is the limit as to the amount of content you can have, so online press is becoming more important than any other form. The fact that studios now have entire departments of publicists and promoters who deal specifically with the online community is evidence to the fact.

How do you approach getting press on the Web differently?

The Web is a visual tool, and its audience is more visual than, say, the *Los Angeles Times* reader, who is going to sit down and read a feature, then maybe glance at a photo. When we approach a Web outlet, our job is to incorporate more interactive participation and make it more interesting for the site's audience. With print, it's a bit more cut and dry and somewhat more controlled.

Does a filmmaker need to hire a publicist to do online press?

I think that anyone can do online promotions themselves. But a publicist is able to come to the table with more of a strategic campaign, which will complement any promotions a filmmaker has already done online. But a filmmaker doesn't necessarily have the relationships [with entities] that would do the larger entertainment features on their film, and as with traditional publicity, you need to have someone open the door for you.

What are the important things for a filmmaker to remember when working with a publicist?

A publicist is not a miracle worker. The ultimate sale of your film depends on how good it is. But a publicist can be an essential part of your team in creating awareness and the infamous "buzz" that everyone listens for at a festival.

KNOW THE MEDIA OUTLET YOU ARE PITCHING

One should never blindly pitch a story to a media outlet. Understand the needs of that outlet before you pitch. Various media will have dramatically different areas of focus—the local newspaper will look for human interest, while a trade publication is looking for a business angle. Consider the spin you are looking for and consider the wants and needs of that outlet.

MAKE FRIENDS WITH THE PRESS
Make friends with the press and, when that friendly critic bashes your movie, continue to smile and be friends. You never know when a press person will come in handy for you later.

"When I worked for *Film Threat* magazine, I specifically looked for films that were in some way rebellious—either through the story, filmmaking style, or simply the maker's guts for doing

what they did. For *American Cinematographer,* I look for visual accomplishment, whether the picture was shot on Super 8, 16mm, 35mm, or video," says writer and editor David E. Williams.

It's important to research the outlet you are targeting before you make the call or send the e-mail. Nothing will close a door faster than pitching an outlet you know nothing about, then sticking your foot in your mouth. When you communicate with the outlet, be sure to compliment them, and then pitch your piece to not only the publication but also a specific place. You might recommend that the story appear in their "What's Hot" or "Upcoming Movies" section. Always be accommodating and accept rejection, because at the end of the day your relationship with that media person or outlet is more important than whether they do the story. They'll remember that you were easy, even in the face of rejection, and it will pay off in good press later on.

QUESTIONS AND ANSWERS

After the screening of your film, you'll want to offer a few quick thank-yous and introduce members of your cast and crew in attendance and are expected to answer some questions from the audience. It helps to be prepared. This is your opportunity to show some personality and potentially win some points. Believe it or not, it is beneficial to wear something outrageous—a bright orange jacket, a wild hat, or a loud shirt. You may even consider dyeing your hair a bright purple. The reason is so that you stand out. When members of the audience run into you during the festival, your unique "look" will be remembered. Besides being an opportunity for a fashion statement, the Q&A is also, much like an important

FOR TRAVELERS: STAY FOR THE Q&A
Often the stories behind the making of the films are better than the actual films. So, always be sure to stay for the post-film question-and-answer session. Selling blood, going bankrupt, following the subject for ten years, nearly dying—the tales of filmmaker's struggles always make for compelling theater.

speech delivered by a politician, a way to win people over to your cause. The best advice is to be genuine, be honest, tell some funny stories and anecdotes, and keep your ego in check. Be gracious. Have a little humility. You may be the "filmmaker" up front doing the Q&A, but the reality is that there are a hundred or more people behind you who helped make the movie possible. Giving them some type of acknowledgment onstage goes a long way toward earning the respect of the audience.

As for any feelings about being nervous when speaking in front of a group, that old trick about picturing the audience naked really works—just don't let it distract you. There are some typical questions you can expect to hear at almost every Q&A, so be prepared to answer any of these:

- How much was the budget?
- How long did it take to shoot?
- Is the film autobiographical?
- Where did you find that actor?
- How did you get the money?
- Where did you get the idea for your film?
- What does the title mean?
- What kind of film did you use?
- How did you shoot that one scene?
- Who are your influences?
- Where did you shoot your film?
- What's the film about?
- What's the film *really* about?
- Do you have another film in mind?

The answers to these questions should be easy; you have struggled to make your film and you know all of this. Keep the answers short, don't meander, and don't play politics—answer the question asked.

Don't fret about money questions—most audiences just don't know any better. The last thing you want to do is reveal the actual budget for your picture. Even if you do give a specific number, people will think you are either naïve or lying—so either way, they won't believe you. Just be vague and say, "Just below $10 million."

THE PARTIES

GET INVITED, MAKE AN IMPRESSION, CRASH, AVOID SPILLING SOMETHING

The single most important event at a festival (other than your own screening) is the party. You may be as talented as Steven Soderbergh when it comes to filmmaking, but your talent is truly judged by how comfortable you are with idle cocktail chitchat. Yes, yet another unfortunate entertainment industry reality.

At the parties you'll be schmoozing with agents, entertainment lawyers, acquisitions executives, distributors,

Yachts are a common place to hold a party at Cannes.

development executives, producers, actors, festival staff, the media, and other filmmakers—basically, the masses of the movie industry. It's important that you make a good impression.

So get social. Grab a drink, grab a table, grab some food, and scan the room. (Hey, you'll probably be too busy to grab dinner, so you'll save a little money on meals by eating party appetizers for days, keeping the cost of your trip very low. Living on chicken fingers and wing dings for a week won't kill you. At least, not right away.)

Now, you've got that person in your sights. The one you need to talk to. The actor for your next film. The agent you want to rep you. The festival director you want to accept your film. The executive you want to pitch for your next film. The bartender you want to pour your next drink. (Okay, I'm getting carried away, but it can be just as hard to get the bartender's attention as it is to spark an agent's interest at these overcrowded events.) There are a few important things to remember at a party when you are there for business. Here is my version of the inevitable list of "Dos and Don'ts."

THE PARTY DOS

- *Do* introduce yourself to people. Most will have festival badges with their names and films and/or companies on them. At any given party you'll find at least a few people you should meet to advance your personal agenda. As annoying as it sounds, remember that you are attending these parties to further your personal goals. If you think otherwise, you are only lying to yourself. Okay, *I'm* there to have fun; everyone else has an agenda.
- *Do* try to find some common ground to begin a conversation. For example, films you each enjoy, a common city, a favorite drink, a popular actor, a sports team, a filmmaker—anything at all to establish the conversation on a positive note.
- *Do* make friends with other filmmakers and get invited to their screenings.
- *Do* tell inoffensive and clever jokes.
- *Do* talk passionately (yet unpretentiously) about your love of film and how your life was changed by the defining moment of one important film. People at film festivals get all mushy when this subject comes up.
- *Do* talk business—that's what these parties are really about anyway.
- *Do* be bold and walk up to that IFC exec and invite him to your screening.
- *Do* take every person you speak with seriously, even if they do not initially seem important to your immediate agenda. The assistant of today is the festival director, agent, or studio head of tomorrow. They'll remember that you showed them respect when no one else would. That's important.
- *Do* hand out business cards.
- *Do* make it a point to follow up and send letters to people you have met when appropriate. Again, you never know how those relationships will pay off.

THE PARTY DON'TS

A party can be a great opportunity to make new friends, make an impression, and, most important, to make deals. If some studio executive likes to hang out and party with you, certainly, he may also want to work with you. That's the secret of the business—people hire other people they like. It's very simple. So keep some things in mind.

above: Filmmakers sober.
below: Filmmakers drunk.

- *Do not,* as I have done, make inappropriate jokes in mixed company.
- *Do not,* as I have done, charge room service to your pals at 3 A.M.
- *Do not,* as I have done, put drinks on the tab of "the table in the corner."
- *Do not,* as I have done, drink way too much alcohol.
- *Do not,* as I have done, try to dance after drinking that alcohol.
- *Do not,* as I have done, schedule 5 A.M. wakeup calls for your colleagues.
- *Do not,* as I have done, mercilessly criticize the award-winning festival film as a total piece of crap when the director is within earshot.
- *Do not,* as I have done, stand on a chair and thank everyone in the room for coming and for their support for your film, when you haven't made the film that the party is for.
- *Do not,* as I have done, avoid the festival party scene to see local bands, find the strip clubs, and visit the after-hours bars.
- *Do not,* as I have done, yell "Fire!" at a crowded party.

I really mean it. Don't do any of these things. I've made every possible mistake anyone could make at a party. Sometimes I just can't resist putting some pretentious moron in his place, or making a point through humor.

DON'T PLAY GAMES

The secret to playing the game is to act like you're not playing the game. Got it? Okay, let me spell it out: If your goal is to get your latest script to the actor across the room or to pitch your movie to the studio executive you just met, my advice is to not do it. Make friends and discuss anything other than business. Be sure to get their card, and then follow up at a later date with your script or pitch. That way, you've already become "friends" (or "friends" in the Hollywood sense) and you can more easily segue into a meaningful business discussion.

Sure, I have a great time, but generally I'm attending a festival to have fun; I like to leave the business at the office. If your goal is to have fun, a few "don'ts" are fine. But more likely, you have a goal in mind—you're trying to sell a film or get another one made. Leave the hard partying for the final festival party.

CRASHING FILM FESTIVAL PARTIES

To get the opportunity to do some schmoozing, you have to *get into* the party. Do whatever it takes to get into the party legitimately first, but when all else fails, it's time to crash!

It's always best to get on the list before arriving at a party, but that's not always possible. Because if you're like me, you're probably not invited. But I've never let that little piece of reality stop me, and neither should you. I am the party-crashing king, and I'll crown you a prince (or princess) if you simply follow my lead.

The first piece of advice I can offer is to put on your poker face. Security is generally loose at film festival parties, and it's up to you to take advantage of that. Remember: You were invited to this shindig, and there must have been some mix-up. Make sure to deliver lines like an actor.

Also, never get upset. The publicists or people at the door are constantly bombarded with Hollywood egos, so why add to their grief? Act understanding. Do something different—be nice. Be cool. Don't be a jackass. Knowingly shake your head as the jerk in front of you mouths off to the publicist. They'll appreciate it. They'll especially appreciate your patience as they frantically flip through the list, then just give up and wave you in.

You can always use someone else's business card. In fact, some fancy computer work with a handy laser printer can now produce pretty convincing business cards with the click of the print button. In fact,

I'm amazed how many times my own business card has been used as my golden ticket into a party.

One tried-and-true trick is to execute the bum's rush. Just walk in with a large group as if you know exactly what you are doing. If caught, just simply point way up into the crowd, too far to see, and declare, "I'm with them." Wave and act convincing. Never fails.

And heck, if all else fails, there's always the back door. Yes, the back door—this is not a movie cliché, I have actually used it to gain entry. Sure, you'll be stumbling through the kitchen, but you're *in*, baby! Sometimes restrooms will have windows that can be easily accessed from the outside. If you know of a great party that you must attend, it's best to do a little reconnaissance and check out the place first. Heck, you may even make a few new friends in the kitchen.

10 SUREFIRE LINES TO USE WHEN CRASHING A PARTY!

No invite? Not on the list? No problem! These lines, if delivered convincingly, will guarantee you entry into any party. However, it is more difficult to crash parties than it used to be just a few years ago. In fact, the exclusive festival parties require a hard invite *and* a photo ID to get in. But that's never stopped me. It's not as easy to crash as it used to be, so you've got to be inventive. Try these surefire lines.

1. **"I did RSVP, but I understand if I can't be let in. Can I just try to find my friend? He's in there? Somewhere?"**

2. **"Excuse me, coming through! Watch it!"**
 Carry a large box filled with something. Could be a case of beer, equipment, posters, flyers—the important thing is that it must be so large and heavy that people have to make way for you to get by or you may drop the damn thing and hurt yourself or somebody else. Be polite and walk right in like you know what you're doing. If stopped, say that you have to get these in there or you'll be in a heap of trouble. If you really want to go for realism, have a walkie-talkie on your belt, tons of laminated credentials around your neck, and carry a flashlight.

3. **"I think I'm going to be sick, can you tell me where the bathroom is?"**
Women are much more convincing for this line. A man would never stand in the way of a sick woman. This works even better if you spit out a mouthful of corn chowder.

4. **"I'm here to drop off my roommate's keys."**
Pretend to know one of the waiters, waitresses, or someone working the bar. Just in case, have an old set of keys you don't mind losing in case they decide to pass them along for you.

5. Weasel your way to the front of the line and walk in like you're supposed to be there. When stopped (and you will be), look shocked and say, **"Hey, I'm in the movie."** Enter party. A variation on this is to wear a baseball cap and say, "Hey, I'm the director!" Don't even bother to try "writer," since it won't work.

6. **"Is this the party for the best film at this festival?"**
Now this is going to take a little planning and might get you in trouble, but give it a shot. Business cards can easily be printed now from laser printers, and they look perfect. Make some phony cards from a really big press outlet. You can even go on the Web and get a logo to make it ultrarealistic. When your name doesn't show up on the list, just be apologetic and pass along your card. Once the impressive card hits the hands of the person holding the list, you'll be let in.

7. **"Hi, I was here earlier and I lost my wallet, do you have a lost and found?"**
This one's called "Lost and Found." Now, here's the trick: You are *not* asking to get into the party like everyone else standing in line. No, siree. Why? Because you were *already there.* Why would you want to go into that awesome party? You're asking about the *lost and found,* so you have deflected the door person's attention from your true intentions. Act distraught. When your "wallet" (or purse, or keys, or jacket, or scarf, whatever) does not turn up in the lost-and-found

box, ask very nicely, "May I go in and take a look around? Maybe I can find it myself." Be sure to nicely wave your wallet to the person on your way out. "Found it!" Everyone loves a happy ending, you found your missing item and you got in. Piece of cake.

8a. I call this one "The Wave."

Wave like you're insane and say "Heeeeey!!!"

8b. I call this one "The Wave and Hug."

Wave hysterically to someone who is *way* beyond the eyesight of the people guarding the door. This could be someone you barely know or no one at all, but wave and act like you're seeing an old friend you haven't seen in ten years. You're so caught up in seeing them after all this time that you merely "forget" to check in. Be sure to really close the deal with a convincing hug. (Hopefully, you'll know the person you're hugging; if not, hopefully you'll find someone overly friendly.) This one only works at a really packed party.

9. This one is still effective and works even better if you learn to read upside down. Casually lean over, without letting the person see you, glance at the list, and pick out a name. Try to select one that is not checked off. Then say: **"I'm the plus one with _____. I have to meet him/her here."**

10. "Hi, I'm Billy Bale. Christian Bale's brother? I'm supposed to meet him here."

The famous always get into parties, but you're not famous. So, who's to say that Christian Bale doesn't have some less attractive brother named Billy? He might. Maybe they're stepbrothers, who knows? This line has actually worked for me. Celebrities are like royalty, and publicists never want to offend a celebrity. Just be sure the celebrity you intend to impersonate as a distant relative is not actually going to attend. If they were there, it would be bad. To say the least. You may find yourself escorted to the VIP lounge being introduced to other celebrity folk. So go ahead, pose as

Kate Hudson's cousin or William H. Macy's stepbrother—why not? This is also only recommended as a last-ditch effort to get into a really exclusive party since there could very well be repercussions involving the cops when using this method. Remember, I warned you about this one.

IF ALL FAILS, USE "THE BEST PARTY-CRASHING LINE EVER"

If any of the above lines do not work, I have to divulge one of the best lines ever. But only to you, the readers of this book. Be sure that you do not share this with anyone; it's our secret. This one is dangerous, mainly because it's *so successful* when trying to gain entry into the most exclusive festival parties. First, you'll need some props: Bring your own pint glass and a can of apple juice or beer. Pour some of the liquid into the glass and walk casually up to the entrance so the doorman does not see you. Make sure he's distracted with the chumps waiting in line who will not be getting in. Next, pay attention to little details—if it's cold outside, take off your jacket and tie it around your waist. Do not make eye contact with the doorman, as that will only give you away. Slowly sidle up to the entrance while he is distracted. Once you are right next to him and just outside the door, very nonchalantly hold up your half-full glass and politely ask the doorman:

"Hey, is it cool if I take this drink out here? Is that okay? I'm just gonna grab a smoke."

Since the party will get shut down if anyone is caught taking alcohol outside, the doorman will literally throw you *into* the party. He's assuming you were already in to begin with, but now you are really in!

Okay, I can't give away all my secrets. I've saved some even better entrance lines for myself, but if you ask me in person, I'll tell you a few. Now remember, I'm a master, so for me it's easy—but practice makes perfect. And you can be creative and come up with your own—you just have to be in the right mind-set and remember that you are supposed to be there. The best advice I can give novice party crashers is this—any plausible excuse delivered with a straight face, in a very polite manner, will get you in.

PUTTING ON A SUCCESSFUL PARTY: CREATE BUZZ AND LEAVE THEM TALKING

Nothing helps create buzz for a film better than a party. (Nothing except, well, maybe a really good film.) The most successful parties are the ones that are impossible to get into. Even as you hand your party passes to friends or associates, make sure to let them know, "This is my last pass— it's going to be really tough to get in so show up early. I can't guarantee you'll make it in, but you can try."

Of course, this statement is repeated to every single person you hand the pass to, which will guarantee that your party becomes a "must attend" event. It's as if you are giving each person a challenge and they will rise to the occasion. The harder it is to get in, the more they will want to go.

There are certainly different opinions about what makes a great party. If you really want them to leave happy, your party must live up to the following:

1. **Make everyone RSVP.**

 This gives you an idea of how many will attend. The harsh reality is that 50 percent or more of those who do RSVP will not show up. Don't take this personally—most RSVP to everything so they have options. However, the party crashers, friends, and members of the press who decide to just "show up" will offset those people who choose to skip your party.

2. **Hold the party at a venue that you know is too small for the number of people showing up.**

 If you leave at least some people at the door, it's considered a party worth getting into. If it doesn't present some challenge—if it's not at least somewhat overbooked—then it's not considered a hot party.

Swag bags can clutter a hotel room.

3. Have an open bar and free food.

Another unfortunate reality is that if you charge for drinks and food or use some annoying "ticket" system, you'll only piss people off. The two most feared words among journalists are "cash bar." Believe it or not, making people pay for drinks can result in bad buzz. Keep the free drinks flowing and let people know when it's last call.

4. Avoid loud music or bands.

It's hard to have conversations with any type or distraction; music set to the max is the worst.

5. Keep any speeches really short and funny. Better yet, how about no speech at all.

Most "speeches" or "announcements" given at party gatherings only serve to stop the party cold. In most cases, this is when the walk-outs begin. Start any speech about a half hour before the scheduled end of the party and keep it to less than three minutes. Say your thank-yous, tell a joke, and then encourage people to attend your screening. That's it. Otherwise, you can kill your own party.

6. Send 'em home with something for free.

A goodie bag is always a good idea. The bag should contain some type of useful freebie that advertises your film. A T-shirt, soundtrack CD, DVD, poster, or some useful item (like lip balm in cold climates or suntan lotion in warm climates) works wonders.

7. Invite celebrities.

Yeah, they can be a distraction, but the fact that they showed up means something. I know, I think it's lame, too, but that's reality. A good publicist will "book" a celeb to stop by and people at the party will talk about it. I am definitely *not* a celebrity, but invite me anyway. Please?!

8. Do something different.

The key here is to simply be inventive and create a memorable party experience. I have always wanted to go to a film festival party with

a carnival dunking booth. You know, one of those ones that people throw baseballs at so the person is "dunked" in a vat of cold water. It would be cool to see world-famous critics or movie actors in that dunk tank. Well, that's just my idea, but anything you do that is unique will get attention. Having your friend's band play will not help and is really not recommended.

SECRETS AND LIES OF FILM FESTIVAL PR

It's no secret that film festivals provide an amazing opportunity to create buzz for a movie. Whether the goal is to simply bank a batch of press clips, or to secure distribution, or to find a champion in the form of a prominent critic, or to mount an Oscar campaign like *Walk the Line,* which premiered at Toronto, the festival PR assault is critical to a film's strategy for success. And while there may be specific goals such as those mentioned above, one cannot ignore the benefits of good word of mouth garnered from enthusiastic festival-goers when they tell their friends or hopefully blog or Twitter about the fantastic movie they just "discovered."

SECRET: CHOOSE THE RIGHT FESTIVAL FOR THE FILM'S PREMIERE.

Every film has a best fit when it comes to a festival, so consider one of the new genre festivals that focus on horror or sci-fi. There are festivals for nearly every genre, so keep these in mind when planning a festival strategy. The movie may find more adoring new fans at a smaller festival focused on a particular genre rather than at a larger fest where it can get lost in the shuffle. It's often better to be a big fish in a little pond. You can easily get lost in the oceans at Sundance among others.

LIE: THERE'S NO SUCH THING AS TOO MUCH HYPE.

Wrong. It's almost always better to manage expectations rather than overhype. Nothing is worse than seeing something billed as the greatest

movie of all time, when it is simply an excellent film. This is very subtle, and it's always better to let others do the talking.

SECRET: MAKE FRIENDS WITH EVERYONE ON THE FESTIVAL STAFF, ESPECIALLY THE VOLUNTEERS.

To me, festival staffs are your best allies when it comes to creating buzz for a film. And the volunteers are even more important as they'll often be asked, "What is the hot ticket?" So treat them well, enlist their aid, and, if appropriate, shower them with gift baskets of muffins or even swag. Nothing is better than seeing a volunteer who has just gotten off a shift slipping on the free T-shirt with your project's name emblazoned on it for all to see.

LIE: DO NOT PLAY TOO MANY FESTIVALS OR RISK OVEREXPOSURE.

MOVIES AREN'T EVERYTHING
Take a day off away from the festival to kick back, learn to snowboard, or get drunk in a Jacuzzi while meeting new friends. I always do.

Yes and no. It makes no sense for a film driving toward a wide theatrical release to play countless dates on the festival circuit. But a smaller indie will benefit by playing right up until its release on DVD. It may even be beneficial to screen in conjunction with the DVD hitting retail, to boost sales.

SECRET: USE ALL THE TOOLS AT YOUR DISPOSAL WITH DISCRETION.

Utilize every tool, from the film's website e-mail list to the EPK to the one name actor allowing you access. It also helps to look for opportunities to provide exclusives to media outlets. This not only makes the press happy, but it also means you'll be creating different impressions for the movie, rather than the same regurgitation of the same content provided to each outlet.

LIE: CRITICS-ONLY SCREENINGS ARE THE PATH TO GETTING THE BEST REVIEWS.

It's often most desirable for a reviewer to see the film with an audience, even if that means you must buy tickets to your own screening and hand them out to critics. Target specific outlets or reviewers who are more likely to be receptive to your film, and then combine them with a packed and enthusiastic audience. This approach will result in better reviews than you'd get from the critics-only screening held at an odd hour in a tiny screening room.

SECRET: TARGET THE HARDCORE FANS.

Each movie is going to have its niche of fanatics, so seek out local groups to support the movie by packing every seat. Nothing is more impressive than a line around the block and a sold-out screening. Even the most obscure film subjects have potential fans. When the documentary *Scrabylon* premiered at Sonoma Valley, we contacted local Scrabble clubs in the Bay Area and they turned out in droves. The film's director even set up a booth that awarded $100 to anyone who could beat the Scrabble champion. No one did, but everyone loved the movie.

LIE: THE MOVIE MUST PREMIERE AT TORONTO, SUNDANCE, OR CANNES.

This is simply not true, especially since a good festival run can work toward creating valuable awareness. And when it comes to indies that will roll out theatrically in a limited number of cities, playing a regional festival will support a solid DVD release in the end.

SECRET: FIND A CHAMPION.

Whether it's a prominent film critic or a well-known actor or a name filmmaker, a positive quote from a respected source will garner more interest.

LIE: BAD REVIEWS WILL HURT THE FILM.

The best thing one can do with a bad review is to ignore it. It's not an exaggeration to say that there are more outlets covering movies today than there are movies being made each year. If you include the Internet and blogs, it's in the tens of thousands! Pick and choose the best ink and ignore the "haters." Someone worth quoting will discover the film, and that one good quote is all you need.

BE A PRODUCER

If being surrounded by film-biz types starts to get on your nerves, hey, just become one of them. Anyone can be a producer. Trust me, it doesn't take much. Some of the least intelligent people I have ever met at festivals have been producers. In fact, I can prove that you're a "producer" right now! Just look in the mirror and say, "I'm a producer." See, that was easy. The hard part is getting something actually produced. But "wannabe" producers already surround you, so join in the fun and completely B.S. your way to a career in film. Believe me, you won't be the only one.

SECRET: KNOW THE OUTLET.

This should be obvious to any seasoned publicist, so I don't mean to offend by bringing this up . . . but the number of pitches that I receive that have no place on my website never ceases to amaze me. Explore the media outlet you plan to pitch before you approach them. It's not difficult to find an angle tailor-made to an outlet that will translate into coverage.

LIE: AWARDS WILL SKYROCKET THE MOVIE INTO A HIT.

You should never turn your nose at any award. However, some festivals hand out awards like free booze—there are just so many. So use those laurels and accolades wisely, highlighting only the most notable. The post-festival press release is your chance to put the best face on the event, so remember to send out that well-timed embargoed press release with highlights of the positive news filled with killer quotes, outstanding attendance numbers, and maybe even some of those noteworthy awards.

SECRET: COACH YOUR FILM'S SPOKESPERSONS.

The director is not necessarily the film's best spokesperson, and while actors are often the most sought after, we all know some of them can be as dumb as a box of dirt. It's impossible to turn your talent into media-savvy publicists overnight, so take the time to provide key talking points and coach everyone who will speak on behalf of the film.

LIE: THE FILM MUST SCREEN AT A KEY TIME ON A FRIDAY OR SATURDAY NIGHT.

While the timing of the screening is important, be aware that often the time that seems the best, 9 P.M. on a Saturday, could be in direct competition with a festival party where all the VIPs and attendees will be drinking and eating the night away. Midnight screenings or even early afternoon can work to your advantage depending on the target audience, so research the festival schedule beyond the screening times you've been assigned and pay close attention to events.

THE MOST IMPORTANT GOAL

To prepare for your film festival debut, the list of things you need to accomplish can seem insurmountable. The "to do" list on page 143 is just to help you get started. You will think of many more things to add to this list based on your individual needs.

Aside from all the distractions and small tasks that come with preparing for a festival, the most important goal you have is to complete the greatest film possible with the resources at your disposal. Do not even consider compromising the integrity of your movie to make a festival deadline—making the best movie is the top priority.

GOALS LIST
It might look something like this:
1. Promote and pack the screening.
2. Get a good review.
3. Meet Chris Gore.
Have a list of specific things you want to accomplish, and then put that list in your pocket. I know, it sounds corny, but if you put it in writing, it becomes more powerful and then it becomes possible. You might not do it all, but writing it down gives you direction.

SECTION 3:
FORMING A FESTIVAL STRATEGY

"*I have not had a better learning experience than that first screening. I watched my film in a much more detached, critical way, and it was an important experience. It made me a better filmmaker.*"

—JOE SWANBERG,
filmmaker

FINDING THE RIGHT FESTIVAL FIT

Whether you have a short film, documentary, or narrative feature, to successfully debut onto the festival circuit, you must have a strategy. First, this involves selecting festivals that are the best fit for your type of movie. Consider festivals that may be more friendly to a particular genre— whether it be animation, comedy, family, gay and lesbian, documentary, experimental, ethnocentric, music, political or social-issue based, or short film. Or you might consider the type of festival that continues to see tremendous growth in popularity: those championing sci-fi, fantasy, and horror. Sometimes it's better to be the toast of a smaller festival than be overlooked at a larger festival.

When it comes to choosing where to submit your film, I recommend you begin by targeting the top-tier festivals, starting with Sundance. (Detailed listings can be found on the online database at www.UltimateFilmFest.com). "A-list" festivals like Sundance, Toronto, Cannes, and SXSW are also backdoor markets for indie films, regularly attended by acquisitions executives. Next, you must strategize a fallback plan in case you do not get into an A-list festival. There are just not enough screenings slots at Sundance, as they only program about 200 films in total. Research and narrow down a list of festivals for your Plan B—these are the ones you will submit to *simultaneously* should your Plan A fall through. These might include strong regional festivals like AFI Fest (both L.A. and Dallas), Atlanta, Austin, Chicago, CineVegas, Denver, Florida, LAFF, Phoenix, San Diego, San Francisco, Seattle,

WHEN IN CANNES . . .
Bring formal wear. An evening gown or tuxedo is actually required to attend the premieres. In fact, not only does everyone walking on the red carpet go through a security check, but there is a fashion check as well. If you're wearing something a little *off*, you can be sure that your wild bow tie will be replaced with a more formal one. For men, the dress is formal and conservative, so don't forget to pack a tux or you won't get in even if you have a ticket.

Sidewalk, Wisconsin, Woodstock, or those genre-based festivals more suited to your particular film. These are all festivals that will result in amazing experiences and opportunities for awards, networking, and

fun, but when it comes to getting a distribution deal, statistically speaking, the top tier have had more filmmakers walk away with distribution than all the other festivals combined. These second-tier fests are also perfect for building buzz and an audience. And, if the right person happens to be there, this can even lead to a deal.

Formal wear is required at premieres at Cannes.

Apply to at least twenty of these festivals, and plan your submission schedule around an annual calendar, mapping out the festivals you will play over the course of a year or so. If you are waiting to learn if you've been accepted into that top-tier festival before accepting an offer to premiere at a festival from your Plan B, don't stress it. As long as you communicate honestly about your dilemma, that smaller festival will keep the film in mind next year once you've made the rounds.

Then—and this is optional—take some chances. Apply to a few out-of-the-way festivals for what might turn out to be a much-deserved vacation. In particular, foreign festivals can be a blast. You may end up with a free trip to Spain for your film's European debut, all because you took a chance and submitted.

All told, your plan should include applying to about forty festivals. It's better to focus on lobbying this focused group that you researched and selected first than to apply aimlessly. Sure, you could apply to

HOW TO ATTEND ANY FESTIVAL FOR FREE

One of the best ways to get into a festival for free is to volunteer. All the major festivals have volunteer programs, and while there's no pay, there's a ton of free swag to be had. Not to mention getting to see free movies (on your off time, of course), and most festivals even set up special volunteer-only screenings for their showcase films. So if you are thinking of entering a festival down the road, consider volunteering first to establish that personal relationship.

hundreds, but you would be wasting a lot of money and valuable time. And remember, lobbying the festival staff (politely, correctly, in a way that gets their attention and does not annoy) is also time better spent than applying randomly. Work smarter, not harder. Once your film is playing the circuit, and receiving accolades, you will be invited to festivals you've never heard of and never submitted to. Festival programmers often talk and share information about what films played well to audiences or what filmmakers were appreciative and easygoing. Once the festival program guide is available online for all to see, that will help to spread awareness of your film. In addition, awards and positive reviews will also help gain attention for further festival invites. Some invitations will be very direct, and others will simply imply that *if* you send in your DVD, it will *most likely* be accepted, and in this case, the application fee is often waived.

EXPLORING FILM FESTIVALS

By accessing www.UltimateFilmFest.com, which is the best perk of having purchased this book, you will find that I have included the most important festivals and detailed information to aid you in your decision to visit a festival or submit your film. In addition to listings of the top festivals requiring your attention, I have compiled lists of festivals that excel in certain areas. Throughout the film festival directory at www.UltimateFilmFest.com you'll find the constantly updated rosters of what I consider to be the best film festivals in categories ranging from Documentary, Short, International, Touring, Underground, Video, Digital, Gay, Party, Vacation, and many more. There's no doubt you'll find the right match for your film if you use the tools provided

Sundance Film Festival marquee

VIRGIN PREMIERE
Protect your festival premiere status as you would your own virginity. (You know, when you were a virgin.) You can't "world premiere" more than once, but if you are unsure about screening at a smaller festival first, consider showing in a TBA slot as a "work in progress." You'll get valuable feedback and leave with your premiere status (and virginity) intact.

Why not gamble on the CineVegas Film Festival?

on www.UltimateFilmFest.com. See page 294 for complete instructions to accessing the online database.

When researching festivals to enter, your decisions should not be based solely on the data contained on www.UltimateFilmFest.com. Seek out other filmmakers' opinions about how they were treated at each festival and the benefits to attending. No festival submission plan for any one filmmaker will be the same, so create a strategy based on your own research.

Now, I could have included detailed printed listings for *every* festival in the world in this book, but it would be ten thousand pages and weigh ten pounds and you wouldn't be able to afford it or even carry it. And it would be out-of-date on the day it was printed. By providing film festival listings digitally via www.UltimateFilmFest.com. I have given you access to the most up-to-date information and research tools, so that you'll now be able to plan the most effective route to your festival premiere.

WHY GO TO FILM FESTIVALS?

1. Get a distribution deal.
2. Get good press and reviews.
3. Find investors for your next film.
4. Meet actors for your next film.
5. Network with fellow filmmakers and make friends for life.
6. Celebrate with your cast and crew.
7. Take satisfaction in seeing your film with a live audience and interacting with them.
8. Make money selling hats, T-shirts, and DVDs.

9. Travel the world.

10. Get laid.

All of these are perfectly valid reasons for going on the festival circuit. But always focus on a few of these goals very specifically before you decide which festivals to go to. Some of these festivals are great for getting distribution, but others are better for getting laid. Whatever your goal is, be very selective about which festivals you apply to. There are just too many out there to apply to them all.

Good luck to you as you begin the journey to your festival debut . . . work hard, have fun, and if you see me, say hello and buy me a drink.

> **FIND THE RIGHT BUYER**
> Do your research on distributors or have the best people possible doing research on your behalf. Look at distributors and find out which ones have been successful with films that may fit your mold. Your representation should know who's buying and what they're looking for. They'll all tell you that they're looking for "good films," but that definition varies greatly depending on the person. Bottom line: Having a great screening really helps.

WIN CASH AND PRIZES ON THE FESTIVAL CIRCUIT

Almost every film festival on the planet offers the chance to win awards. A hunk of metal, Lucite, or glass with the name of your film on it from a festival can certainly be helpful in gaining attention for your movie. But let's face it, so many awards are given away at festivals nowadays that they're practically worthless. Just try to find an independent film at the video store that *doesn't* have those feathery-lookin' laurels on it—nearly *all* independent films released to home video tout some kind of award. Given the choice, I'm guessing that most filmmakers would prefer winning money over a trophy. Cold, hard cash. Or prizes like film equipment, cars, or even land. Or film services worth tens of thousands of dollars. Well, it's out there for the winning!

Even better than any cash award is landing distribution with a major studio, but only a lucky few filmmakers ever win that prize. However, film festivals are stepping up in greater numbers to offer

substantial cash awards and incredibly valuable prizes to filmmakers as a way of drawing attention to their events.

In doing research for the updated, fourth edition of this book, I discovered more than $1 million in cash and prizes in the United States alone. It's interesting to note that most of the best prizes are not found at the major film festivals. Sure, Sundance offers the much-coveted Alfred P. Sloan Prize, a cool twenty grand to movies showcasing the work of emerging filmmakers tackling compelling topics in science. But science and technology may *not* be the topic of your film, and the truth is that the larger cash awards are more abundant at perhaps lesser-known destinations on the festival circuit.

COMPETITION
It only helps to be in competition at a festival if you win. Awards are always a plus and will get the notice of distributors. If you lose, there's no downside, so don't stress competitions.

Ann Arbor, Michigan, is home to the Ann Arbor Film Festival, which gives away $3,000 in what they call the "Ken Burns Best of the Festival." Ann Arbor also awards $1,000 prizes for the most promising filmmaker, the best experimental film, and the funniest film, among others.

The San Francisco International Film Festival holds the Golden Gate Awards, a competitive section for documentaries, shorts, animation, experimental films, student films, and even works for television. Juries at the fest award cash prizes ranging up to $5,000 in ten of the fourteen categories.

The American Black Film Festival has found a sponsor in HBO, who gifts a $20,000 cash prize each for the best feature and best short by an African American filmmaker.

The Heartland Film Festival in Indiana celebrates what they call "moving pictures"—basically family movies and heartfelt dramas. Heartland's top prize is $50,000 for dramatic feature, and the festival has given away $1.3 million in cash prizes to filmmakers over the course of twelve years.

Target is the sponsor of the IFP Los Angeles Film Festival's cash awards, which include $50,000 for best dramatic feature and $25,000 for best documentary.

Jury members at the Atlanta Film Festival give away over $100,000 in cash and in-kind prizes, including the Southeastern Media Award

presented to an individual artist, which awards a package consisting of in-kind donations from local businesses valued at about $80,000.

One of the single best prizes is given away at the Hamptons International Film Festival. The event is supported by a group of generous wealthy folks, so it's no surprise that its Golden Starfish Award for best narrative feature results in over $180,000 in goods and in-kind services. Several generous locals also personally contribute $5,000 cash awards for films deserving recognition for their inspiration and screenwriting.

I'd love to offer concrete advice on exactly how to walk away with one of these cash awards. Honestly, there's nothing I can really say that will help you win, but it does help to be armed with useful knowledge—so here's what you need to know:

ELIGIBILITY

Be sure to thoroughly research all eligibility requirements when entering a festival in pursuit of a specific award. There will always be a host of strict rules you'll need to follow. Most festivals have a cutoff period for when the film will have needed to complete production. Many demand that your film must fit into a specific theme. Some require that your film's budget fall within a certain range, while others insist that the filmmakers be students or of a specific age, gender, or ethnicity. Whatever the requirements, be sure that your film qualifies in the category you seek to win.

JURIES

Most awards are given by juries. And if the history of our own legal system is any indication, it's almost impossible to figure out the logic by which their decisions are made. While it helps to know whom the jury members are (most are usually prominent film folks), you should definitely avoid pandering to the jury directly. Any ass-kissing will most certainly come off as insincere. However, it doesn't hurt to get to know them during one of the festival's many social events, so try to get in some face time with the jurors. Sure, you want to make a good

impression—just don't make it so obvious that you're trying to make a good impression. Got it?

TAXES

Should you be lucky enough to actually win a cash award, you'll have to report that income on your taxes and Uncle Sam is going to want a piece. You'll pay almost a third in taxes, so if you win $10,000, it's actually more like winning just under $7,000. So don't buy the entire bar a round of drinks or rush out and spend it all. Check with your accountant regarding the best way to report this unexpected cash windfall. And if you win something like a $5,000 camera, be mindful that while you may get the equipment for free, you'll still have to pay taxes on it.

JUST TAO IT

The best mental mind-set to enter when you are actually up for an award is to avoid thinking about it. Taking the "Tao" approach to the whole experience is perhaps the best way to go. The worst thing is going into an awards ceremony with an expectation. If you win, great; if not, there's always another festival. (I'm not going to explain Tao here; you can look it up. Or better yet, watch that movie with Donal Logue called *The Tao of Steve* and you'll know what I'm talking about.)

GIVE THANKS

Most important, don't forget to express your gratitude when accepting the award at the festival, and afterward send notes in writing to the festival folks and/or the sponsor who put up the money for the award. The good will you spread to one festival will be felt by others and only aid you in your festival journey.

FESTIVALS FOR SHORTS

I love short films. Nothing is more enjoyable than discovering something less than ten minutes long that makes me think about it long after the lights have come up. Too often, filmmakers are so eager to jump into the game, placing themselves on some kind of insane personal timeline—like, "I must make my feature by the age of thirty"—that they ignore the benefits to be gained by traveling the festival circuit with a short. There are just too many rewards to name, chief among them being that there are really no expectations. If you can prove that you can tell a compelling story and maintain the audience's interest for the total running time, you can certainly do the same in a longer format. Before you endeavor to make your feature debut, you should absolutely tour with a short. Not only will you learn about the festival circuit as a whole, but also you will see your film in front of an audience, which is the best way to educate yourself about making movies. And the more opportunities you have to see your film through the eyes of the audience, the more much-needed insight you'll gain.

Unfortunately, filmmakers specializing in shorts are not always treated with respect on the festival circuit, being last in line for benefits like travel, lodging, or freebies. If you're on the festival circuit with a short, you just have to take what you can get. However, you will gain valuable knowledge for the next project, and you may find rewards in the most unlikely places.

SHORT FILM, SHORT CREDIT SEQUENCE

Nothing is worse than watching a short film with an interminably long beginning or end credit sequence that thanks everyone in the cast and crew, and the filmmaker's parents. Do two versions of your short. First, do one you send to festivals with a very brief (five to fifteen seconds maximum) end credit sequence including only the major people who actually worked on the film. Then, do another version with an end credit sequence that goes on as long as you'd like—send this one to family, friends, and the crew. Include all the thank-yous you want. Let the credits take five minutes or more to roll! Go wild!

It's important to apply to the Palm Springs International Short Film Festival, which *only* plays short films. The shorts screened at Palm Springs are broken down by genre, so there are various programs of children's shorts, experimental shorts, dramatic shorts, animated shorts, fantasy shorts, and so on. Also, Palm Springs attracts festival programmers from all over the world seeking shorts, so there is no better place for exposure. To make it convenient for those seeking films, the organizers at Palm Springs provide a library of videos, so that if they miss a screening, a short may be seen on video. In addition to the above-mentioned benefits, you will be surrounded by other short film filmmakers, which usually results in great conversation and opportunities to meet a lot of new friends whom you will see at other fests. Your fellow short pals will impart all their knowledge of their festival journeys and filmmaking experiences. I cannot say enough good things about Palm Springs—for those making short films, this is *their* Sundance.

In addition to targeting the top tier, submit to festivals where short-film winners qualify to be nominated for an Academy Award. The most updated list of accredited festivals is available at Oscars.org. Be sure to submit carefully to the festivals on this list, as some are genre specific and the list is long, making it cost prohibitive to apply to all of them.

SHORT FILMS AWARDS FESTIVALS LIST

For convenience and to get you started, I've included the list of festivals accredited by the Academy. This is the most current list available for this edition's publication, but this may change without notice, so check Oscars.org for the most up-to-date list of festivals.

AFI Fest (Los Angeles, California)

Grand Jury Prize—Short Film Award

www.afi.com/onscreen/AFIFest

Academia de las Artes y Ciencias Cinematograficas de España (Spain)

Goya Award for Best Short Live Action

Goya Award for Best Short Animation

www.academiadecine.com

Académie des Arts et Techniques Du Cinéma (César) (France)

Best Short Film

www.lescesarducinema.com

Academy of Canadian Cinema & Television (Genie)

Best Live Action Short Drama

Best Animated Short

www.academy.ca

Academy of Motion Picture Arts and Sciences (Student Academy Awards) (USA)

Gold Medal—Alternative

Gold Medal—Animation

Gold Medal—Narrative

Honorary Foreign Film Student Award

www.oscars.org

Ann Arbor Film Festival (Ann Arbor, Michigan)

Best of the Festival

www.aafilmfest.org

Annecy Festival International du Cinema d'Animation (France)

Le Cristal d'Annecy

Special Jury Award

www.annecy.org

Aspen Shortsfest (Aspen, Colorado)

Animated Eye Award

Best Comedy

Best Drama

Best Short Short

www.aspenfilm.org

Athens International Film Festival (Athens, Ohio)

Best Narrative

Best Animation

Best Experimental

www.athensfest.org

Atlanta Film Festival (Atlanta, Georgia)

Grand Jury Prize

Best Animated Short

Best Narrative Short

www.atlantafilmfestival.com

Austin Film Festival (Austin, Texas)

Narrative Short Jury Award

Animated Short Jury Award

Narrative Student Short Jury Award

www.austinfilmfestival.com

Berlin International Film Festival (Germany)

Golden Bear—International Shorts Competition

www.berlinale.de

Bermuda International Film Festival (Bermuda)

Bermuda Shorts Award Winner

www.biff.bm

Bilbao International Festival of Documentary & Short Films (Spain)

Grand Prize of the Bilbao Festival

Golden Mikeldi for Animation

Golden Mikeldi for Fiction

www.zinebi.com

British Academy of Film and Television Arts (BAFTA) Awards (UK)

Best Short Film

Best Short Animation Film

www.bafta.org

Canadian Film Centre's Worldwide Short Film Festival (Canada)

Best Live Action Short Film

Best Animated Short Film

www.worldwideshortfilmfest.com

Cannes Festival International du Film (France)

Palme d'Or (Short Films)

www.festival-cannes.fr

Cartagena International Film Festival (Colombia)

Best Short Animation—Golden Catalina Indian

Best Short Narrative—Golden Catalina Indian

www.festicinecartagena.org

Chicago International Children's Film Festival (Chicago, Illinois)

Adult Jury First Place Live-Action Short Film or Video

Adult Jury First Place Animated Short Film or Video

www.cicff.org

Chicago International Film Festival (Chicago, Illinois)

Golden Hugo for Best Short Film

www.chicagofilmfestival.org

Cinanima International Animation Film Festival (Portugal)

Grand Prize

www.cinanima.pt

Cinequest Film Festival (San Jose, California)

Best Short Narrative

Best Animated Short

www.cinequest.org

Clermont-Ferrand International Short Film Festival (France)

International Grand Prix

National Grand Prix

www.clermont-filmfest.com

David Di Donatello Award (Accademia del Cinema Italiano) (Italy)

Best Short Film

www.daviddidonatello.it

European Film Awards

European Short Film—Prix UIP

www.europeanfilmacademy.org

Festival de Cine de Huesca (Spain)

International Short Films Contest—Gold Danzante Award

Iberoamerican Short Films Contest—Gold Danzante Award

www.huesca-filmfestival.com

Flickerfestinternational Short Films Festival (Australia)

The Coopers Award for Best Film

The Yoram Gross Award for Best Animation

www.flickerfest.com.au

Florida Film Festival (Maitland, Florida)

Grand Jury Award Best Narrative Short

www.floridafilmfestival.com

Foyle Film Festival (Ireland)

Best Irish Short

Best International Short

Best Animation

www.foylefilmfestival.org

Gijon International Film Festival for Young People (Spain)

Premio Principado De Asturios Al Mejor Cortometraje (Best Short Film)

www.gijonfilmfestival.com

Hamptons International Film Festival (Long Island, New York)

Golden Starfish Best Short Film Award

www.hamptonsfilmfest.org

Hiroshima International Animation Festival (Japan)

Grand Prize

www.urban.ne.jp/home/hiroanim/

Krakow Film Festival (Poland)

The Grand Prix—The Golden Dragon

www.kff.com.pl

Locarno International Film Festival (Switzerland)

Golden Leopard—Live Action Short

Golden Leopard—Animation Short

www.pardo.ch

Los Angeles Film Festival (Los Angeles, California)

Best Animated Short Film

Best Narrative Short Film

www.lafilmfest.com

Los Angeles International Short Film Festival (Los Angeles, California)

Best of the Fest

Best Foreign Film

Best Drama Film

Best Comedy Film

Best Animation Film

Best Experimental Film

www.lashortsfest.com

Los Angeles Latino International Film Festival (Los Angeles, California)

Best Short

www.latinofilm.org

Melbourne International Film Festival (Australia)

The City of Melbourne Grand Prix, Best Short Film

Best Fiction Short Film

Best Animated Short Film

Best Experimental Short Film

www.melbournefilmfestival.com.au

Montreal's Festival Nouveau Cinema (Canada)

Best Short Film

www.nouveaucinema.ca

Montreal World Film Festival (Canada)

1st Prize—Short Film

www.nouveaucinema.ca

Morelia International Film Festival (Mexico)

Best Animated Short Film

Best Fiction Short Film

www.moreliafilmfest.com

Nashville Film Festival (Nashville, Tennessee)

Best Animation

Best Short Narrative

www.nashvillefilmfestival.org

Oberhausen International Short Film Festival (Germany)

Grand Prize of the City of Oberhausen

www.kurzfilmtage.de

Ottawa International Animation Festival (Canada)

Grand Prize to the Best Independent Short

www.awn.com/ottawa

Palm Springs International Festival of Short Films (Palm Springs, California)

Best Animation

Best Live Action (15 minutes and under)

Best Live Action (over 15 minutes)

Best of the Festival Award (may be awarded to any genre)

www.psfilmfest.org/festival/index.aspx?FID=26

Rhode Island International Film Festival (Providence, Rhode Island)

Best Short

www.film-festival.org

Rio de Janeiro International Short Film Festival (Brazil)

Grand Prix—International Competition

Grand Prix—National Competition

www.curtacinema.com.br

St. Louis International Film Festival (St. Louis, Missouri)

Best of the Festival

Best Live Action Short Film

Best Animation Short Film

www.cinemastlouis.org

San Francisco International Film Festival (San Francisco, California)

Golden Gate Award Narrative Short

Golden Gate Award Animated Short

www.sffs.org

Santa Barbara International Film Festival (Santa Barbara, California)

Bruce C. Corwin Award—Best Live Action Short Film

Bruce C. Corwin Award—Best Animation

www.sbfilmfestival.org

Shortshorts Film Festival (Santa Monica, California)

Best of Festival Award

www.shortshorts.org

Siggraph (Los Angeles, California)

Best Animated Short Film

www.siggraph.org

Slamdance Film Festival (Park City, Utah)

Grand Jury Prize for Best Narrative Short

Grand Jury Prize for Best Animated Short

www.slamdance.com

Stuttgart International Animation Festival (Germany)

 Grand Prix International Competition

 Best Animated Children's Film

 Best Student Film

 www.itfs.de

Sundance Film Festival (Park City, Utah)

 Jury Prize in Short Filmmaking

 International Jury Prize in Short Filmmaking

 festival.sundance.org

Sydney Film Festival (Australia)

 Dendy Awards for Australian Films—Fiction

 The Yoram Gross Animation Award

 www.sydneyfilmfestival.org

Tampere International Short Film Festival (Finland)

 Grand Prix—International Competition

 National Main Prize (under 30 minutes)

 www.tamperefilmfestival.fi

Torino Film Festival (Torino, Italy)

 Short Film Competition—Best Film

 www.torinofilmfest.org

Uppsala International Short Film Festival (Uppsala, Sweden)

 Grand Prix

 Best Children's Film

 www.shortfilmfestival.com

USA Film Festival—National Short Film & Video Competition (Dallas, Texas)

 Fiction First Place

 Animation First Place

 www.usafilmfestival.com

Venice International Film Festival (Italy)

 Corto Cortissimo Lion—Best Short Film

 www.labiennale.org/en/cinema

Zagreb World Festival of Animated Films (Croatia)

 Grand Prix—Best Short Film at Festival

 www.animafest.hr

FESTIVALS FOR DOCUMENTARIES

What I love most about documentary filmmakers is that some of the best ones never started out as filmmakers at all. They only became filmmakers when making a movie became the best way to communicate their story to an audience. Sometimes that story ends up becoming a cause, as is the case in Michael Moore's work, but for the most part, docs are just more entertaining than ever.

Filmmakers always appreciate a gift basket. Sometimes you leave a festival and that's all you get.

In the entertainment world as a whole, documentaries have enjoyed a kind of renaissance. Technology has made it possible to make an ambitious documentary for a reasonable budget. In fact, entire home production studios often cost less than the travel and other expenses, resulting in more documentaries being produced now than at any other time in history. Now that doesn't mean they are all good, but on the festival circuit, where the cream often rises to the top, documentaries are often the best films.

In addition to submitting to the top-tier festivals, documentary filmmakers should consider this list of prominent doc film festivals as a good place to start—of course, supplemented by your own online research. Be sure to explore these thoroughly, as each of these fests has a unique focus and requirements.

FILM FESTIVALS/MARKETS EXCLUSIVELY
SCREENING DOCUMENTARIES

Academia Film Olomouc
Amnesty International Film Festival
docfest
Doclands

DocSide Film Festival

DoubleTake Documentary Film Festival

Doxa Documentary Film and Video Festival

Encounters South African International Documentary Film Festival

Fairfax Documentary Film Festival

Festival dei Popoli

Hot Docs Canadian International Documentary Festival

The Hot Springs Documentary Film Festival

International Documentary Film Festival, Amsterdam

International Documentary Film Festival (DOCtober)

Margaret Mead Film & Video Festival

The Museum of Television & Radio's Television Documentary Festival

One World International Human Rights Film Festival

Samos Mediterranean Documentary Film Festival

Sheffield International Documentary Festival

SILVERDOCS AFI/Discovery Channel Documentary Festival

Sunny Side of the Doc

Thessaloniki Documentary Festival

United Nations Association Film Festival

Yamagata International Documentary Film Festival

In addition, check the website of the IDA (International Documentary Association, www.documentary.org) for more information about how to apply for grants and obtain specific tools for documentarians. At the very least, by visiting a documentary festival, you'll gain the opportunity to socialize with like-minded filmmakers talking about the business and the craft.

FESTIVALS FOR NARRATIVE FEATURES

They are the darlings of the festival world and almost always the movies that open and close the festival. Narrative feature films get the bulk of the hype, generate the longest lines from eager audiences, and are the most sought after by distributors, resulting in the most

lucrative deals. They are also the most difficult and expensive films to pull off successfully, often resulting in a journey taking an average of seven years from concept to completion.

In addition to applying to the top-tier festivals, again, it's very important to take a look at where your film may fit within a festival that champions a particular genre. To help you along the way, I've separated my top ten lists based on those best for narrative features for the United States and then for the world.

TOP FILM FESTIVALS FOR AMERICAN INDEPENDENTS (U.S. ONLY)

1. Sundance
2. SXSW
3. AFI Fest (LA)
4. Los Angeles
5. Tribeca
6. Telluride
7. San Francisco International
8. Seattle International
9. Denver International
10. Cinequest

TOP FILM FESTIVALS WORLDWIDE (NOT INCLUDING U.S.)

1. Toronto
2. Cannes
3. Berlin
4. Rotterdam
5. Oldenburg
6. Durban
7. London
8. Melbourne
9. Vancouver
10. Tokyo

STAYING ALIVE: TIPS FOR THE FILM FESTIVAL TRAVELER

While a tour book about your festival destination will contain the best regional information, I've learned some tried-and-true tips along the way that will enhance your travel experience. Sometimes, I've learned the hard way.

- **RESERVATIONS**. For hotel, car, plane, the works. You cannot overdo it when it comes to reservations—and that includes dinner reservations. Be sure to check the restrictions, which means cover your butt and make sure to find out if there are penalties for late cancellations. Remember, the further in advance you make the reservations for flights, the more money you will save. Flights fill up fast, so reserve your ticket early. Do not wait until the last minute. Making advance dinner reservations is key as well; you don't want to wait more than hour for a table. Robert Redford's restaurant, Zoom, is always booked up months before Sundance. Also, sign up for every frequent-flyer plan in existence. You'll be surprised how quickly those points and free trips add up. And also be sure to check on restrictions for flying standby. Some airlines will tell you over the phone that you must pay $75 or more to change your return flight. If you just show up to the airport and wait on standby, you can often bypass this flight-change fee altogether. It depends on the type of ticket you purchase, so be sure to check.

STUDENTS CAN GET TO CANNES CHEAP
There is a student volunteer program through the American Pavilion that allows students to work at the pavilion at Cannes while staying at dorm facilities during the fest. The American Pavilion is *the* hangout for anyone traveling from the United States and will give you amazing access to filmmakers and celebs attending Cannes. Plus, as a volunteer you'll have easy access to scam tickets and get party passes from attendees. Get details at: www.ampav.com.

- **PLANNING.** Get the festival schedule in advance from the festival website and make a plan. Don't be afraid to modify the plan as you go; you can always pawn off a few tickets to a movie you discover you want to avoid. I type up a schedule before I leave so I know what films I'm seeing when, what parties I'm going to (or crashing), and whom I'm meeting with and when. I never follow my plan exactly, but it helps me to start with some kind of structure before I begin to deviate from it by crashing parties.

- **ADDRESS BOOK.** On my schedule, I also print a mini address book. Essentially, this is just a collection of local phone numbers and the cell phone numbers of pals I plan to meet. This is all printed in very tiny type, and I make multiple copies so I never lose it. The info is printed small enough so it fits right in my wallet. (Is it just me, or am I sounding like a compulsive geek?)

- **BACKPACK.** You have to have one. It's the guy's version of a purse and totally essential to navigating a festival. Or a man purse. Which are very fashionable, I might add. I'm prepared for anything with my pack in tow. Mine always contains the all-important address book, festival schedule, lip balm, water bottle, cell phone, pens, flyers, a folder of party invitations, something to read, energy bar (emergency meal), camera, map, tape recorder, notepad, batteries, breath mints, business cards, matches, headache pills, eyedrops, eyeglass cleaner, tissues, comb, sunglasses, mini flashlight, and a hat. (The hat is used for early morning screenings. When bed head is at its worst, a hat can be a lifesaver.)

- **VITAMINS AND WATER.** Film festivals can get exhausting very quickly. Plan on sleeping less and drinking probably more alcohol than normal and know that you'll be surrounded by cigarette smoke at every party. During Sundance, I get about four hours of sleep a night. I make it a point to drink lots of water and take extra vitamins. (I'm partial to vitamins in the B category myself.) I also keep a bottle of pills with a mix of capsules that includes Tylenol, aspirin, Pepto-Bismol pills, sinus headache medicine,

migraine headache medicine, Tums, and plenty of other remedies all crammed into one bottle. Sometimes my friends think I'm nuts—until I whip out this pill bottle and cure them of what ails them.

- **CLOTHES.** Obviously you should be prepared to bring clothes that match the climate for the festival. Wear mainly casual clothes, but it's also important to bring at least one dressy outfit so you're ready for a meet-and-greet event at which you have to impress. Also, keep in mind that clothes make the filmmaker. Be unique. If you want to stand out from all the other filmmakers wearing the artist's favorite uniform—you know, black—choose something really outrageous to wear. A bright hat, a loud jacket, or a bold pair of shoes is not a bad idea. When members of the audience run into you during the festival, your unique "look" will be remembered. Clothes are about image building, so have fun with it.

- **LEARN A FOREIGN LANGUAGE FAST.** When you're traveling to a foreign country, it's extremely helpful to get one of those quickie learn-a-language courses on tape. While learning the language is crucial, be sure to pay as close attention to local customs, which can be even more important than words. Reciting phrases over and over again is great for getting pronunciations correct, but you might want to try my own personal favorite way to learn another language—by watching movies. Many

> **FOR TRAVELERS: STUDY THE PROGRAM GUIDE**
>
> Be sure to research the films you are about to see. If you depend on the cryptic descriptions in some official program guides (which are often confusing and sometimes have little to do with the actual film) you may end up seeing some really bad movies. Look for buzzwords like "earnest," which can often translate into "boring." Also, be sure to find out which films are opening later in the year or will be playing on HBO or PBS next month. You can skip these films and see them when they are out in commercial release or on television. I always try to catch features or documentaries without distribution since they may not be in theaters or on TV for years to come. And when I say "research," I mean talk to your fellow festival-goers on the street. You'd be surprised what you learn by listening to the "buzz."

movie geeks like myself have the dialogue for certain films memorized from beginning to end. Purchase a DVD with foreign language tracks, a foreign language version of your favorite video, or a DVD with closed captioning, or even watch television with the SAP mode turned on. By watching your favorite flick in another language over and over, you'll know that "Que la Fuerza te acompane" means, "May the Force be with you" in Spanish. You'll be quoting popular movie lines to all your new international pals in no time! And after all, movies are the international language.

• **SEE THE WORLD.** While you're traveling, don't forget to take at least a day away from the festival to see the local sights. You may never be back to this part of the country or the world. It's also refreshing to take a break from the fest and get away from people constantly talking about movies. But only for one day!

> **FOR TRAVELERS:**
> **MAKE A PLAN B**
> Each morning make a list of films to see and an alternate list in case those screenings are sold out. And leave time between screenings for one decent meal, which is all you'll have time for.

Use basic common sense when traveling. Don't hesitate to ask a festival staffer or a local for advice or help when lost. You'll almost always find them ready to give you the information you need.

HOW TO HANDLE SUCCESS OR FAILURE

As you go through the process of forming your strategy, remember that the festival tour is a marathon, not a race . . . well, if marathons had movies, goodie bags, and an open bar. Your festival tour may begin with one stop at a major festival where the film is then sold to a distributor, leading to a profitable sale and a theatrical release. But that is not likely. For most, the journey is a longer one. It may last as long as two years on the festival circuit as you screen all over the world, ending with a release on DVD and cable. No one filmmaker's journey is the same, so prepare for a long ride either way. There is no

such thing as an overnight success in this business. Any "overnight" success you may have read about in the entertainment media is really just an untold story of years of preparation, planning, and hard work paying off. If you are disciplined and patient, success in some form will find its way to you. Even if you only end up with the knowledge that you failed in your intended goals, you will have the advantage of taking those lessons into the next project. That knowledge, in itself, is an asset.

In many ways, your *second* film is almost more important than your first. It's when you discover whether you learned from the mistakes you made the first time around. Your second film is your opportunity to apply those lessons, hopefully with a better result or greater success. It helps to realize that you cannot control success or failure, only how you react to it. I'm going to make you read that again, because I feel this statement is so important:

You cannot control success or failure, only how you react to it.

So to maintain a positive attitude, you must manage your expectations. I've observed filmmakers who had tremendous success their first time out, who then went on to do absolutely nothing. They never even made another film. I've also seen filmmakers who failed their first time out and who also, not surprisingly, never made a film again. Conversely, I've seen filmmakers fail miserably their first time—they made a bad film and never succeeded in getting into a festival and their film sits on a shelf— and then seen that very same failed filmmaker deliver a *second* movie that was absolutely brilliant. And that film went on to enjoy accolades and become a huge hit. Anything is possible. Having a strategy and a solid plan guarantees nothing—it can only help increase your chances when you have already made a fantastic film.

NEXT!
Have your next movie, a "go to" project, ready. It can be a script or idea you're working on, or another piece of material you'd like to adapt, or you could option another script—it doesn't matter, just have something. Don't have five projects, just one more that you really feel passionate about. Passion is the key. Someone may find fault with your film, but if you exude passion for it, others will want to be a part of it. Act as if your life depended on getting this next film made. (A lot of times, it does.)

STAYING ON TOP OF IT ALL

No matter what kind of film you have made, your list of the things you need to accomplish will generally be the same, but tackling them all will be challenging. The following checklist is a complete rundown of the tasks you need to perform and/or plan while you wait to receive your first acceptance letter. Previous sections of this book have addressed how to create all the necessary materials—now you must carefully prioritize these tasks. Do not hesitate to delegate projects to others involved in the production of the film. It is important, however, that people most qualified to see those tasks through to completion by a deadline do those jobs. And there's never enough time to do it all, so I suggest taking this list and breaking down the larger responsibilities into smaller goals.

It's extremely helpful to work on some of these tasks during production—e.g., taking photos for marketing and shooting video that might be used for the EPK and as extras for a DVD or digital download release. The same kind of project management that went into the monumental work involved with making the film should be applied here. And if you can't do it all, don't worry. Hardly any filmmaker or team of filmmakers has the time to complete everything on the list, but since a festival tour can be as long as two years, you can continue to work and check them off as you go. In addition, after screening a few times, you'll see what works and what doesn't so that you can rethink marketing materials or even how you describe the movie to potential festival-goers.

Now get to work.

THE ULTIMATE FILM FESTIVAL "TO DO" LIST

1. Submit to Film Festivals

The key here is to have a focused plan of attack when submitting rather than to submit blindly.

- ☐ Do not allow deadlines to affect the quality of your film.
- ☐ Budget for marketing, travel, and your festival debut.
- ☐ Research festivals thoroughly.
- ☐ Schedule your best- and worst-case scenario festival tour up to two years, including deadline for submission and festival dates.
- ☐ Plan A: Submit to top-tier film festivals for distribution.
- ☐ Plan B: Submit to other film festivals friendly to your film's genre or for fun.
- ☐ Plan C: If rejected, consider self-distribution and research options.
- ☐ Follow up with festival staff.
- ☐ Build website and promote online.
- ☐ Persuade local media to write a story.
- ☐ Map out your tour on an actual map. While not absolutely necessary, it looks really cool.
- ☐ Build awareness through all of your efforts above.

2. Build the Team

Get the best team members possible with a combination of the following:

- ☐ Publicist
- ☐ Lawyer
- ☐ Agent
- ☐ Producer's rep

- ☐ Manager
- ☐ Consultant
- ☐ Advocates (a built-in fan base related to the cast or genre, who make excellent volunteers in the future)
- ☐ Friends (for support and for assistance)

3. Create Marketing Materials

Put together a unified and clever campaign with a unique message that clearly demonstrates how the film might be sold to an audience.

- ☐ Take production stills during shooting.
- ☐ Take headshots of key cast and crew.
- ☐ Schedule photo shoot during production, for pictures that might be used on the poster, DVD sleeve, and, potentially, for magazine covers and press.
- ☐ Stickers with movie logo
- ☐ Press kit (with B&W, color, and digital photos)
- ☐ Poster
- ☐ Flyers
- ☐ Postcards
- ☐ Promo item(s)
- ☐ Website (with e-mail newsletter to promote film)
- ☐ Create a "Press Only" area of your website for photos and press materials.
- ☐ EPK (electronic press kit) on Beta SP (for TV)
- ☐ EPK on CD-ROM/DVD
- ☐ Trailer (post it online but only when the time is right)
- ☐ Invitations/postcards to screening
- ☐ Sponsors—Seek a fit to sponsor a party for drinkables and/ or goodie bag swag.
- ☐ Plan a party or what one might look like.

4. Don't Forget

Be organized when it comes to the little details—it will only make your experience go smoothly.

- ☐ Book travel.
- ☐ Reward programs. Apply for every travel rewards program for airlines, hotels, and car rentals, and use credit cards that boost the points for these rewards.
- ☐ Restaurant reservations.
- ☐ Make a schedule of screenings, parties, events.
- ☐ List your goals and keep them in your wallet.

5. During the Festival

Most important, make valuable contacts and, if possible, lots of new friends. (And I mean real friends, not industry friends—there is a big difference.)

- ☐ Invite reviewers, distributors, and VIPs.
- ☐ If necessary, make screeners available only for key critics.
- ☐ Distribute postcards and posters at festival.
- ☐ Contact local media.
- ☐ Paper the town with your marketing materials.
- ☐ Give out promo items.
- ☐ Promote your screening.
- ☐ Get reviewed.
- ☐ Wear something that stands out.
- ☐ Throw a party.
- ☐ Attend parties.

6. Seeking Distribution

Secure distribution, and to that end, do not forget these important things:

- ☐ Make contacts with distributors.
- ☐ Set up post-festival screenings.
- ☐ Collect all press clippings and reviews.
- ☐ Explore attending other festivals.
- ☐ Have a next project.
- ☐ Send thank-you letters

SECTION 4:
FROM THE FRONT LINES OF FILMMAKING

"If you're not experiencing some level of failure, you're probably not taking enough chances. Independent film is all about taking risks . . . "

—JEREMY COON,
producer of *Napoleon Dynamite*

MEET THE FESTIVAL VETERANS

I have enlisted the aid of a diverse group of filmmakers to share their festival experiences along with their advice. Each filmmaker and his or her work act as a case study demonstrating the dos and don'ts and the hows and the whys of the world of festivals and independent filmmaking. All have reached the end of their festival journeys with one or more projects finding lucrative distribution deals, a moderate release on cable and DVD, or self-distribution—but you never would have guessed how they got to where they are now. By taking a truthful and sometimes painful look at the paths they chose, the group you are about to meet prove that a healthy dose of self-criticism allows filmmakers to grow as artists. What you are about to read seem less like interviews and more like confessionals—each person offering a detailed account of his or her triumphs and failures.

I carefully selected interview subjects who would avoid being diplomatic and offer useful information to filmmakers and festival-goers. These interviewees constitute the best and the brightest in independent film. Each person delivers the real deal—hard information, free of polite spin.

The filmmakers interviewed for the fourth edition of this book have created a wide range of films, including shorts, documentaries, and narrative features. The subject matter touches on everything from social issues, to the music of Kurt Cobain, to video game obsession, to a musical real estate comedy, to a zombie mockumentary, to a documentary exploring the effects of fast food, to the misadventures of a likable nerd in rural America. The movies are as diverse as each filmmaker. Each of these movies represents one of the numerous paths a filmmaker can take when seeking success through a film festival. Some of these paths include:

- Submit to Sundance, make it into Sundance, screen at Sundance, sell film for theatrical distribution.

- Get rejected from Sundance, play another festival like SXSW, where the movie is then discovered and sold.
- Get rejected from every top-tier festival, only to become a hit on the smaller film festival circuit.
- Get rejected from almost every festival, go home empty but filled with hard lessons.
- Get rejected from nearly every film festival on the planet, seek self-distribution as the final option.

There are certainly more roads than those mentioned and new ones that filmmakers will invent for themselves out of necessity. And whether you are making a short, a documentary, or a feature, you'll find something to be learned from every type of filmmaker. Look to them for their inspiration, entertainment, and enlightenment, but most of all, learn from their experiences.

MORGAN SPURLOCK
Documentary filmmaker

FILMS: *Where in the World Is Osama Bin Laden?, Super Size Me, 30 Days*
FESTIVAL EXPERIENCE: Screened films at Sundance, SXSW
AWARDS: Winner of Sundance's Best Director prize in Documentary Competition, Academy Award nomination for Best Documentary
DEAL: *Super Size Me* sold at Sundance for $1 million

"Know what you want to achieve, and picking the right fest for your film will be easy."

West Virginia native Morgan Spurlock did not exactly burst onto the scene, but looking in from the outside it just might seem that way. His documentary feature *Super Size Me* was the hit of Sundance 2004 and propelled him into the spotlight with his hilarious issue-based doc dealing with fast food's impact on obesity in America. The always-smiling

Spurlock is like Michael Moore without that chip on his shoulder. He's a filmmaker on a mission, and his debut feature secured his spot in independent film history. His success continues with the FX reality series *30 Days* and as a producer on projects such as *Chalk* and *What Would Jesus Buy?* His latest feature, *Where in the World Is Osama Bin Laden?*, premiered at Sundance, but what everyone wants to know is, where did he start?

Morgan Spurlock
(Photo: Ari Gerver)

So Morgan, where did you get your start?

I grew up in West Virginia. My parents rule— they were always encouraging and basically let me pursue whatever creative outlet I wanted. If it wasn't for them, I'd probably be handing out mints and towels in a bathroom somewhere.

When I graduated from high school in 1989, I went to USC to try to get into their film program. Because that's what you do, right? I was accepted into their Broadcast Journalism department and thought that once there it would be easy for me to get into the film school. Boy, was I wrong. I was rejected *five times*! I applied every semester . . . and got rejected every semester. The last time I also applied to NYU's Tisch School of the Arts and in their infinite wisdom they accepted me into the undergrad program. So, in the summer of 1991, I left L.A. bound for New York and the promise of a filmmaking future.

I graduated in 1993 and began working in the industry immediately. I did anything and everything. I shoveled shit on the set of *The Professional*, but I also got to shoot the last frame of film for the movie on the roof of the Essex Hotel with director Luc Besson. I got yelled at by pedestrians while holding traffic in Times Square on the set of *Bullets over Broadway*, but I also got to see and hear Woody Allen direct actors. I fetched coffee and fruit and danishes during the rehearsals for *Boys on the Side*.

While on the film *Kiss of Death* in 1994, I got a friend of mine a job working for Tracy Moore Marable (one of the coolest people on the planet) in the casting department. A few weeks later, they sent me to go

audition to be the national spokesman for Sony Electronics. I had no agent and I hadn't auditioned in years—not since my stand-up years at USC and NYU. What were they thinking? I ran downtown to drop off some film and on my way back to the office I ran in and auditioned. Two weeks later I found out that I got the job and was off traveling the country, far away from the schlepping and fetching.

Once on the road with Sony, I put my film degree to work by creating and shooting videos for them while also doing a lot of on-camera announcing for both them and their partners. Meanwhile, I kept directing and I kept writing. For Sony, Hasbro—any client that would pay me.

In 1999, my full-length play, *The Phoenix,* won the Audience Favorite Award at the New York International Fringe Festival; it then won the Route 66 National Playwright Competition. However, I also had the worst music video directing experience of my life that same year—and it was that spark that lit the fuse for me to start my own production company.

In 2000, The Con was formed, and our first show, *I Bet You Will,* blew up on the Web. It received more than 48 million unique visitors in eighteen months, and news stories were written about it worldwide. CBS optioned the idea—our worries were over. Then 9/11 happened and business in New York fell apart. I couldn't find any work, I was evicted from my apartment, and had to sleep on a hammock in my office. I maxed out all my credit cards to feed employees, pay rent, and pay other credit cards. CBS dropped the option. It was the worst of times. I was more than $300,000 in debt and the bottom seemed to be getting closer every day.

Then MTV called after seeing us on *Sally Jesse Raphael* and bought the show. It went on to become the first program ever to go from the Web to TV. In 2002, we produced fifty-three episodes for the network and when the show was cancelled in October of that year, I decided to take the small pile of money we made on the show and make our first feature. That was the foundation for *Super Size Me.* The film went on to win me the Best Director prize in Documentary Competition at the 2004 Sundance Film Festival.

What's my point in telling you all this? First, you can never dictate nor envision what ultimate path your career will take to get you to the "promised land." Also, even when I was doing the crappiest of jobs, I realized that it was merely a piece of the bigger whole and that it was

only on small step of a longer journey. I've known countless talents over the years who have given up on their dreams. Be true to you, stay the path, keep working, and you will reap the rewards.

What made you want to make a film exposing the dangers of fast food consumption?

When I first got the idea of *Super Size Me*, I had no conception of what it would blossom into. I thought it was a funny concept that would make a great movie, be socially relevant, and tell a cohesive story. That's it. For me, it wasn't until I got deeper into the subject matter that I hoped for a film that could [create] change.

How did you get into Sundance?

We had a test screening before we sent our first cut to Sundance to ensure we were on the right track. Probably one month before the deadline. We had a second screening right after that to see what folks thought of the cut we sent. The audience loved it, so we kept moving forward. I think a lot of people send things too early in a rush to "make Sundance." I believe you need to make the best movie you can first. If you can get it into Sundance, great, but if not, there are plenty of other great fests out there today.

Also, I was talking with a sales team early on in the process. My company was already repped by John Sloss's law firm, so it was only natural that we would also go with his sales company, Cinetic. There are plenty of reputable companies that can represent your film to buyers, and having them come on early to start the ball rolling, lobbying on behalf of your film, is also a huge plus.

Do your research, talk to other filmmakers, get the lay of the land. I spoke to countless "alumni" about their experiences and asked what, in their opinions, we should do to guarantee the best Sundance experience possible. Everyone had a different answer and everyone was quite helpful in opening my

Don't put all your eggs in the Sundance basket—there are countless fests around the world that may also be perfect for your film.

eyes to the path we needed to be on at the festival. If you're applying to the festival, first you should make sure the film you're sending in is a good representation of the final product. You don't need to send a finished film—we sent a rough cut, but at the time I would say the movie was about 85 percent there. Also, don't put all your eggs in the Sundance basket—there are countless fests around the world that may also be perfect for your film. We kept sending the movie out. For me, I just wanted to get the movie out there for people to see. Anywhere.

What other festivals did you apply to?

We applied to everything, probably forty festivals in all—all over the world. We were accepted into about half of all them. It's such a bittersweet position to be in when your film is well received, because while you want to show it everywhere, the reality is you shouldn't. You need to be very smart about the festivals you plan to attend, outlining exactly what your goals are in attending the festival. Each festival offers a variety of pluses, so do your research and find out what would be best for your goals and your movie.

There are festivals that are prestigious, fests that have markets and enable you to interact with global buyers, fests that are key outlets for up-and-coming filmmakers, and there are fests that are all about taking a vacation. Know what you want to achieve, and picking the right fest for your film will be easy.

How did you prepare for your first Sundance screening?

We finished our movie five days before it was to premiere at Sundance. So, needless to say, we were freaking out a little. Prior to going to Sundance, I also hired a publicist to rep the film. It will cost you anywhere from $5,000 to $8,000 and is definitely worth every penny. I went with Dave Magdael and his team at TC:DM and Associates. Beginning in December we started putting together our marketing plan. This is another essential tool for Sundance because this will service the most important question you need to ask yourself: What do I want to get out of Sundance? For me, I wanted to (a) sell my movie, (b) create vast awareness about

it and its subject matter, and (c) lay the foundation for future projects.

You have to realize that as much as your film is art—it's also a product. They key to every product is developing and building the brand.

Having a plan in place will help you put together a cohesive strategy. You have to realize that as much as your film is art—it's also a product. The key to every product being successful is developing and building the brand. It was my goal to make brand *Super Size Me* one of the most talked about at the festival. So, TC:DM and I discussed ways to get the word out. Luckily, we had hit upon a subject that most of America was passionate about. But that didn't mean our work was over.

Here were the pieces of the *Super Size Me* marketing puzzle and what each meant to me and the film.

- **BRANDING ONE: THE POSTER.** We made posters prior to the festival that reflected the subject and were engaging (see the "Fat Ronald" poster on page 157). This is a key piece of your marketing material.

- **BRANDING TWO: THE SWAG.** We also made *Super Size Me* skullcaps that we gave to key festival personnel— theater volunteers, parking attendants, etc. The more places your can get the name of your movie the better.

- **BRANDING THREE: THE TAKEAWAY.** We made postcards that we put in restaurants, the press office, bars—anywhere that they would let us. The Fat Ronald was a natural pick since that was our poster, but the "Fry Mouth" was an afterthought. I had done a session with photographer Julie Soefer—a brilliant New York City photographer who helped out on the film—to get some publicity photos for the film. This picture came out of that session and quickly became the poster-boy image for the movie. My advice to you is to have a photographer take publicity stills for your movie that reflect the film's theme. These will be staged and will deliver exactly the effect you want. It turned out to be a greatest visual tool.

- **BRANDING FOUR: THE PROMOTIONAL ITEM.** Create something else that gets the word out in an original way. We chose buttons since everyone in Park City loves to wear them—on their jackets, hats, lanyards, you name it. We made 1,500 Obesity buttons (designed and created by NYC artist Syntax)—everywhere you went, you saw someone rocking the button. It was great branding for the film, and it helped build the buzz around it.

- **BRANDING FIVE: THE GIFT BAG.** We wanted to take care of all the volunteers and media personnel who had taken care of us. This is such a great thing to do because these guys all bust their asses for nothing and are the biggest buzz generators when it comes to your movie. We made "Unhappy Meals"—printed paper bags that were filled with goodies that related to the movie and supported the *Super Size Me* brand. We made 250 Unhappy Meals, each containing a CD with the movie's theme song (which we burned and labeled ourselves), a postcard from the film, a skullcap, either a burger phone book or french fry coin purse, and a key chain. People loved these Unhappy Meals, and being one of the filmmaker who remembers these hardworking folks goes a long way.

- **BRANDING SIX: THE STREET TEAM.** Everyone who worked on *Super Size Me* worked for free. So, as soon as we were accepted into Sundance, I told them all that I would take them. Now I had to pay to get nineteen people to Park City! *Me and my big mouth!* Luckily, once your film gets accepted into the festival, you have something of tremendous value. I called some producer friends of mine, Heather Winters & J. R. Morley, and hit them up for an investment. They had invested in many film projects in the past, and I thought this was right up their alley. After seeing the movie, they were onboard. They would get their money back first after the sale plus a percentage on top of that as well as an executive producer credit—in return, I would be able to take the whole team to the festival. A fair trade any day of the week in my book.

Now, why is this so important? Because once you get to the festival, you realize how overwhelming it would be to have to do everything on your own. Not only did I have my whole production team there, but now I had nineteen volunteers whose sole job would be to help promote the movie.

I had a wardrobe supervisor friend of mine contact Ride Snowboards, who graciously donated jackets to outfit Team *Super Size Me*. You couldn't walk down Main Street without running into one of our team members. And they always had a pocket with postcards and another filled with buttons. Having all of them there definitely got the word out quicker and enabled us to accomplish more in less time.

- **BRANDING SEVEN: THE SUPER-SECRET SPECIAL SWAG.** I wanted to make something up that only a few very special people would get at the festival. I called a friend of mine in China and had him find a manufacturer who could make these Fat Ronald dolls.

We only made a hundred of them and they became one of the hottest "must have" items at the festival. The drawback: Since I had to have them sent overnight air from China to ensure they made it to the festival, I spent more on the shipping than I did on the dolls!

How did you go about hiring your publicist?

As soon as my sales team Cinetic was hired, I sat down with them and asked about publicists. They've been selling movies for years and know all the top publicists. Together we whittled the list to three we all believed would have the right sensibility for our movie. I then called them all personally. Your publicist has to be able to not only connect with you but also

Super Size Me poster art

your movie; you know after about two minutes whether you're talking to the right person.

We were all in agreement that Dave Magdael was the best choice, and we scheduled a face-to-face meeting immediately. Dave is a great contrast to my personality. He is a very calm person. For me, especially in the heated madness of Sundance, I was ecstatic to have someone behind me who never got frazzled or bent out of shape. He and his team were so focused and they definitely maximized the exposure of both our film and me as the filmmaker.

How did your first screening go?

I was so nervous before the first screening. We had just transferred our film to an HD master five days earlier, so when the audience watched the print for the first time, it was my first time as well. Talk about nerve-racking. For me, I just tried to relax as much as I could before I went to the theater. We rented a house with a hot tub, so I spent a good hour in the tub before we had to go to the premiere. That's a big thing at Sundance—you have to take care of yourself. At that point, the movie is out of your hands. There's nothing you can do but watch, hope, and pray. I learned to let go.

Were you prepared for the questions from the audience?

I had rehearsed the answers to possible questions over and over in my head and in the shower—you know, like when we all give our Academy Awards acceptance speeches in the shower. So I think I was pretty prepared. Someone always throws you a curve, but be confident and trust in yourself. No one knows your movie better than you.

What did you do to get acquisition executives into your screenings?

Luckily, I didn't have to do anything. By hiring a top-notch sales team, I had one less thing to worry about. They made the calls and got all the

biggest executives into the screening. Cinetic really made my life easy at the festival.

What was important for you in determining what distributor was right for the film?

The most important thing I wanted was final cut. I wanted to make sure that whoever distributed the film would not alter it in any way. For me, this was very important in a distributor.

Second, the company had to be as passionate about the film as I was. The company we ended up going with, a tag team release with Roadside Attractions and Samuel Goldwyn, was everything I wanted.

They were passionate, they were persistent, and they got the film completely. They were also the very first company to come forward and make an offer. Being first to the dance is something I put great value in because it shows they are thinking for themselves and not just following other companies or the press.

Did you target certain distributors before the screening, and if so, how?

Cinetic had a short list of thirty to forty distributors that they felt may be right for *Super Size Me*. Over the next five days after the first screening, we narrowed the field until we were only left with a select handful. The deal was negotiated by John Sloss and me. We got our first deals on the table at Sundance, but the negotiations for the theatrical release continued for a few weeks following the festival as we hammered it out.

What did you look for in the deal?

Decent money up front, better money on the back end, and creative control. I can't imagine what a nightmare this would have been had I not had an experienced sales team running the show. My advice is to get a sales agent. If your movie is good enough to get into Sundance, then it's definitely good enough to get a sales rep.

Can you be specific about the deal you eventually agreed upon?

The combined value of our TV cable and theatrical sales (just for the United States) was over $1 million. Not bad for a movie that only cost us $65,000 to get to Sundance. We also negotiated a generous back-end percentage on the theatrical and video revenue. Most important to me, we held on to worldwide rights. We hired a foreign sales company just after Sundance (Fortissimo—they are fantastic!) and then, with their guidance and expertise, we sold many foreign territories separately: Spain, Portugal, France, Italy, Japan, Canada, Mexico, the Netherlands, Israel, Australia, New Zealand, the United Kingdom, Scandinavia, Russia, Poland, Switzerland, Belgium . . . the end result was much more money than we ever would have seen had we sold all global rights as one package.

How did you handle the vast number of press requests after Sundance?

Samuel Goldwyn's PR guru, R. J. Millard, juggled the requests like a champion. He hired an additional New York company to support the East Coast requests and kept on Dave Magdael to handle all the West Coast action. Once again, the less stuff you have to worry about, the more time you have to focus on the movie—which is the *most* important element of the whole equation.

Morgan Spurlock

How were you expected to support the release of the film?

I traveled extensively to promote the film, both in the United States and abroad, to film festivals and to major media television outlets (like *Oprah* and the *Today Show*). Whatever it takes. The way I saw it, I'd already poured fourteen months of my life into this project—another year to really get the word out was the least I could do when it came to something as serious as the obesity epidemic in America.

What kind of impact do you feel the film had?

After Sundance, McDonald's announced that they were doing away with Super Size portions. Now, it doesn't take a rocket scientist to see that this is a direct preemptive step by the company to lessen the blow my film had when it opened—even though the company said that "it [had] nothing to do with that film whatsoever."

That was a tremendous accomplishment. Overwhelming, actually. When I heard the news, I jumped and screamed and yelled and ran around the office. The little guy had won, and Goliath was backpedaling.

So to all you filmmakers out there who think that what you say isn't important or who feel that what you do cannot make a difference . . . guess again. You work in the most influential and powerful medium in the world—your actions can move mountains and your images can inspire generations to come. Don't stop working. Persistence. Dedication. Time. And belief. These are the foundations of success, and these will help you change the world.

AJ SCHNACK
Documentary filmmaker

FILMS: *Convention, Kurt Cobain: About a Son, Gigantic*
FESTIVAL EXPERIENCE: Screened films at Sundance, SXSW, Toronto, and forty others
AWARDS: Independent Spirit Awards nomination
DEALS: Balcony Releasing, Cowboy Pictures

". . . once you've made some films, you begin to realize that there are all these people who have made their way without having Sundance shine its light upon them. So look down the line to the next festivals—SXSW, Berlin, Hot Docs, Rotterdam, SILVERDOCS, Los Angeles, etc."

AJ Schnack grew up in Edwardsville, Illinois, a small town just outside St. Louis. In grade school he knew he wanted to make movies, but there was no direct route from Edwardsville to working in film. He studied journalism at the University of Missouri, but, two weeks before graduation,

he moved to Los Angeles and got a job working in game shows for titans like Dick Clark and Merv Griffin. AJ then got involved in music videos, starting a production company with his partner, Shirley Moyers. They did more than a hundred projects over a five-year period. During that time, he made the feature-length documentary *Gigantic* about his friends Flansburgh and Linnell (the two Johns behind indie band They Might Be Giants).

AJ tells us about *Gigantic* and his critically acclaimed doc *Kurt Cobain: About a Son*, which premiered at the Toronto International Film Festival.

AJ Schnack

What led to the inspired approach you came up with for your doc Kurt Cobain: About a Son?

I'm really interested in photography and in visual storytelling in nonfiction filmmaking. Working with audio-only source material like Michael Azerrad's intimate interviews with Kurt allowed us to remove the iconography of Kurt (the grunge, the flannel, the early '90s video look) and place him in a context that reflected his presence as well as his absence.

How did your previous filmmaking experience help with making a music documentary?

The early music videos I was involved with were so run-and-gun. Sometimes it would just be two or three of us running around Copenhagen with 16mm cameras following a band through the streets. Having that experience and knowing that you had to move quickly

and be flexible was crucial to both the highly constructed shooting of *About a Son*, where we shot on 35mm but would go to as many as eight or nine locations a day.

You also began with a short film that played the festival circuit. How did that experience help you when you approached your first doc feature, Gigantic?

My first short film was probably rejected by a dozen festivals before it premiered at the Los Angeles Short Film Festival. It had been like nine months of rejections, so I think I had about given up by that point. But then we got into L.A., and the film went on to have a nice long festival run. So, I think that I started to learn that each film has its own specific festival life, and you can't get too wrapped up in getting into one particular festival. I actually think that we did some pretty smart things on *Gigantic*—reaching out to fans of They Might Be Giants, building an Internet presence, creating stuff we could sell (posters, special DVD surprise boxes filled with "random crap from the office")—that we probably could have done better on *About a Son*. But the movies were so different—they are like polar opposites—that it was hard to imagine doing the same level of fun marketing on *About a Son* that seemed so natural on *Gigantic*.

As a festival veteran, did you still have to go through the application process? Can't you just, you know, make a call and get in?

It's not quite that easy. I have good relationships with a lot of festival programmers, and I think it's fair to say that they are interested in seeing my new work, so it's not like I have to blindly submit my films anymore. But, not every film is right for every festival, and there are myriad reasons why different films do or don't get programmed. I can have pretty straightforward conversations

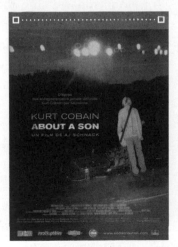

Kurt Cobain: About a Son poster art

with programmers about why a film of mine works or doesn't for a particular fest.

What really is the best way to get into Sundance?

Don't get insane about it.

I talk a lot about not getting wrapped up in a single festival, and let's be honest: The unnamed "single festival" is almost always Sundance. There are reasons why Sundance gets all the attention, not least because it's a name brand—even your Grandma has heard of Sundance—and because of all the stories of people finding fame and fortune there. But, once you've made some films you begin to realize that there are all these people who have made their way without having Sundance shine its light upon them. So make a great film and then look down the line to the next festivals—SXSW, Berlin, Hot Docs, Rotterdam, SILVERDOCS, Los Angeles, etc.

What other festivals did you apply to?

On *Gigantic* we turned in an insanely long cut to Sundance for the 2002 festival. It must have been three hours, and I can't imagine how embarrassing that cut must be. Then we kept working and turned in something far more sensible to SXSW, where Matt Dentler saw it and programmed it. After SXSW, we just applied everywhere, sometimes because festivals asked us to send them a cut, and had a great little run, playing at Seattle, CineVegas, St. Louis, and Denver, among others.

About a Son was very different. We submitted a pretty finished cut to Toronto, right at their deadline. Thom Powers, the documentary programmer there, saw it and called us pretty quickly to let us know that we were in. Then, because of the subject matter and because the film is such a nontraditional film about a rock star, we had a long, two-year-plus festival run, and in nearly every case, it's been the festival requesting the film. After that, I don't think we did very much in the way of submitting. It just became a film that was well known and well regarded on the festival circuit.

You've done your own publicity, but when does it make sense to hire a publicist?

For *Gigantic* we did our own publicity. Shirley would get in touch with the festival and ask for a press list and ask them to set up interviews. We were pretty brazen about it, but it worked to our benefit most of the time. The word would get out to They Might Be Giants fans and we'd have a good crowd. Then they'd go online and buy posters or sign up for the DVD.

For *About a Son*, we worked with David Magdael and his team when we premiered at Toronto. I don't think you can reasonably go to Toronto or Sundance without a good publicist who understands that landscape. It's just way too big, with too much going on—both for you as a filmmaker as well as for people who are writing about film. You need to have someone who can be your liaison.

What really creates hype for a film at a festival?

For years there were all these stories about how people would go to Sundance and do insane or creative things on Main Street to grab attention for their films. But I've been to Sundance a bunch of times as a viewer or as a film writer, and most of that stuff—and there's a lot of it—strikes me as just noise. I don't really remember any gimmicky thing that has stuck with me for longer than a day or so. And nothing has made me rush off to a screening. What makes me see a film is strong word-of-mouth. I'd recommend targeting (nicely and not in a badgering, hectoring way) a few film writers who you like and trying to get them to come to one of your first screenings at a festival. If they like your film and write about it quickly, that can build buzz faster than any flyer or funny costume.

What's that first public screening like?

On both of my first two films, I was extremely nervous and emotional for the first public screenings. It's hard work making a film, and usually your team is there to share the moment with you, so it can be overwhelming

to all be together to see your work screened for the first audience. I find a few drinks help.

How did you secure distribution for Gigantic?

Our sales rep was Jeff Dowd, and he really looked out for Shirley and me. There were so many things that we didn't know coming in to this new world, and he really protected us and guided us. We still had to do a lot of work, though, which I think some filmmakers think won't happen. Like, "the sales rep will take care of everything." Well, maybe that's true if you sell in a bidding war at Sundance, but for everyone else it takes a lot of work on your part.

For *Gigantic*, we had a harder time getting people to come to the screening at SXSW, because frankly it's harder to get distributors to come to screenings in Austin. It's not known as a marketplace in the same way that Park City is. So after SXSW was over we had a screening in New York City that some distributors, including Gary Hustwit from Plexifilm, came to. Gary wanted to acquire the film for DVD. Shirley and I really wanted Cowboy Pictures to distribute the film. And Cowboy and Plexi had just worked together on the documentary *I Am Trying to Break Your Heart*. So everything ended up coming together, and that became a great partnership.

How did that compare with About a Son?

We had vastly different experiences on *Gigantic* and *About a Son*, primarily because *About a Son* was premiering in Toronto and it was a film that a lot of distributors were interested in taking a look at. But because *About a Son* was not exactly what people thought they'd be getting from a rock documentary, we had a tough time with distributors.

On *About a Son*, we had a lot of people working. Jared Moshe, one of the producers at our partner company, closed a deal with a Japanese company right after we premiered. Our U.S. sales rep was Josh Braun, and he pulled together our DVD deal and our cable TV deal. I reached out to my friends Connie White and Greg Kendall at Balcony and we

worked out a deal with them to handle theatrical distribution. And our music supervisor, Linda Cohen, got us a great soundtrack deal with the Seattle indie label Barsuk Records. Meanwhile, we had a foreign sales agent who got us deals in the UK, France, Australia, Mexico, and a bunch of other countries. Even though that film was a difficult sell, it was hard to keep track of everything that was going on.

None of these deals were for a ton of money. A couple of the elements of *About a Son* were low six figures, which was great, but not anything that gave us as filmmakers a big return.

Once a film has distribution, how important is an aggressive festival tour for promoting a documentary?

For every film except those that were acquired soon after their premiere, their distribution comes after they played a number of festivals. At this point, you've probably played every A-list and even B-list festival that you're going to get into. Now you're starting to get invited to smaller, regional festivals where there may not be an art house. Playing that fest—even if you've never heard of it—could be your only opportunity to play in that area, which may get your film stocked in a local video store or purchased by ten people who went to see it. Plus there may be small screening fees that you can get from a festival. It may only be a few hundred dollars, but that can be helpful.

I've been surprised both with *Gigantic* and with *About a Son* as to how much work fell to me during the festival and theatrical runs. And a lot of times, people just expect that you'll work for free, because it's your film and you want to get it out there. Of course, you do want to get it seen, in the proper context and with the right DVD extras and marketing and trailer. But unless you've been acquired by someone with deep pockets, you have to stay on top of all of that—without much in the way of payment—if you care about that side of the process.

Are docs finally . . . hot?

Sometimes I feel that there's a built-in bias toward nonfiction filmmakers at festivals because more and more documentaries reach audiences

largely through their festival run. So, they tend to travel with their films longer and work harder to bring audiences out. I actually recently went to a festival in Europe that screened both nonfiction and narrative, and the festival paid for all the doc filmmakers to come but not for the narrative filmmakers.

What is the best way to handle the press or the occasional negative reviews?

Try not to get too upset about bad reviews. They're going to happen–that's just the nature of things. You've sent your art out into the world and now critics are going to comment. You can hope that each review, even the negative ones, would be thoughtful and constructive, but the reality is that a bad review may be mean-spirited or miss the point of your work entirely. The thing is to have restraint and not respond. I've seen a lot of filmmakers respond to critics over negative reviews, and it almost always makes the filmmaker look bad.

> I've seen a lot of filmmakers respond to critics over negative reviews, and it almost always makes the filmmaker look bad.

Other than that, be friendly. Be yourself. Be charming. Don't be a pain in the ass.

PAUL RACHMAN
Documentary filmmaker

FILMS: *American Hardcore, Four Dogs Playing Poker, Drive Baby Drive*
FESTIVAL EXPERIENCE: Screened films at Sundance, Palm Springs International, Avignon
DEALS: *American Hardcore* acquired by Sony Pictures Classics

"The best advice I can give is to make the best film possible, apply, and then forget about it. Go back to working on your film or just enjoying your life."

Paul Rachman's pursuit of filmmaking coincided with the music scene of the early 1980s. Heavily influenced by punk during his formative years, he went on to direct over one hundred music videos for Alice in Chains, the Replacements, Roger Waters, Pantera, and Kiss, among others. Paul then made *Drive Baby Drive*, a 35mm black-and-white thriller, which he also wrote and financed. The film was rejected by Sundance, so in 1994, Paul joined forces with Dan Mirvish, John Fitzgerald, Shane Kuhn, and Peter Baxter to organize the Slamdance Film Festival—Anarchy in Utah. This guerrilla

Paul Rachman

film festival was created as a protest to point out how commercial the Sundance Film Festival had become. In 1999, through the help of an agent, he was hired to direct his first feature film, *Four Dogs Playing Poker*, starring Forrest Whittaker, Balthazar Getty, and Tim Curry.

Paul talks about his festival experiences and how he got *American Hardcore* into Sundance.

What inspired you to make American Hardcore?

In 1999, after the difficult experience of making a feature film as a director for hire on *Four Dogs Playing Poker*, I moved back to New York City and really wanted to sink my teeth into something close, personal, and very independent. My friend Steve Blush, a rock journalist, had been telling me about his book of interviews with members of the hardcore scene that he started writing in 1995. I kept telling him of my idea of making it into a documentary film. He liked that idea and trusted me as a friend and member of the punk scene. This was in part the story of my life, too, particularly the values and ethics that came out of hardcore punk: Fuck the establishment, DIY, speak your mind, etc. They were also the same values that Slamdance adhered to early on.

The project was perfect for me at the time, and I really felt and understood the voice that this film could have. I also still had a lot of footage from back in the day that hadn't been seen yet.

169

Steven finished the book in 2000. I proceeded to put a proposal together to try and raise some money. I took it around to all the usual suspects in independent film, people I had come to know through my years in L.A. and in Park City during the film festivals. Everyone said no. I could not raise a single penny or get the slightest serious interest from anyone. I guess it didn't help that the cover of the book was an image of a kid with a bloodied face singing into a microphone. In that moment I said to myself, "Fuck the film business. I don't need them to make this movie, just like the bands in *American Hardcore* didn't need the music business to make and play their music." That attitude and mandate gave me the energy and confidence to start shooting *American Hardcore* on miniDV in December of 2001.

By 2003, we had a twenty-minute work-in-progress, which we took to IFP (Independent Feature Project) in New York, and again we were not able to raise a single fucking penny. But the unveiling at IFP created a buzz in the punk world, and we knew we had an audience. We continued shooting and editing, and at the same time I relied on my editing experience to earn a living and finance the film.

How did your previous filmmaking experience help with making a music documentary?

The most important aspects for the director of a documentary are to know your subject and have the people involved trust you. So besides my obvious experience as a music video and narrative filmmaker, and my ability to shoot and edit, the fact that all or most of the people in the *American Hardcore* movie knew me or knew who I was made them comfortable and very accessible. A lot of them had either slept on my floor back in the day when they played shows in Boston or I knew them from my travels with bands on the road. These were by no means easy people to deal with. Most of them still carried the hardcore punk ethic of keeping things to yourself. They still carried some anger toward the scene and the music establishment and how they'd been ripped off, and it was not easy to track some of these people down. You had to know where to look for them, how to look for them, and how to approach them. Once we got the

bigger players from the scene, such as Ian MacKaye from Minor Threat, Henry Rollins and Gregg Ginn from Black Flag, and HR from the Bad Brains, then that showed the others that this film was okay and things got easier.

What is the most common mistake filmmakers make with regard to documentaries?

I think the hardest thing with a documentary film is keeping focused on the subject and the story and letting the film take the time it needs to become that story. Obstacles sometimes present themselves, and the hardships they present might actually make for a better film, so don't avoid them.

What insights did you gain from having been on both ends of the spectrum—as a person involved with a festival and a filmmaker?

Dan Mirvish and I were always founders-at-large of the Slamdance Film Festival. In the first years of the festival, I was involved mostly with the programming of the films because I was still very busy directing music videos. Now that I have moved to New York City, my official title is co-founder/East Coast director, and along with East Coast manager Tom Soper, I organize New York screenings and events to keep the New York Slamdance alumni filmmakers in touch with each other. I have found that it is always easier to give good advice to others than to yourself. In the years of my continuing involvement with Slamdance, I have always kept focus on the filmmakers and their projects. You learn so much from going to Park City year after year and hearing about films in production that want to apply to Slamdance. I've gained the ability to see between the lines, in those shady areas between the difficulty a filmmaker faces completing a film, how programmers watch, react to, and choose a film, and how the industry might receive a film at its premiere. The lines between these areas are very blurry and constantly changing, and the best piece of advice I find myself giving is to never ever give up.

Besides filling out the application, writing the check, and mailing your video into Sundance, what else did you do to ensure your best chance for acceptance into the festival?

I was forever certain that I was blacklisted from Sundance because of my involvement with Slamdance. So in my case, with *American Hardcore*, all I did do was fill out the application, write a check, and send in my rough cut. I was completely prepared and expecting my rejection letter. I proceeded to figure out how I could screen the film at Slamdance as a special screening and bring some bands in.

After Thanksgiving in 2005 I went on a short vacation to the Dominican Republic with my fiancée (now my wife), Karin Hayes, who I met at Slamdance in 2003, where she won the Audience Award for her film *Missing Piece*, now titled *The Kidnapping of Ingrid Betancourt* and broadcast on HBO/Cinemax. On the last day of our trip I thought it might be a good idea to check the home answering machine for any emergencies. On the main drag of the dirt road beach town we went to a phone center just as it was closing, and there were two or three messages from Trevor Groth from Sundance telling me that they had accepted *American Hardcore* and that they were concerned that they hadn't heard back from me yet, that the press release was going out and they needed to know ASAP. I was totally thrown for a loop—everything in my normal life at that moment changed.

I called Trevor back and before accepting I asked him if he knew who I was with regard to Slamdance. I wanted to make sure I wouldn't be kicked out of Sundance the next day. At first he had no idea, then he put two and two together and realized it, but he assured me it did not matter because he loved the film and so did the other Sundance programmers. Before accepting I also asked for a Salt Lake City screening slot in addition to the Park City screenings because I felt it was important to bring the film down to the real punks in Salt Lake City. They agreed and I accepted.

Any advice to others on applying to Sundance?

The one thing I learned from *American Hardcore* is that the Sundance programmers choose films that they love and admire for a particular

reason at that moment. Contrary to the myth that you have to know someone or be part of a Sundance clique, they really do not program films based on who the director is or who the producer is and

> Make the best film possible, apply, and then forget about it. Go back to working on your film or just enjoying your life.

whatnot. If they like the film and it fits the program for that year, it will rise to the top and be selected. So the best advice I can give is to make the best film possible, apply, and then *forget about it*. Go back to working on your film or just enjoying your life. Today there are a lot of ways besides a Sundance premiere to get your film recognized.

What other festivals did you apply to?

Initially, the only other festivals we applied to beyond Sundance were Slamdance and SXSW because we knew they would also be great premieres for the film.

Were you concerned about appying to other festivals before you got word from Sundance?

No. We knew that the film would not be ready until January at the earliest. If we didn't get into Sundance or for that matter Slamdance—the rule we set for Slamdance years ago is that *everyone*, including staff and founders, have to go through the submission process—then we would probably have gone to Park City guerrilla-style and tried to have a screening somewhere and a kickass punk rock show with the bands from the movie. Luckily we didn't have to go that route, because it would have been difficult to pull off.

How did you prepare for your first Sundance screening?

The most important thing about our Sundance world premiere is that it was just that—a true world premiere. Nobody at all, other than our film sales reps, the Sundance programming team, and a handful of people who gave us notes during the rough cut stage, had seen the film. I fielded a lot of requests before the festival from distributors, agents, reps, and all

sorts of people for a DVD screener or a screening and I turned them all down. The film had generated a little bit of buzz, and I wanted to build on that buzz for the world premiere.

If you get into Sundance, or Slamdance for that matter, and you have a little bit of buzz and a film that distributors want to see, then that becomes your most powerful asset. As a filmmaker going to a major film festival attended by major distributors who are there to buy, you must 100 percent believe in your film and its position in that market. Guard your premiere—the premiere will only have the impact you seek if it is a true premiere for the distributors. Most distributors want to see films before the festival to really just start crossing films off their list. That information, especially if it's bad, sometimes travels within the industry—somehow word gets out through the network of acquisition executives and their assistants. The impact a film has when it's seen with an audience of two hundred or four hundred people in a theater is totally different than when someone watches a DVD on his computer while answering e-mails and taking phone calls. This can be a deciding factor in the commercial life of a film.

> Guard your premiere—the premiere will only have the impact you seek if it is a true premiere for the distributors.

What did you do to hype your film at Sundance?

At Sundance, you want the hype to at least appear as if it is coming from the fans and audiences and not just marketed directly from the filmmakers all the time.

It is very important to create a viable *story* for your film. That story is what is going to be communicated, repeated, and hyped by the film community. For *American Hardcore* the punk rock community was already buzzing about the film, but in reality that is a pretty insular and small community. We wanted *American Hardcore* to be more that just a DVD we would sell to punk rock fans. We had to find another way to "break" a more mainstream story about the film.

An incredible opportunity ended up presenting itself. A couple of days after the Sundance lineup was announced, Charles Lyons, a journalist friend of mine who regularly writes about independent film for *Variety*

and the *New York Times,* called me because he needed help editing a reel. We decided to meet for lunch so I could get his materials. Over that lunch I mentioned to him that *American Hardcore* got into Sundance. His eyes immediately lit up and he said that that was fantastic and that there was a story there because I was a Slamdance founder and was going to Sundance. He asked if he could pitch it to the *New York Times.* I agreed, and on December 20, 2005, there was an article on the front page of the *New York Times* Arts section that had a picture of me and the headline "Sundance or Slamdance? A Rebel Director Gets His Pick."

Within a couple of days that same story was picked up by AP, Reuters, and AFP and was basically reprinted in newspapers around the world. This was a month before the festival and was probably the most important thing that happened for the film in terms of setting it up. Phone calls kept coming from people who wanted to see the film, and there were more requests for interviews—all sorts of stuff started happening.

Not everybody has a journalist friend who happens to call for an unrelated favor and writes for the *New York Times,* but he saw a story there. Stories get picked up by wire services from newspapers all over the world, even small-town papers, so definitely try to think through these types of opportunities. Finding the story for your film—one that can be mainstream—is probably the best thing you can do to set up your film.

Did you hire a publicist?

No, we did not hire a publicist for Sundance. First of all, we couldn't really afford it, and best of all, the *New York Times* article put us on the radar of the global press community that would be reporting at Sundance. Until that article I was a little worried about the publicist issue. I really did not know any savvy Sundance-type publicists who knew anything about the underground history and the punk rock community that *American Hardcore* is about.

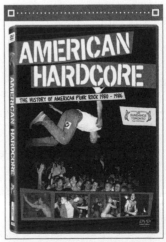

American Hardcore DVD box art.

I also knew that any music biz publicist who's never been to Sundance would not get us anything because they do not have the established connections needed to make things happen there. I think sometimes a publicist is only as good as the information you give them to work with. Some also tend to take on too many films, and the competition for press is very intense. I've seen and heard of many films and filmmakers who spent $5,000 to $10,000 on a publicist and end up with hardly any mentions. This was not the road I was willing to take.

So, then, how did you do your own publicity?

We asked Karin [Hayes] if she would be the publicist. She and her filmmaking partner, Victoria Bruce, had done their own publicity at Slamdance in 2003 and had done a good job. Karin was also very organized, thorough, and had been to Park City before. We created an e-mail address for her, made some business cards, and she started cold-calling. She called and e-mailed people on a film publicity list we had compiled from other filmmakers and friends, plus contacts she had from her film's publicity in 2003, and magazines, newspapers, and blogs that had anything to do with music and/or film. These included *Variety*, *Filmmaker* magazine, *Premiere* magazine, *Salt Lake City Tribune*, *Rolling Stone*, *Time*, *Newsweek*, *Indiewire*, Sundance Channel, IFC, MTV, CNN, and others. Many people were very receptive to the calls and e-mails because they had heard of the film and the "Sundance vs. Slamdance" story in the *New York Times* article. Karin had to figure out why they should be interested in the film beyond that article, and since we planned to bring the bands Circle Jerks and D.O.A. (both featured in the film) to Park City to perform, that became part of the pitch for a story. Also, we discovered that many people we contacted in the press had been connected to the hardcore era in some way—they had been fans, they had heard of the bands, etc. We scheduled some magazine interviews and made contact for other interviews to happen in Park City.

Once we got to Park City, we followed up and also received calls for interviews from press that we had not yet been in contact with. We worked like crazy the six weeks prior to Sundance, and once we got to Sundance we were running from place to place, but we got a lot of coverage.

Now let me get back to the film publicity list and also dealing with the Sundance press office. There's a constantly mutating list of journalists and press people with contact info that tends to get passed along and vetted within the independent film community. Most filmmakers who have been to Sundance or Slamdance and have relied on self-promotion have that list in some form. Getting a complete contact list for the press attending Sundance is the ideal, but it's often an impossible task. I think the Sundance press office may have stopped handing it out to filmmakers several years ago after complaints from the press corps. So, instead, we worked from a list from the previous festival year that was not too out-of-date.

If you are going to do your own publicity, it is very important to have the Sundance press office recognize you as capable and professional. Karin was our designated publicist, and she was the only contact person for the Sundance press office and the press. She was very professional and organized, is a great communicator, and is incredibly charming and likeable—she is also my wife! These are very important qualities if you want to generate results during these twelve mad days of the film festival. The Sundance press office can be helpful in putting interested press in touch with your publicist, but for the best results, don't rely on them for everything. It's up to you to generate your own press.

There is also a sponsorship office at Sundance, which is helpful in finding companies wanting to sponsor parties and films. We did get a few beverage sponsors and some recommendations of venues from them.

What would you have done differently in preparing for your film's debut?

More time to contact more media outlets would have been good, but I think we really did all we could. We premiered in a 250-seat theater at the Holiday Village Cinema, and the premiere screening had been sold out for weeks. Our sales reps, Diana Holtzberg and Jan Rofekamp of Films Transit International, got all the important distributors there, and the fact that nobody had seen the film made the premiere that much better.

Any advice you'd like to pass on to other filmmakers regarding the creation of hype?

The best advice I can give anyone about creating hype is do not limit yourself in any way. It is very, very hard work, and if you do not feel completely exhausted, then there is probably a lot more you can do. Posters, flyers, business cards, any other promo tool that goes with your film (it doesn't have to be expensive—creative is better)—always have them handy. Find the niche market and audience that relates to your film and tap into that to help you spread the word. Use all the power of the Internet and the networking communities, such as MySpace, Facebook, and Twitter, to reach out and create your audience. The word about your film can spread rapidly. Make a trailer, send out e-mails and notifications about the film. Reach your hometown or neighborhood through schools, clubs, and community centers—any type of communication about your film will spread. We got as many bands as possible in the film to mention us on their websites, Facebook, and MySpace pages. Also find the community in Salt Lake City and near Park City that relates to your film. Be sure to reach out to them before you head to Sundance to get them excited about your film and help support it with their attendance and word of mouth. Same thing for any other city where your film plays.

> Use all the power of the Internet and the network communities, such as Facebook, My Space, and Twitter, to reach out and create your audience.

Were you nervous at the screening, and if so, how did you deal with it?

It wasn't my first premiere, but of course I was very nervous. You have to be able to let go. The nerves really set in during the final hour before the screening. That is also very busy time. At Sundance there is usually some kind of media present at the premiere, so you are usually doing some interviews and dealing with people wanting tickets, which keeps your mind off the nerves, but underneath it all the nervousness is building. If you are doing your own publicity, or have friends with

you helping out, designate some people to make sure that all the distributors that need tickets get them and get into your film. The ticket situation was extremely hectic in the final twenty minutes before the film started, but Diana Holtzberg, Karin, and our friend Matt Scott helped out tremendously with this, and we were able to get everyone in. Once the film starts rolling, it is actually a big relief. You get the feeling that your are finally letting

Hardcore fans get tattooed with the name of the film.

go of something you have been preparing for for years, in the making of your film. It is the beginning of the life of the film as a film for audiences, and that feels great.

Did you feel you were treated differently as a doc filmmaker?

The Sundance staff treated us the same as they did the narrative filmmakers—there was no difference where that was concerned.

We came into the festival with enough buzz that we felt we were getting a fair amount of attention. That was due to all the work we had done before getting to Sundance. It is very important to work as hard as you can on things you want to happen for you at Sundance way before you get on a plane to Park City. *American Hardcore* was not in competition at Sundance—something people do not realize. We were in the midnight film section. I think that was a blessing for the film—it took the pressure off of worrying about whether we would win an award. Also, the midnight section is actually one of the most successful in terms of making sales. *The Blair Witch Project* and *Saw* are both films that premiered as midnight films. Also, our film was music related, so that automatically has a specific subsection of interest.

What did you learn from that first screening?

I learned that it is impossible to get every one of your friends into your world premiere. I had a lot of friends in Park City that I had made over

> When ticket sales for Sundance become available online, buy as many as you can among yourself and friends that you know will attend.

the years from coming to Slamdance, and I definitely did not have enough tickets. This is always a hard thing to deal with, especially if you have a large cast and crew in attendance. So, when ticket sales for Sundance become available online, buy as many as you can among yourself and friends that you know will attend. The other thing I learned is that it is very exciting to have a world premiere at an A-list festival. It really felt special showing the film for the first time, and I could feel the excitement in the theater.

Who negotiated the deal for American Hardcore?

We had Diana Holtzberg from Films Transit International represent the film for the U.S. domestic deal and Jan Rofekamp, also of Films Transit International, handle international sales. We also had a legal team that were not at the festival—Marc Glick and Steven Briemer, who were really invaluable in negotiating with the distributor's lawyers once we entered into a deal. I cannot emphasize enough how important a good entertainment lawyer is in closing a deal, and preferably one who has dealt with indie films and the level of distributor who wants your film. A lawyer is going to really go over every line of the contract in detail.

How did the deal come about?

We got three or four offers for the film immediately after the premiere. We then met each of those distributors the next day or so, when they gave us their pitch as to why they wanted the film, what they planned to do with it, and they made an offer. A lot of these offers can sound very complicated because beyond just the dollar amount of the advance, which is sometimes all a film will see for a very long time, these offers go into detail about the deal structure, territories, points, television, DVD, and Internet. It is very wise to have a good sales representative who knows exactly what the offer really is.

The initial offers for *American Hardcore* were low. We still had a lot of the film to pay off, so we started to negotiate for better offers. It is very important to know your bottom line—the least amount you are willing to take—and keep that number close to your chest. We decided that we wanted a deal that would do no less than pay the amount we had invested in the film so far plus all the costs that we would incur to deliver the film to a distributor—35mm print, 5.1 sound mix, HD versions, and all the rights and clearances for the images and music, as well as all the legal and business expenses. While we shot and edited the film on a low budget, to deliver to a major distributor like Sony Pictures Classics you are essentially going to deliver a product that works with the studio system. They want a lot of paperwork and physical materials that can easily cost almost an additional $200,000, so no matter how cheap you make a movie, once you sell it to a major distributor those costs become very real. We were able to negotiate the price from high five figures to mid-six figures, which met our minimum requirements to cover the costs.

We accepted an offer from Sony Pictures Classics for five territories: the United States, Canada, Mexico, Germany, and Australia. We did not sign the deal until the end of March 2006, two months later. It sometimes takes a long time to negotiate these deals to the point of signing, and then the physical delivery starts. We did not see our first advance money until May 2006.

What did you learn about closing a distribution deal?

If you're lucky enough to get decent offers, try to leave Sundance or Slamdance with a deal of some kind at some stage of negotiation. You might not close the deal at the festival, but at least leave with one in tow that can be signed in the coming weeks. If you do not get any offers at all then you need to start planning for the next festival, which will usually come forth since a lot of festivals around the country and the world look to Sundance for programming. You might also want to consider specific industry screenings after Park City that you set up yourself in Los Angeles and New York for distributors that might not have seen the film yet. Maybe start sending out some DVDs to potential alternate distributors or think about self-distribution on DVD and the Web.

Any things you would have done differently?

I think we should have tried to make more time to set up more international deals at Sundance, as most of the main distributors in the world are there. We got a good Japanese deal with King Records in addition to the Sony deal, but some European territories were not sold for a long time and some still remain available.

How were you expected to support the release of the film?

The one thing that we were very happy about with Sony Pictures Classics is that we were included in every step of the process: artwork approval, marketing plans. Steve Blush, the writer and co-producer of the film, and I went on a fifteen-day promotional tour across the United States to do press as the film was unrolling theatrically. We also had to continue pushing the film ourselves to the underground punk community using e-mail blasts, MySpace, and Facebook. These Internet networks worked very well for us in terms of raising awareness in different cities as the film opened in those cities. Do not leave everything up to the distributor—they might be releasing two or three films at the same time—so you want to do as much as possible yourself, and push your film to the max.

How did getting a deal affect your ability to play other festivals?

Sony Pictures Classics back in 2006 did not want the film to play any more festivals in their territories, particularly the United States, until the film was ready to be released to theaters. Their policy might be different now because marketing plans tend to change with time. We had to pull the film out of SXSW at their request, which was very difficult. We loved that festival and the people who run it, and we also felt that Austin had an important punk scene back in the day. SPC wanted to release the film in the fall, so we had a big launch at the Toronto Film Festival in September of 2006, the week before the film opened at the Angelika theater in New York and the Nuart theater in Los Angeles.

Can you describe your whirlwind film festival tour?

We decided to do a fall European tour with the film, which took us from Spain on up through to Norway. We traveled to eight countries in just under a month, spending anywhere from three to ten days at various festivals. The most important aspect of going on a such a tour is to coordinate a schedule of film festivals that can work one after another, and to get the festivals to pay for as much as possible, particularly flights and accommodations.

I remember when I toured film festivals around the world in 1994–2000. Film festivals back then had a lot more money, and now it has become harder to get much out of them, especially transatlantic flights, and especially if you have a short film. What I did was buy a ticket from New York to Barcelona—Spain was our first festival stop— and a return to New York from Oslo, Norway, our last film festival of the tour. All the travel and lodging in between was paid for by the different European festivals. If you can, try to organize this type of festival route. There are a lot of film festivals in Europe and Asia that will work this way, because it ensures their best chance of getting the latest festival films on the circuit. Again, go for press, hand out flyers, work with your local distributor if you have one. We tried and mostly achieved our goal of having at least one major interview or article in the biggest newspaper in each city we played.

What was your best festival experience?

Sundance. Because it was our world premiere, we were able to get a decent deal, and the global film community was there. After that I think Stockholm and Oslo were awesome—they know how to party, the people are great, and they love rock and roll. A lot of bands turned out to the film in those cities. Thinking back, even the worst experience was fun and rewarding in some odd way. I was lucky enough not to have a bad festival run with *American Hardcore*.

> To avoid a bad screening, make sure you do a very elaborate tech check with the projectionist who will be running your film.

To avoid a bad screening, make sure you do a very elaborate tech check with the projectionist who will be running your film. Check for brightness and color levels, sound levels, and aspect ratio— meaning the size of the picture being projected. This way, if you've done the work to pack the theater, you can avoid any bad scenarios through diligence.

What's the secret to surviving Sundance as a filmmaker?

At Sundance, rent a house if you can. Keeping your team together is much more productive. Rent a car and get a friend to drive or hire a local PA to be a driver, especially if you've got cast members to shuttle around or a big party to put together.

A Sundance or Slamdance premiere is not the end all or be all of launches for a new film. There are several important festivals, and there are many European festivals, such as Berlin, and Edinburgh in Scotland, that program indie films and can attract distributors. In the United States, the opportunities are really opening up with various forms of self-distribution using the Web to reach out. More and more distributors will be looking at films that start breaking out that way.

SETH GORDON
Director, documentary filmmaker

FILMS: *The King of Kong: A Fistful of Quarters, Four Christmases, Suicide Squad*
FESTIVAL EXPERIENCE: Screened films at Slamdance, SXSW, Seattle, Fantasia, Newport Beach
DEALS: Sold the doc-version remake rights for *The King of Kong* to New Line

........................

"Don't make it 'more commercial,' don't 'dumb it down,' don't guess what buyers will like."

Seth Gordon discovered film while working as a teacher in Kenya during his escape from college. An admitted video game fan, he caught the documentary film bug after capturing a series of unexpected events with his Hi-8 camera during his stay in Kenya. From that experience, he learned to love documentary storytelling.

Seth tells us about his journey from the arcade to Slamdance to theatrical distribution for his amazing video-game documentary, *The King of Kong*.

Seth Gordon

How did The King of Kong *come about?*

I love video games and the eccentric people that master them. That an archetypal David and Goliath story would emerge in that world was a surprise to us all. Beyond that I think I was inspired by the many great verité docs over the years: anything by the Maylses or Pennebaker, for example. I also love character docs like *Hands on a Hard Body*.

I never thought our film was especially important and was just doing it for the love of the topic, not for the politics or the need to inform. I think that allowed us to focus on Steve and Billy's personal story, which ended up being the point. I don't particularly like issues films and never wanted ours to be one.

Did you have a plan for The King of Kong *when you began submitting to film festivals?*

Nope. We were shocked that covering this material yielded a film anyone wanted to watch. We applied to Toronto with a rough cut and got rejected. We then applied to Slamdance and Sundance

Still from *The King of Kong*

simultaneously only to learn that another video game documentary, *Chasing Ghosts*, had been accepted early to Sundance. We held our breath and hoped to get into Slamdance and we did.

You submitted the film to Sundance, and you were rejected, yet were accepted by Slamdance. Were you disappointed?

Not really. We'd had films in both festivals before, and buyers all sort of think of Park City as one big market. We knew we were at a historical disadvantage but were confident in our friends' response to early screenings on *Kong* that it was fun and special.

How did this change your plan, and how did you prepare for your first Slamdance screening?

We thought if we waited until Park City we would be screwed, not because we were in Slamdance but because we heard there was another video game doc in the marketplace. So, with the help of Endeavor (our sales rep), we arranged a screening in L.A. before Thanksgiving and invited buyers to attend. We thought it would be better to sell it before Park City if possible, since we had no idea what the competing doc was about and wanted to beat their sales team to the punch if possible.

What did you do to hype your film at Slamdance?

We actually found out the deal was going to close with New Line on our drive up to Park City. That was a *long* drive with a lot of phone calls, and we were relieved to arrive in Park City close to a done deal. As the timing turned out, we signed papers the night of our first screening. That week was just about trying to get people to come see our film, and we made posters and postcards, which were eventually used as our theatrical one-sheets.

We couldn't afford a publicist, but Endeavor helped with some of those duties because they have those connections, and they arranged for the early screening. Publicity never came up before the eventual theatrical release of the film the next fall.

The King of Kong *had incredible buzz in
Park City. Who helped this happen?*

If your film rocks, make sure the sales agencies (CAA, WME
Entertainment, UTA) know about it long before Park City. The market is
designed to sell quality material, so they will find you if you make even
the slightest effort to reach out.

When you learned that Chasing Ghosts, *another
video-game-related documentary, was playing
at Sundance, how did you respond?*

We held an early screening in Los Angeles and invited a bunch of buyers.
The eventual buyer did not attend that screening, but instead a friend of
the assistant of the executive who eventually coordinated the sale did.

Ultimately, when you became aware of Chasing Ghosts, *did
you feel it might hurt your chances of getting distribution?*

Absolutely. By the time we heard we got into Slamdance, we heard that
they'd gotten into Sundance, and were very afraid that only one of the
two docs would sell, so we got into gear. It completely changed the way
we played the game.

Who negotiated the deal?

Endeavor arranged everything and has all the
relationships, and I would recommend their
team to anyone. Graham Taylor ran point and
was an all-star quarterback. Mark Ankner was
a critical team member as well. It became clear
early on that remake rights for *Kong* were as
valuable as the documentary itself. Remake
rights for a doc are worthless without the life
rights of the subjects involved, so we had to race
to arrange for those as well.

The King of Kong poster art

What did you look for in the deal?

Our fallback position was Netflix/self-distribution. Several of our friends have had success with this model. We wanted the best advance and the highest offer for remake rights, since our doc had that potential. I've heard that minimum guaranteed screens is a useful deal point, but we didn't push that one. All I can say is the advance is the only thing that matters and very likely the only money you will see.

> The advance is the only thing that matters and very likely the only money you will see.

How were you, as the filmmaker, expected to support the release of the film? Are you ever really done when the film hits multiple outlets, such as theatrical, DVD, and cable?

I'm definitely not done, since I'm slated to direct the remake for New Line. I was expected to do any- and everything to support the film, and I gladly obliged. What got a far greater response than my presence, however, was the presence of one of the film's subjects, Steve Wiebe, on the few occasions when he could attend festivals and screenings.

What was your best festival experience?

SXSW was the most fun by far, with the best venues for screenings. In my opinion, Sundance is vastly overrated, and the film-selection process is somewhat corrupt due to the amount of money a rare few films fetch in that marketplace.

If your closest friend were entering the world of independent film, what advice would you offer?

Follow your gut and make the film you want to make and don't try to tailor it in any way other than honoring what it wants to be. If that doesn't make sense, you're probably already dead in the water. Don't make it "more commercial," don't "dumb it down," don't guess what buyers will like. Be rooted and in that way radical. The more original your film, the better.

LINCOLN RUCHTI
Documentary filmmaker

FILMS: *Chasing Ghosts: Beyond the Arcade*

FESTIVAL EXPERIENCE: Screened at Sundance, Los Angeles Film Festival, Austin Film Festival

DEALS: Sold *Chasing Ghosts* to Showtime

"Our main mistake was taking the competition a little too lightly."

Lincoln Ruchti, the director of that other video-game documentary, talks bluntly about the Sundance premiere of *Chasing Ghosts* and having to deal with unexpected challenges.

What inspired you to make Chasing Ghosts?

My producing partner urged me to start a video-game project because gaming is so hot now. When I discovered a picture of the 1982 arcade champions, I knew I wanted to make the film. I felt like with the picture I finally had an emotional connection. All these guys wanted to do was compete for a living, and of course we know it didn't work out so great for them. That type of story appeals to me.

Chasing Ghosts poster art

What is the one mistake documentary filmmakers make that you were able to avoid?

I guess we picked a topic that kind of sold itself. Meaning as long as the final product didn't totally suck, there would be people interested in seeing it.

What mistakes did you make that you wished you'd learned before?

Our main mistake was taking the competition a little too lightly. We knew there were other people out there making docs on some of the guys in our film, and we should have pursued and considered that a bit more. We just assumed that we were making the definitive movie on the eighties arcade, and everyone else's was going to pale in comparison. Honestly, we hardly even talked about it. Which is stupid.

Besides filling out the application, writing the check, and mailing your video into Sundance, what else did you do to ensure your best chance for acceptance into the festival?

We took our rough cut to some small distribution companies who showed initial interest but ultimately rejected us. One of them suggested we apply to some big festivals, including Sundance. We sent out the film and were very happy to be accepted into the Hamptons Film Festival. Then, shortly after accepting the Hamptons invite, we got a call from Sundance asking if we would premiere there. The choice was obvious. We had to burn Hamptons, and that wasn't a good feeling, but as first-time filmmakers, Sundance was where we had to premiere.

How did you react to the news that you got into Sundance?

I was surprised, particularly after hearing nothing from them for so long. I felt like maybe I'd actually accomplished what I set out to do with the film. Someone at Sundance must have connected with it, right?

How did you prepare for your first Sundance screening?

We didn't. We flew in, set up an arcade on Main Street with like forty games, then walked into a screening for the Sundance volunteers. We were exhausted, which was a good thing for me. I have a tendency to dwell on stressful things and probably would have been chewing my fist all day had it not been for the Defender machine I had to dolly up the icy Park City sidewalk.

What did you do to hype your film at Sundance?

The arcade was supposed to be our big draw. I have no idea if it helped or not, but people loved it. All the games were set to free play so folks could just walk in, get warm, and play a few games. It was kind of like our home base the rest of the festival. We also made buttons.

Did you hire a publicist?

Yes, and they were so good to us. We were very hands-off publicity-wise. Whatever David and Winston suggested, we tried to do. It's kind of nice having someone handle those types of affairs when you've got an arcade to run.

Regarding festival hype, much of that was built in for us with our subject matter. We were moving people through the arcade, but we didn't feel like it was generating enough buzz for the film. So we adopted our strategy. I went to Wal-Mart Park City (cozy little mom-and-pop) and bought a Hula-hoop, some felt, and a bunch of other supplies and created a Pac-Man costume that my buddy Chris could wear to promote the film. I think it actually got the word out better than the arcade. I wish we'd come up with that idea sooner.

Were you nervous at the first screening, and if so, how did you deal with it?

Again, I stayed busy. The arcade gave me a place to let off some steam and just talk to people. Also, I think the Sundance crowd really wants to like you and your film. Watching your film with an audience like that makes it a lot easier. Not sure how I would have done had the reaction been solidly negative.

What did you learn from that first screening?

The first screening was for the Sundance volunteers. We walked in about twenty minutes after they'd started the film and everyone was laughing. So that was working. Also, with that many viewers, I was able to easily

pick out a few spots that were dragging that I'd never seen before. I think I understand test screenings a bit better now.

How did you respond when you found out there was another video-game-related documentary playing at Slamdance?

We knew this going in. Behind the scenes there was a real battle going on to get into Sundance. Somehow we came out on top, but it turned out to be a small victory as they ultimately got picked up before we even screened at Sundance. That was tough for us. Our problem I think was that we didn't react. It's pretty obvious now that we should have been more cautious with exclusivity.

Ultimately, did the success of The King of Kong hurt your chances of distribution, since the movies both cover much of the same historical period and real-life characters?

What hurt us more about *King of Kong* was the possibility of a fictional remake. As explained to us by our reps, the real pot of gold was not the docs *but the remakes* that could follow—a remake could make a lot more money.

Whichever team could get Billy Mitchell's life rights would get picked up. We battled for months to try to get Billy to sign with us, but ultimately he signed with [*The King of Kong*] without seeing his depiction in their film. Once that happened they secured a deal no problem, like I said, before we had our first screening. Also, they made a good film. So that helped them, too.

When you did not get distribution at Sundance, how did that change your strategy going forward?

Pac Man walked the streets of Park City to promote *Chasing Ghosts.*

Our hopes of a bidding war quickly diminished, but the strategy remained the same. Sell.

Are there any things you would have done differently?

There's of course the persistent "what if" knot in my gut, but my first movie played at Sundance and got distribution. That's okay. Cinetic negotiated everything, and we premiered in December 2008 on Showtime. It came about after much interest for many, many months.

By far the best experience was my overnight trip to Skywalker Ranch, care of the L.A. Film Festival. There is so much hype built up about the place, and I don't know if it's all projected or what, but when you get there it feels special. Like a retreat, only you mix a movie between horse rides and mani/pedis. They were mixing *Into the Wild* when I was there. Sean Penn ducked out when we all walked in.

JEREMY COON
Producer

FILMS: *Napoleon Dynamite, The Sasquatch Gang, Humble Pie (aka American Fork)*

FESTIVAL EXPERIENCE: Screened films at Sundance, Slamdance, SXSW, London, U.S. Comedy Arts Aspen, Nantucket, Sidewalk, and more than forty more

AWARDS: Nominated for Independent Spirit Awards, won MTV Movie Award for Best Movie, and too many more to list

DEALS: Sold *Napoleon Dynamite* to Fox Searchlight for $4.7 million

"People's reactions to films are largely based on expectations. You want people just aware of enough of the film so that there are butts in the seats, but you don't want expectations so high that they leave disappointed."

Jeremy Coon is a native Texan and graduated from BYU with an undergraduate degree in film and an MBA. He's produced several feature

Jeremy Coon with actor Jon Gries

films to date. The first (*Napoleon Dynamite*) you've probably heard of; the second (*The Sasquatch Gang*) you might have heard of; and the most recent (*American Fork [aka Humble Pie]*) you may never have heard of. All three are independent films that played the festival circuit extensively. Jeremy is unique as a producer since he also performs double duty as a highly skilled editor. He became a film buff at the age of seven when his dad took him to see *Aliens* in the theater, and he's been hooked ever since.

Jeremy talks candidly about the making of *Napoleon Dynamite* and its sale at Sundance, as well as the fate of his other independent film projects, plus the scoop on *Napoleon Dynamite Part 2*.

Tell me about your role in the making of Napoleon Dynamite *and how the project came about.*

I met Jared Hess, the writer/director of *Napoleon Dynamite*, while we were students at BYU film school, and we became good friends around 2001. Jared ran the production section of the student facility and I ran postproduction. We usually had a ton of downtime. It was a sweet setup. The school inadvertently paid us to work on our own films, and we had access to all the equipment without having to go through any red tape. Anyway, Jared and I would chat about stuff like how awesome *The A-Team* was and movies in general. We've always both been obsessed with all things Mr. T, and I don't see us losing that with age. I edited Jared's *Peluca* (the short that served as a basis for *Napoleon*), and it was a great experience, and we started talking about working on a feature together. I had access to some funding for a low-budget feature through my contacts and we decided do a feature version of *Peluca*. We targeted summer of 2003 for production.

Jared and Jersuha (his wife) worked on the script and I moved out to L.A. to get things rolling out there. My original career goal was to be

an editor. Producing was something that I started doing in film school because no one was very good at it and I knew I could do a better job. On *Napoleon*, I felt the worse case was I would have my first sole feature editing credit. Jared and Jerusha's first draft of *Napoleon* was about seventy-five pages long, and it was great, but it got punched up with a couple of more revisions. We got the funding we needed, had a great script, and just set out to make it the best way we could and learned a lot along the way.

Is there a secret to getting into Sundance?

There really is no secret way to get into Sundance, at least in my opinion. All the programmers I know are pretty objective and do not play favorites. The films really get in on their own merit, so it's a level playing field. Trevor Groth, a programmer at Sundance, watched *Napoleon* the first time from a pile of VHS tapes at like 2 A.M. He liked it so much, he watched it again right after and really fought to get the film into dramatic competition.

The best way to ensure your film gets accepted is to submit the most complete version of the film you can and submit it as early as you can. If you submit something that's too rough too soon, the stigma of that first rough cut will likely stick, so be cautious. The earlier you submit it, the less slammed the programmers will be and more of them will have a chance to watch it. Other than that obvious hint, the next best alternative is to either develop a relationship with a programmer or find someone who already has one, and have them talk directly about your film, even if it's a non-business-related connection, like their hair stylist. Any personal connection, no matter how small, definitely helps. After the conversation, you can submit your film directly to their attention. Adding this personal qualifier will separate you from the masses and ensure that your film will get considered under the best of circumstances—but again, nothing will ensure acceptance.

> Develop a relationship with a programmer or find someone who already has one, and have them talk directly about your film, even if it's a non-business-related connection, like their hair stylist.

*Any advice to others about selecting the
best festivals for their project?*

Ask yourself why you're applying to certain festivals. Are you applying
just because everyone else does? If so, that generally is not a very good
reason. Also, the best "in" at a festival is to be a local. Local press loves the
story of a local person coming back to town and showing their film, and
you'll get special attention simply because of that. I experienced this with
the Deep Ellum Film Festival, which later evolved into AFI Dallas. I also
developed friendships (both staff and filmmakers) that have lasted long
beyond the films playing there, which is always a great thing. Also, the
next time you have a film, you're almost prequalified (assuming the film
is good) to play again at a festival because you have a solid connection
with the programming staff. Local festivals also give you an excuse to
travel back home (assuming you're looking for an excuse).

What other festivals did you apply to with **Napoleon?**

Initially we only applied to Sundance and Slamdance. We felt one of
those festivals was our best shot at distribution and we'd reevaluate our
strategy if we got rejected by both. We also didn't want additional copies
of the film floating around at other festivals that might get leaked out to
distributors early, especially since it was a rough cut that was submitted.

*Were you concerned about applying to other
festivals before you got word from Sundance?*

I was very concerned, which is why we only applied to two. Like all
filmmakers, we knew Sundance was the Holy Grail of film festivals and
every other festival was a distant second. We only applied to Slamdance
because *Peluca* had been well received there the year before, and if we
didn't get into Sundance, we could still have screenings and a presence
up in Park City at the same time. Slamdance actually accepted *Napoleon*
first and I had a series of hectic phone calls trying to find out if Sundance
had accepted the film or not. Ultimately, I had to make a decision and

we ended up turning down Slamdance without knowing for certain if we were in Sundance or not.

How did you prepare for your first Napoleon screening?

To be honest, we were so busy finishing the film that it's kind of a blur to me. The pre-Sundance time was the busiest I've ever been. I was the editor and postproduction supervisor and I was juggling all the producer duties at the same time. The best piece of advice Cinetic gave us was to make sure that we didn't overhype the film. People's reaction to films is largely based off of expectations. You want people just aware of enough of the film so that there are butts in the seats, but you don't want expectations so high that they leave disappointed. If you go into a film not expecting much and it's decent, you'll be impressed. Conversely, if you're expecting a film to be exceptional and it's decent, you'll leave disappointed. We wanted as little information out as possible so we could manage expectations and allow the film to really pop unexpectedly at the festival.

What promotional pieces did you create, and how did you pack the festival screenings for Napoleon?

The best promotional piece we created was the school election buttons. We had five thousand "Vote for Pedro" buttons and another thousand "Vote for Summer" buttons made and flooded Park City with them. Everyone was wearing them and it became a badge of being cool. The buttons would start conversations with people who didn't know about the film and helped identify fans of the film. I can't remember how much these buttons cost, but it was nominal compared to the exposure it gave the film.

As far as packing the screenings, we didn't have to do much of anything. All of our screenings sold out almost immediately. Part of that is that we had more of a local presence than other films, but I know plenty of friends who were unable to get tickets. The biggest reason for the demand is probably the terrific synopsis that Trevor Groth wrote for the Sundance program. It was so glowing and nice that it was as if one of

our mothers had written it. The majority of people are going to base their decision to see a film or not off of the program, so make sure you're happy with your description and photo in the festival program.

Did you hire a publicist?

Yeah, we hired Jeff Hill from International House of Publicity (IHOP) to do our PR. Anyone who'd name their PR firm IHOP seemed like a great fit with us. Jeff did a great job getting us good, solid press, and we were very glad to have him onboard.

> A good publicist can help make the most of the situation, but how audiences ultimately react to your film is largely outside of a publicist's control.

Generally, I have mixed feelings about publicists. There are a handful like Jeff who really add value because they have connections and their opinions are well respected. I'm sure this is going to offend some publicity peeps, but I think most are overpriced and often get more credit than they deserve.

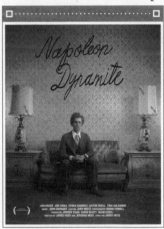

Napoleon Dynamite poster art

Some publicists really just manage incoming requests, which really anyone could do. If you have a hot film, journalists will want to do press for it, but if you have a dud, they don't. A good publicist can help make the most of the situation, but how audiences ultimately react to your film is largely outside of a publicist's control. For festivals other than Sundance or Toronto, I would not hire a publicist and would save your money for other expenses if money is tight.

What was the most important thing for you in determining which distributor was the right fit?

Cinetic Media was our producer's rep for *Napoleon*, and they played a large role in helping us determine which distributor was right for us. The clear leader was Fox Searchlight because their marketing department blows any other distributors out of the water. Searchlight really puts a

lot of effort into each ad campaign and thinks outside the box to tailor the campaign to the uniqueness of the film. The most important thing to us was that the film would get the best release possible and garner the most attention. Don't get me wrong: Money is important, but I would recommend to any filmmaker not to be so focused on the financials that they lose focus of what's really important—having a film career and being able to make another film. You

We easily could have sold Napoleon to another distributor for likely more money, but if the release was botched we would have lost in the long run, both financially and for our careers.

want your film to be a launching pad to more work and clout. We easily could have sold *Napoleon* to another distributor for likely more money, but if the release was botched we would have lost in the long run, both financially and for our careers.

Any advice on getting the distribution deal?

Don't get too greedy. Just as quickly as buzz can build on a film, it can implode even quicker. This is something I learned on *Sasquatch*. We did a screening before Slamdance in L.A. and New York and got strong interest from a good distributor that night. Things were looking great and I thought we were going to close a deal in a matter of days. They offered $2 million, but some people on our team wanted the floor of the offer to be $3 million, which meant that the film had to be screened by other departments (namely marketing) to authorize the higher price.

There are way more reasons to not buy a film than to buy one, and the longer a distributor thinks about it, the more likely they are to talk themselves out of buying. It doesn't take much negativity to turn the tides within a company. Once that marketing department saw *Sasquatch*, they felt that it didn't have enough big-name talent and they didn't want to (or couldn't) put in the effort to create a unique campaign like Searchlight did with *Napoleon*. That response all but killed the deal for us. So again, don't get too caught up in the hype. If you have a good offer on the table and

> If you have a good offer on the table and you don't have a fallback option, be careful of negotiating too aggressively. It might backfire on you.

you don't have a fallback option, be careful of negotiating too aggressively. It might backfire on you.

Are there any things you would have done differently?

On *Napoleon*, I can honestly say that I wouldn't do much of anything differently. It really was a near-perfect experience from beginning to end. However, if I had one piece of advice to give, I would have spent some more time analyzing the distribution contract with Fox and probably hired my own outside lawyer to provide a second opinion and look out for just my interests. Cinetic is both a law firm and sales agent, which is great synergy and they're a great company, but I think it is a mild conflict of interests. Our distribution contract with Searchlight was about eighty pages long, and in the rush of getting things done, I think some things were overlooked. If it's your first film, chances are you're going to get screwed because you don't have a ton of leverage to negotiate with on specific standard terms, but it can't hurt to try. Hiring a lawyer for a second opinion and taking a bit more time to review may not have made much of a difference, but it would be worth the piece of mind.

What do the numbers look like on a big deal like the one for Napoleon Dynamite?

We sold *Napoleon* to Fox Searchlight for a $4.75 million advance. We also received box office bonuses of $350K at $20 mil, $25 mil, $35 mil, and $40 mil for a total of $1.4 mil. Both of these payments are advances against future profits, and we get 50 percent of any remaining net profits. "Net profits" can be a very loose term, and I would recommend filmmakers pay particular attention to how that term is defined. Usually it's what's left over from revenue minus expenses and distribution fees. However, it's very easy for studios to implement some creative accounting that can make any hit film look like a loss, so watch out for it. Expenses can be inflated or taken from other films and charged to more successful ones. I would recommend having additional payments linked to concrete events like the box office bonuses. That way there is no gray area—the event that

triggers the payment either happens or it doesn't, and they are paid in a timely manner.

How were you expected to support the release of the film?

Fox Searchlight is very filmmaker-friendly and kept us involved in many aspects of the marketing, including the trailer, poster, etc. Beyond that, it was just agreeing to do a lot of interviews. Jon Heder (who played Napoleon) had the busiest schedule by far and was on countless talk shows for a while. We also went to a lot of film festivals to do Q&As, which was a lot of fun.

Could you recount some of the more memorable moments of your whirlwind Sundance experience?

Two moments stick out to me. The first was our first screening. It was such a crazy marathon to finish the film and get it ready for Sundance, but we had never watched it with an actual audience before. We had no idea if it would play well. Jared and I were most concerned about the dance scene climax and whether it would be climatic enough to really drive the film home. We went through countless revisions and worked on it till the very last minute—we'd actually made it into a small separate film reel so we'd have more time to edit. At that first screening at Sundance the crowd cheers within the film seemed really loud, and then when it cut to the next scene people were still cheering and we realized that it was actually the audience cheering. Jared turned around to me and said, "We did it!" and we power-slammed each other. It was such a relief and joy to have that sense of accomplishment after all the work so many people had put into the film.

The other moment was when the actual sale of *Napoleon* was closed with Fox Searchlight. We knew we weren't going to accept any offers until after the third screening. *Napoleon* had its first screening at 5 P.M., then 11 P.M., and then 11 P.M. the next day, so we had a majority of our screenings within an eighteen-hour period. We knew the screenings were going extremely well but had no idea what it meant. After the third

screening, John Sloss (the head of Cinetic) invited Jared and me up to their condo to discuss the offers. We sat around for about an hour or two and nothing was going on. I was wondering why we were just sitting there chilling. I'll admit I was a little worried for a brief time. I realized later on that John just wanted Jared and me out of sight so that no distributor could ambush us. Selling a film at Sundance is a total game, and John is very good at it. The first offer came in from MTV Films for $3 million. That was when I realized that something really special was going on. The most I had even hoped to sell the film for was maybe $3.25 million and now I knew our floor was $3 million and we could use that as leverage against other distributors.

The next two hours was a flurry of activity. We were basically down to two distributors very quickly: Searchlight and Warner Independent. We had an appointment with Warner, but Searchlight was first and told us that they all had to go to the screening of *The Motorcycle Diaries* in two hours and were leaving with or without the film. Peter Rice and the entire executive team came to the meeting, and each department talked to us about how they would handle the film. After that we went into separate rooms while John Sloss ran back and forth with the offer as we negotiated and ended up with $4.75 million. As we were closing the deal, Warner was driving up the hill to the condo and we told them what the price was at and asked if they wanted to go higher. They thought we were bluffing and turned around—and we closed the deal with Searchlight. It all happened so quickly that it took a while for it to really sink into us. I totally understand now why people get emotional after winning a championship or a gold medal. After so much time and work, it's almost an emotional overload to actually get what you've strived for, for so long.

Can you explain how you raised the money for your films?

Each film needs to have a different and unique fundraising strategy. It depends on the size of the budget, genre, and economic conditions. Unfortunately for *Napoleon*, this isn't a very interesting answer. I had a relative who could afford the initial $320K investment, believed in me,

and wanted to give me a shot at my dream. There was no lengthy contract or lawyers, just an e-mail and a handshake. Once we got into Sundance and wanted to do a film print, he invested another $80K so we could complete that for a total investment of just over $400K.

On *Sasquatch*, we wanted to work with more established forms of financing from production companies because the budget was higher this time: $1.35 million. We felt it would be an easy sale to get someone to put up the money after the success of *Napoleon* and wanted to capitalize on that. On my third film, *American Fork*, we went back to a single private wealthy investor. I've been fortunate enough that I haven't had much of a problem raising money for films. Again, I know that's not interesting or probably useful. Once you get your first one down, raising money usually gets easier with each subsequent film. The best advice I would give is find someone who is excited about the film and then get them excited about your vision for it. I'm also a firm believer that almost any film can get made on any budget if you can get creative enough.

What key piece of advice you would give to someone closing a financing deal for a film?

Don't blow too much smoke at any investors. Be brutally honest. I've always told every investor I've talked to that any film is a bad investment, but as independent films go, I think what we're doing is better than many alternatives for various reasons. I'd mention things like

> The investor needs to be prepared to lose 100 percent of their investment.

the budget is as low as possible to increase profitability and that each dollar will be well spent. I really believe that creativity thrives best under constraints. The investor also needs to be prepared to lose 100 percent of their investment. This might mean that you burn through many potential investors, but it's better in the long run. If they can't stomach the financial hit, it's better to sift them out now, because it will only cause problems and feelings of guilt later on if things don't work out. Many investors respond well to this dose of honesty, which helps facilitate a sense of trust.

What advice would you give to someone investing in a film?

No investment in any film is likely a wise investment strictly from a financial point of view, and if someone tells you it is, they are either lying or a fool. Producers can draw projections from similar films and how they performed, but ultimately no one knows, and I would put little weight in it. An extreme example is one business plan I saw where they were doing a fantasy film in the vein of *Lord of the Rings* and looking for $3 million for the budget. They projected that *Lord of the Rings* grossed north of $300 million so if they got just 1 percent of that, the film would break even. Ridiculous. Every time you see a revenue or gross projection, keep in mind that they don't mean much, regardless of who made it.

Producer Jeremy Coon (at left) with the cast and crew on the set of *Napoleon Dynamite*

That said, most people invest in a film mostly for reasons other than financial, so focus on those. Things like helping a family member by giving them a shot (like I experienced), really believing in the script, or maybe a rich person would just like to experience visiting a set and vicariously being a producer. Those are elements you have control over and can guarantee. There is so much out of your control that helps make a film successful that if you invest solely based on an expected financial return, you're bound to be disappointed.

What do you consider the best way to seek funding?

You can always start with the three F's: family, friends, and fools. I kid a little bit, but if you have no track record and are looking to make your first film, chances are you'll have to at least initially hit up one or more of these three. These funding options usually allow the filmmakers the most control over how the film is made. This is most important for first-time filmmakers, because it frees them up to achieve their vision.

I've got a great pitch for Napoleon Dynamite Part 2.
Want to hear it? Okay, I'm kidding, but how do you
respond to that kind of success where the movie
becomes such a big part of the cultural zeitgeist?

Hmm, let me list the number of derivatives of *Napoleon* I've had pitched to me. First there's the numerous cultural reinterpretations, such as the African American, Indian, and Asian versions. Then there was the plane ride where I had to hear ideas of how to combine the *Girls Gone Wild* brand with *Napoleon*. I had to just sit there, smile, and nod since there was nowhere to escape. One guy also sent me a package telling me that he felt his life's work was to create the Broadway musical version of *Napoleon* and included two original songs. My personal favorite sequel idea is that Kip and Napoleon actually get the time machine to work and they travel to different time periods a la *Back to the Future*.

There is no way to plan for the kind of success and attention that *Napoleon* received. It just happens and you deal with it. I think I realized that *Napoleon* had entered the cultural zeitgeist either when Napoleon Dynamite was used as a descriptive adjective in a *New York Times* article or when we got our own Trivial Pursuit question. One agent early on told us that Tom Cruise hosted a screening of *Napoleon* at his house for Will Smith, Jim Carrey, and some other celebrities, and they all loved it. Denzel Washington and Clint Eastwood are also both huge fans. That stuff seems so strange, but assuming it's all true, that's so cool. It still feels strange that so many people know about and love this little film we shot with a bunch of buddies in Idaho. Even all these years later, I still regularly meet huge fans that are excited to know anyone who worked on the film. I always try to be really thankful to fans, because they're the ones that made our dreams come true by helping us have film careers.

You've made several projects since Napoleon, *but it's hard to*
top that kind of unprecedented success. How do you manage
the expectations of a new director or team of filmmakers?

There are also so many issues that are out of your control that help lead to a film's success, the biggest probably being timing. *Napoleon* was

probably a once-in-a-lifetime opportunity for me, and I know it will be hard to top that experience, especially since it was our first film. I've always wondered if *Napoleon* would have been as well received and successful had it been made a year earlier or later. We were at Sundance with a great group of films, such as *Garden State* and *Super Size Me*. Films that had high commercial appeal, yet still retained indie roots, which definitely helped. So I tell new directors just to do their best and not worry about things outside of their control. All we can do is make the best film we can under the circumstances and present it as best we can.

What led to your next project, The Sasquatch Gang?

Tim Skousen, a good friend and first AD on *Napoleon*, wrote a script and sent it to me to read. It was a little rough and a long first draft, but I knew a good film was in there and it just took a few more revisions to get it to a really solid and unique script. We pitched it as the feel of *Goonies* but told in the nonlinear narrative style of *Pulp Fiction*. Given the clout we gained from doing *Napoleon*, we had much easier access to a number of financing sources.

We thought briefly about going the studio route, but at the time, I didn't want to deal with the slow process, the politics, or risk losing creative control, especially with a first-time director. I think a director's first film needs to be on a smaller budget so there is less pressure and no studio executive constantly looking over their shoulder. Directing your first film is hard, and if you're not allowed to experiment, make mistakes, and learn from them, the film will probably suffer.

> Directing your first film is hard, and if you're not allowed to experiment, make mistakes, and learn from them, the film will probably suffer.

Again, I brought in Cinetic Media to act as our agent, but this time early on to find funding in addition to handling the distribution rights. Ultimately, we ended up partnering with Kevin Spacey's Trigger Street Productions. They agreed to put up the money for the film and give us the creative freedom we were looking for.

Sasquatch *played Slamdance but did not get into Sundance—how did that affect your festival strategy?*

Initially we were disappointed about not getting into Sundance, as any filmmakers would be, but I think it was a blessing in disguise. Sundance may not always be the best platform to premiere all films. For *Sasquatch*, the comparisons to *Napoleon* would be inevitable given the similar genre and number of the same filmmakers involved. Also, the audience's expectations would be unrealistically high, and it would be difficult to live up to the hype no matter how good the film was. We also felt that *Sasquatch* skewed much younger than *Napoleon*. The combination of screening a heavily hyped film to an audience significantly older than the intended audience would likely have resulted in bad screenings and would be very difficult to recover from.

Definitely think about what kind of audience you expect to dig your film, and then think about what audiences go to different festivals. A good starting point is looking at past films that have been accepted to various festivals and been well received there. This can also help you target and narrow your search for film festivals to apply to in general.

Slamdance is a very different festival and experience than Sundance. It's much smaller and the venue isn't great, but the festival puts out a very cool energy and vibe. Basically, it's more fartsy and less artsy compared to typical Sundance films. As far as our strategy, we wanted to have a presence in Park City so distributors could see the movie but wanted to keep a low profile so if the screenings didn't go well, we wouldn't be DOA. If *Sasquatch* failed to connect with audiences at Slamdance, it could do so quietly, and if it hit, we could get some traction for a deal.

The hard part was getting busy distributors to head up to the film's screening at the Treasure Mountain Inn. Knowing that, we did one screening in L.A. and one in New York about a week before the festival. Tons of distributors showed up to each screening and we packed the theater with kids who were the exact demographic for the film. We even invited distributors to bring their families and children. This way the distributors were seeing it with a real audience and not a stuffy industry-type crowd. We were able to generate a lot of interest and

awareness for the film so that by the time the festival started we were on a lot of people's radar and not lost in the shuffle of the hundred-plus films playing.

What other festivals did Sasquatch play?

We probably played twenty festivals or so. Once you get into a Sundance or Slamdance, each invitation to another film festival leads into another. My favorites were the HBO U.S. Comedy Arts Festival in Aspen, the Waterfront Film Festival, the Sidewalk Film Festival, and the Florida Film Festival. The film also played internationally at the Stockholm and New Zealand Film Festivals. Waterfront, Sidewalk, and Florida are really good film festivals that might be under the radar. They all take extremely good care of the invited filmmakers and usually cover most, if not all, your travel expenses and, more important, show you an awesome time.

How did your experience with Sasquatch compare to Napoleon?

Sasquatch was a total rollercoaster ride and not in the best way. The film was incredibly well received, but the buyers were not coming like they were with Sundance. I attribute some of that just to timing. Sundance seems to go through cycles where distributors go crazy and buy up tons of films, which eventually leads to overpaying for films that underperform. This scares distributors who would rather not buy than risk the embarrassment of paying too much for a dud. It seems to happen about every five to seven years, and I think we are experiencing a bottom now with the current economic climate. The good news is that it's cyclical, so the situation will always come around for the better.

We ended up selling the U.S. film rights to Sony BMG Films for less than $1 million and divided up the international rights to make the most of each territory. It was much more work and for less money than Napoleon. Sony BMG sat on the film for a while and the label ended up being shut down. So the film sat on the shelf for over a year until it was sold to Screen Media and finally released in November 2007. I'm still very proud of the film and just happy that it got released and is easily available on DVD. There are

plenty of indie films that don't even get to experience that moderate level of success. Who knows, maybe *Sasquatch* could even legitimately become a cult film as it's discovered by more people on DVD.

How did you approach the eventual deal knowing Sasquatch was not going to be as big a mainstream hit as Napoleon?

We just wanted the film out soon and really wanted it to have a shot theatrically. On the deal, we gave the distributor very good financial terms on theatrical revenue to provide an incentive for them to release the film theatrically, and we got a better share of the DVD revenue—30 percent instead of the typical 20 percent. Feeling that it was going to be more a cult film and that *Napoleon* DVD sales were huge compared with its theatrical gross, getting the large share of home video was important to us. If I had to do it over again, I'm not sure I'd push for a theatrical release as strongly as before. For some reason, films seem cheaper if they aren't released in theaters, but I think that stigma has changed over the last few years. Unless the distributor is going to really put some serious marketing money behind the film or have an ingenious plan, it's probably best to forgo a theatrical release. Screen Media probably spent somewhere in the ballpark of $500,000 in P&A [prints and advertising] on *Sasquatch*, which is a sizable investment, but that money doesn't get you much on a national scale or drive people to see the film. And now, the film is $500,000 more in the hole because that money needs to be recouped before the film is profitable.

> Unless the distributor is going to really put some serious marketing money behind the film or have an ingenious plan, it's probably best to forgo a theatrical release.

As a producer on the road to a long career, what lessons did you feel you learned from the projects that did not perform as well as Napoleon?

Napoleon, our first experience, was a best-case scenario. We had zero expectations and had the ultimate reception. I know that I will never

experience something as cool and new as that again, but most people don't get that experience even one time. You need to feel proud of each film regardless of the reception, because even unsuccessful films take at least as much time and effort as a good film. Your desire to make a film should come from yourself and not from the reactions of others per se. That's not to say you should work in a vacuum and not listen to others, but it's shaky ground to base your efforts solely on what you think other people think or want. I don't have kids as of now, but I've always seen each film as a child. You love each of them, but some are definitely more difficult than others, and those are the ones that typically don't perform as well. The really successful ones sometimes seem to magically come together.

You've experienced both success and failure with projects. How do you stay positive and persevere?

Everyone has failures or disappoints at some point in their career. It's inevitable. If you're not experiencing some level of failure, you're probably not taking enough chances or stretching yourself far enough. Independent film is all about taking risks and telling stories that studios are not in a position to tell. I feel confident that if we had pitched the script for *Napoleon* around to the studios, there would have been no takers because no executives would have gotten it. If you know you're taking risks, you know failure is coming eventually, so when it does, it's not a total shock. You can then recover quickly and move on to the next project, having learned from your mistakes, and are better prepared should a similar situation arrive in the future. That's how you grow as a filmmaker.

Through it all, you've remained successful in a tough business. What's your secret?

My secret is surrounding myself with good people, creating a solid team, and being loyal to them. Making films is an extremely collaborative experience, and there's no way someone can be successful on their own. I was fortunate enough to be in film school at the same time as a lot

of cool and talented people who are also extremely close friends. Doing what you love and being able to work with many of your best friends is a great and rewarding experience in and of itself, and I'm very thankful for that. Once you find someone good who you like, do everything you can to hang on and work with that person. You can meet them in school, at film festivals, through mutual friends, or really anywhere, so be nice and pay attention, because you never know when it'll happen. Eventually with enough time and effort you can assemble an awesome team that will stick together through both the good times and the bad. The success of each film definitely helps, but the team will stick together because of the camaraderie.

GRACE LEE
Director

FILMS: *American Zombie*
FESTIVAL EXPERIENCE: Screened at Slamdance, SXSW, San Francisco International Asian American Film Festival, Visual Communications in Los Angeles, Hawaii, Sitges Fantastic Film Festival, Puchon Fantastic Film Festival, Singapore International Film Festival, Brussels Fantastic Film Festival
DEALS: Sold to Cinema Libre

Grace Lee

"Be open to requests from festivals you've never heard of. When I say be strategic, I mean study their programs and get a sense of if your film would fit in there."

Grace Lee was born and raised in Columbia, Missouri, which is also home to the True/False documentary film festival. Grace tells us about her first feature, *American Zombie*, and ways to market a small indie.

How did you get your start in film?

I grew up in the eighties, and my hometown felt like a cultural wasteland. I am also Korean American, so growing up in Middle America definitely instilled in me an appreciation and curiosity about other people and places—particularly outsiders to mainstream society. I was always interested in storytelling, but I didn't get into filmmaking until I was living in Korea after college and decided to make a documentary about prostitution around U.S. military bases. After that, I worked in documentary and indie feature production for a few years before going back to graduate film school at UCLA. I made a short film called *Barrier Device,* which stars Sandra Oh and Suzy Nakamura and won a Student Academy Award, among other accolades. I'm probably most well known for *The Grace Lee Project,* which is a personal documentary about an identity crisis and women named Grace Lee—a very common Asian name. *American Zombie* is my first feature, and it is sort of like *The Grace Lee Project* but with zombies.

What inspired you to make American Zombie?

American Zombie is a "fictional documentary" about two filmmakers who set out to document a community of high-functioning zombies living in Los Angeles. The idea was inspired by a conversation between co-writer Rebecca Sonnenshine and me. We were looking for something we could work on together. Rebecca was having some really gnarly dreams and suffering from insomnia. She described an incident in one dream involving a zombie, and it made me wonder aloud whether she was part zombie and if this repressed part of her identity was coming out subconsciously. I thought this would make a fascinating and hilarious character—someone who seems so nice and normal on the outside but is hiding an unresolved darkness underneath. As a filmmaker, I'm naturally drawn to characters with contradictory tendencies. Plus it seemed like a good vehicle to make fun of documentary filmmaking, identity politics, and life in Los Angeles—all things I'm exposed to on a daily basis.

Having come from docs, how was the transition to
something scripted within the mockumentary genre?

I have worked on fiction films before—with scripts and actors—so that
aspect of it was not a problem. My main challenge came from being so
intimately familiar with the documentary form and understanding what a
small documentary crew would be able to shoot. On actual documentary
shoots, you just show up to an interview or situation and have to make
do with what's there. To have to recreate that sort of authenticity can
be quite time-consuming—especially when you have to come up with
a character's environment and her weird idiosyncrasies from scratch.
Another challenge was that even though we had a script, I would often
allow for improvisation as part of the shooting process. The actors
would often come up with some incredibly funny bits, but back in the
editing room I would have to cut them out because it almost seemed too
scripted, as in too jokey.

How did your previous festival experiences shape
your strategies for American Zombie?

I had been on the festival circuit before with an award-winning short
fiction film (*Barrier Device*) as well as a feature documentary (*The Grace
Lee Project*). In both those cases, I had basically financed, produced,
directed, wrote, made the postcards, and made all the decisions when
it came to festivals and afterward with distribution. With *American
Zombie*, all of the big decisions were made by someone else—with my
input, of course—but I didn't have the final say. We had a production
company from Korea who financed the movie as well as a producer's rep
and publicist for our premiere. The production company and producer's
rep decided which festivals would be the best to attend with the main
goal of getting distribution.

How did you get into Slamdance?

I did nothing but send the film in by the deadline. I didn't know
anybody there and was pleasantly surprised to get the acceptance call.

With other festivals–where I knew a programmer from previously having a film there—I would send an e-mail or cover letter to them personally letting them know I had a new film. I think the best any filmmaker can do is just make sure their film gets seen amongst the piles and piles of submissions. If I didn't know someone at the festival, I might ask someone who did if they could put in a good word, but only if they were a fan of the film. You definitely don't want someone to recommend your film if they are not enthusiastic about it.

> You definitely don't want someone to recommend your film if they are not enthusiastic about it.

The best thing to do is to have your film be completely finished. People are always trying to submit rough cuts or versions with temp music or unmixed sound, which puts you automatically at a disadvantage from films that are already finished and on the circuit and have even won awards. You may be able to see your masterpiece without the final titles and a properly mixed sound track, but that's because you essentially saw your finished film when you were in the process of writing it.

Be strategic when looking at the more well-known festivals and where to premiere. But once that is out of the way, also be open to requests from festivals you've never heard of. When I say be strategic, I mean study their programs and get a sense if your film would fit in there. I know lots of people who just send their film to dozens of festivals at once and wait for any or all to respond. I think that's a waste of time and money. I have sometimes contacted a festival I was interested in or even just curious about to describe my film. If it had been in a previous festival, I might mention that, or if it had won an award. In some cases, not all, the festival would invite me to submit the film and waive the fee. I could also tell by talking with a live human being whether it would be a good match. It can't hurt to ask whether they might do that, but if they say no, then respect their policy.

What major festivals were you rejected from?

Sundance. Los Angeles Film Festival. Tribeca. But I think having played SXSW eliminated the chances for the latter two. I still don't quite get

why all these festivals are such sticklers for premiere status. If I hear of an interesting film that plays in New York, I may never get a chance to see it if it doesn't play in a festival in Los Angeles—especially as theatrical distribution becomes more difficult for independent cinema.

I would have applied to more festivals or sent off the many requests for screeners, but as I mentioned before, the decision wasn't mine to make. The company that financed the film ultimately made the decisions of where the film could play. Kind of a bummer since as a filmmaker I am all about people seeing my work, but we were dealing with another strategy here.

Were you concerned about applying to other festivals before you got word from Sundance?

I had been rejected by Sundance in the past so I wasn't holding my breath. I know there is a tendency, especially for newer filmmakers, to think their life is over if they don't get into Sundance. It is true that it's an incredibly important festival. At the same time, I think I got over my Sundance obsession when I started traveling to festivals in Europe and Asia and even other regional U.S. festivals. It's very encouraging to participate in a festival where you see that the local film culture is actually subsidized by

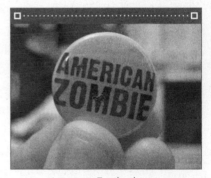

American Zombie button

the government and supported by regular people who just love movies and don't have to be there because it's part of their job. I personally hate having to hawk my film at festivals—even though I will do it. Maybe I am just shy when it comes to stuff like that.

How did you generate interest in American Zombie?

We hired a publicist and at the same time made sure we had a team of people from the film (both crew and cast) to do the legwork of helping raise awareness of the film once we were in Park City. The publicist was

great in helping shape the general thrust of the media campaign and getting press coverage–that is their job. But long before we left for the festival we had begun creating our own unique swag. We had a couple of parties before we left for Slamdance where everyone got together and helped make *Amerian Zombie* buttons (with my button maker—yes, I own one) and put together *American Zombie* zines. It was a great way to build excitement for the finished film amongst our team as well as get excited about going to Park City. Once we were there, people took turns volunteering to put up posters, and everyone handed out postcards whenever they went out.

What would you have done differently in preparing for your film's debut?

Next time I would like to schedule it so that the film is completely finished a couple of months before the festival premiere. You can't always control this, but if I could eliminate some of the stress of actually finishing the movie I would be much happier at the debut instead of just exhausted and relieved. We had only completed the final sound mix a couple of weeks before Slamdance, so that made things really rushed. I was simultaneously trying to focus on all the technical crap involved in getting a good screening, while having to shift gears and write a press kit (yes, you do it yourself if you want to control the content) and figure out logistics of actually getting to the festival . . . and all of this right around the holidays. I am a pretty good multitasker, but it definitely takes its toll.

> Make sure you have people on your team who do enjoy calling attention to themselves to help promote the movie. Generally actors are pretty good at this and are used to having to sell themselves while making it all look effortless and genuine.

I'm a pretty low-key person and hardly an extrovert. I'm the kind of person who would rather talk to someone one-on-one while standing in line than take to the streets drawing attention to myself. So my advice is to make sure you have people on your team who *do* enjoy calling attention to themselves to help promote the movie. Generally actors are pretty good at this and are used to having

to sell themselves while making it all look effortless and genuine. Take advantage of their energy and try to learn from it.

One thing I saw one of the actors do was pretty clever. This was in Park City, which is constantly teeming with people clamoring for access to the latest *buzz-worthy* movie. He would be in a crowd of people and start talking into his cell phone about how he had just seen *American Zombie* and how great it was. He did it loud enough so that people could overhear him and remember the title and even made sure he did it around people who looked like they might be executives or distributors. Who knows if it worked, but he seemed to enjoy doing it!

What unique marketing tools did you use to promote American Zombie?

In the film there is a character named Joel who works at an activist organization called the Zombie Advocacy Group (ZAG). We had already created ZAG merchandise, including T-shirts, "Deadstrong" wristbands, and buttons for the movie, so we just ordered more to help promote the screenings. There are quite a few tie-ins to the movie—which make the swag a lot more interesting because it is actually part of the story. For example, there is a character who creates a zine called *American Zombie*. The actor, Austin Basis, is a really great artist and did all the drawings himself in the movie. He created a special "Slamdance" version of the *American Zombie* zine where he writes poetry and draws pictures of zombies snowboarding. Because we were financed by a Korean company, we also had these great cell phone cleaners—which are really popular in Asia—with the *American Zombie* poster art on it. Those were really popular because they were unique, and who wants a dirty cell phone?

How did you secure funding for American Zombie?

The Korean company that financed us, IhQ, had never made a film in the United States or in English before. I had gotten to know folks at IhQ because I was trying to make another film in Korea and had met quite a few people at various Korean companies in the process. When I was meeting with one of the producers there, I just told her that I was working

on this small, low-budget zombie thing, and she was intrigued. When her boss and other colleague came to the American Film Market that fall, I pitched it to them and they immediately said they wanted to work with us. It was totally unexpected, but they just responded to the idea. I feel very lucky to have made this film with them because it is a very American, very indie, genre-bending movie that has absolutely nothing to do with anything Korean. I think the lesson here is to cultivate your relationships with people in a genuine way and to always be ready to pitch your idea—you really never know what people will like or be looking for.

I think in general you figure out what is the bare minimum you need to realistically make the movie, taking into account the favors you will be calling in and making sure you are not insulting people for their time and talent. With a low-budget movie, it's very important for me to be up front with people that it is low budget and the offers we make are the best they can be. When you are absolutely clear about this, people will lend their talents if they are interested in being part of the project. They certainly aren't doing it to for the money!

> Always be ready to pitch your idea—you really never know what people will like or be looking for.

What did you learn from the first screening of Zombie?

The first screening was actually a nightmare because the projector broke at about ten minutes into the film and we had to wait at least another fifteen minutes for someone to fix it. I thought I was going to have a heart attack, but I have to say this for the Slamdance audience: They stuck through it, and you could tell that people were excited to be there, excited by what they had seen, and, once things were up and running, they were really into the movie. What sucked, though, was there were some distributors in the audience who couldn't wait around and decided

Grace Lee and the *American Zombie* crew at Slamdance

to leave for the next screening. That was pretty demoralizing. It was an exercise in patience and trying to remain calm in the eye of the storm, even though I felt like strangling someone. There was nothing I could have done in that moment except wait. We had a tech screening where things seemed to be fine. Shit happens sometimes, and you just have to go with the flow while it's happening. And then you have to do everything in your power not to let it happen again.

What did you do to get distributors into your screenings?

We had a producer's rep who had alerted many people on his own. At the same time, we invited any connection we had to the screening and invited anyone who had worked on the film who was personally invested in its success to do the same. You never know what contacts your costume designer or someone who only has a few lines in the film may have—but if they also feel like it is their movie they will make the call.

Did you have a list of must-haves to include in any deal?

In general, I want to make sure that there are very specific terms included about the duration of the contract, specifics about how much marketing will be done (including a budget), and the specifics around digital download or whatever new technology will be around in the years my film is out there.

How did you finally get a distribution deal with Cinema Libre?

It was a pretty straightforward process. Someone at Cinema Libre had seen a screener that had been sent to them by the producer's rep. Everyone there liked it, and we all had a meeting where they expressed their enthusiasm for the movie and explained how they would distribute it. The deal was negotiated between IhQ and Cinema Libre with the help of Glen Reynolds, our producer's rep from Circus Road Films. The deal with Cinema Libre is with North America only. Since the Korean company didn't have experience distributing an English-language American movie, it was important to have someone in place who had done it.

Unless you are a lawyer or have loads of experience doing this by yourself, get a lawyer or producer's rep onboard. I have no idea what most of the terms people are talking about mean or even refer to, nor do I have the expertise in negotiating something like this.

Well, IhQ is also the international sales agent. I know that there will be a small release in Korea, and I believe they are still working on others. I knew going in that I was signing away my rights to control many things I had been used to controlling because I wanted to get the movie made. Going forward, I'm more interested in the alternative distribution methods filmmakers are using to get their movies out there—whether it is self-distribution or teaming up with others to form a sort of traveling tour. But I would probably only work on a strategy like this if I knew that it would be part of the process and if it was appropriate for the film's content. It takes so much out of you to make a film—and to have to switch gears and become a distributor is another two-year commitment (at least) that one needs to be aware of.

Any advice on handling press?

It's good to convey ideas about your movie in succinct sentences, if you haven't already done it. There are so many small outlets, websites, and radio shows that you have never heard of but that have loyal readers and listeners. I think if you make a film that has an identifiable audience—be they documentary film followers, zombie aficionados, or horror fans—you have a responsibility to make yourself available to that outlet. On the other hand, it's more interesting and rewarding to do an interview with someone who has actually done her homework and watched the film or done some research on you. If they haven't, then you basically have to think of what you want to talk about and incorporate those answers into their usually generic questions.

> If you make a film that has an identifiable audience—be they documentary film followers, zombie aficionados, or horror fans—you have a responsibility to make yourself available to that outlet.

How did you support the release of the film after the festival tour?

When we opened in Los Angeles, where the film takes place and where most of the cast and crew lives, we did as much grassroots promotion as we could in addition to the press outreach from the distributor. We also decided to recreate a zombie art show that appears at one point in the film at a local ice cream shop/gallery. Austin (who plays the zine maker) created another zine, and we featured some artwork that had been used in the movie and commissioned some new stuff. We also had an art show opening the day before the movie opened, and the ice cream shop owner created special *American Zombie* flavors based on the main characters.

What was your best festival experience?

SXSW was the best for me. The pressure was off from the first screening, and Austin is a great town. The weather is warm, and you don't have to trudge through snow and stay in an expensive ski resort. Plus, the audiences are amazing. There were two sold-out shows, and I kept running into people later who would tell me that they had been there. It's just a more laid-back atmosphere than the industry frenzy of Park City.

ALEX CAMPBELL
Producer, agent

FILMS: *Super High Me, Little Odessa, Melvin Goes to Dinner*
FESTIVAL EXPERIENCE: Screened films at Slamdance, SXSW, and Woodstock, among others
DEALS: Sold to Netflix, in addition to self-distribution

"Don't make movies to make money. There are so many easier ways to make money."

Alex Campbell

Alex Campbell attended USC film school and started working in the movie business right after graduation. He got his first break as an assistant at Addis-Wechsler and Associates and was made an executive within one year of joining the company. While at Addis-Wechsler, he worked on many notable indie projects, including *Little Odessa, Love Jones, Eve's Bayou,* and *Trees Lounge.* As a production executive and talent manager at Addis-Wechsler for five years, he was able to see exactly how indie movies got made, both as a producer and as a rep. Alex left and produced several large-scale independents with $10 million-plus budgets, primarily with European sources of financing.

At the beginning of the decade, he could see the writing on the wall as far as distribution of indie "film" was concerned and chose to explore digital filmmaking. Alex was one of the first to make webisodes and produced AOL's initial attempts at digital entertainment, a short form series called *Hollywood Confidential.* Unfortunately, this was before broadband was widely available, and people didn't want to watch something that was three minutes long but took twenty minutes to download. Alex became hooked on the ease of producing with digital video and knew that the future of independent film was heading in that direction. He line-produced Bob Odenkirk's directorial debut, *Melvin Goes to Dinner,* also shot on DV, which won the Audience Award at the 2003 SXSW Festival. Most recently, he created and produced the indie cult success *Super High Me,* a comedic take on *Super Size Me* starring comedian Doug Benson.

Alex dispenses sobering advice from the perspectives of a producer, a rep, and an agent.

If you had a very good friend about to enter the indie film business, what would be the one thing you would tell him or her?

I would say that is not a business and to plan on losing money. You will be much happier in the long run if you accept the fact that you are *not*

going to become wealthy making independent film. In fact, you *may not* be able to make a living wage, especially if you are a producer, as almost every project I have been involved with has required that the producers reduce or defer their fees in order to get the films made. You should *only* get into the indie film world if you love film and want to tell interesting and provocative stories. The truth is that every independent production company in the history of American film has always eventually failed. Or they have been purchased by a corporation (Miramax and New Line, for example) and they are no longer truly independent.

How should one go about getting name talent to appear in a film when it's low budget?

Talent will always respond to a good script. The best way to proceed is for an indie filmmaker to find a producer who has a track record of shepherding independent films and get them onboard. That producer can help the filmmaker navigate the tricky shoals of the talent representation world and, more important, financing.

But the bottom line is that a good script will attract name talent. It may take time, but an interesting script and a director with vision can get name talent to work for scale, especially if you are shooting in L.A. or New York. It can be a little bit harder to get people to go on location for scale, but it happens. And once you get that first actor to sign on, the other agencies in town start to take notice and

Get a good casting director onboard. That will help give your project credibility in the talent rep world.

will take you more seriously. The truth is that for the most part, actors want to do independent film. They get to take more artistic chances and generally have a more satisfying experience. However, most of the agents out there don't want their clients doing indies because it means a far smaller payday and hence a smaller commission. If you don't have a relationship with a manager or agent and you are calling them to try to get their client interested you can almost forget it. They are going to throw your script in the corner and call you back in three weeks to tell you their client passed. The other thing is to get a good casting director

onboard. That will also help give your project credibility in the talent rep world.

What do movies that get accepted into a major festival all have in common?

A bold point of view and unique storytelling. Great independent films take chances and succeed. There is no magic formula; every film is different.

Are there common mistakes or elements seen in films that get rejected from festivals?

I don't think there are any "common" mistakes. Different festivals have different agendas. When we made *Super High Me*, we knew Sundance wouldn't accept us because we were a comedy and we were parodying a Sundance darling. We also didn't get accepted to Toronto, and even our worst-case fallback festival, the Los Angeles Film Festival, didn't accept the film. Luckily, we had a relationship with Matt Dentler at SXSW and showed him the picture. He loved it and ended up making us the opening night film in 2008. Something that doesn't work for Sundance might work for Tribeca or Toronto. A good film will get accepted at a good festival. I've seen too many filmmakers get their hopes dashed because they don't get invited to Sundance. However, I think it is actually a curse to get accepted to Sundance. My first choice of festivals is always Toronto and more recently SXSW.

Is there a good way to apply gentle pressure on a festival to gain acceptance?

The only pressure I've ever seen work is pressure that comes from a distributor. And if you have a distributor already, you don't need a festival! If anything, any type of pressure you place on a festival can backfire and cause the programmers to not want to work with you.

I knew a filmmaker who tried to get Toronto to take a picture by telling them that Venice wanted it. The truth is that they were *bluffing*.

The programmers in Toronto called Venice, and guess what? Venice wasn't taking the film either, so he didn't get into either festival.

What is the most effective way to become a must-see at a film festival?

At Sundance, have your friends walk up and down Main Street extolling the virtues of your film. When I worked in the representation game, I would get to Sundance a day early and just walk up and down the hill shaking hands and talking up our films. Now with all of the blogging going on, I think an effective strategy would be to get the bloggers in the independent film world to champion your film.

I'm skeptical about gimmicks at film festivals. Let the film speak for itself. If you have a gimmick, your film probably isn't very good—that's always my first read.

> Get the bloggers in the independent film world to champion your film.

How exactly did you secure the financing for the several projects you've produced?

Friends, family, doctors, and dentists—healthcare professionals have been a good source for raising money for independent films over the years. The truth is that most first-time filmmakers cobble together their budget in small pieces from friends and family. Because most independent films end up losing money, there aren't many sources to secure financing. You used to be able to raise money based on the names in your cast from international sales, but that is becoming very difficult. Raising funds for making movies has always been difficult, and it isn't getting any easier. To raise money outside of friends and family, you need to have a track record. It's the old chicken-and-egg conundrum.

What advice do you give investors about to pour their money into a project?

I always try to give them the worst-case scenario. That way there are no hard feelings if we don't recoup. My goal on any independent project is

for everyone to get whole. They might not make money, but if we can get their initial investment back, chances are they will give us another investment the next time around.

As a manager, you played an active role in helping films get distribution. How has distribution changed since you entered the independent film scene?

When I started there were quite a few true independents, with Miramax being the 800-pound gorilla. But most of them have been bought by corporations, and there are very few true independent distribs around today, and it seems like I am always hearing about another one closing their doors. I also think there is a misnomer about "independent" these days. Some of the majors started specialty divisions to try and cash in on the indie scene in the nineties, but they have become nothing more than smaller studio divisions. I don't consider a film with an $8 million negative cost and a $15 million marketing budget an independent film. On the flip side, services like Netflix and the Internet are allowing films that may have not had an audience before to find their audience. The "mumblecore" movement is an example of this. And like it or not, *Loose Change* is a revolutionary film. I don't agree with the filmmaker's message, but how can you argue with the number of people who have seen that film? I think we are close to coming up with alternatives to studio-based distribution. We had tremendous success with *Super High Me* and our "free" distribution of the film through b-side [bside.com].

Are there any specific things filmmakers can do while playing the festival circuit to gain the attention of distributors, other than beg them to come to a screening?

Hire a sales rep and get *them* to start the buzz. Movie execs are for the most part afraid to miss something. So if they hear about the latest, greatest thing they will want to see it because they are all afraid of missing the next *Blair Witch*. Hollywood runs on heat, so get the buzz machine started with everything you can.

On the other hand, execs are also afraid to buy things and take a stand because every time they advocate something, they are potentially putting their job on the line. So they tend to make the safe choice. You have to show them who the movie can be sold to and how, because if you don't, they will come up with a million reasons to say no.

> The synopsis and the one-line description of the film that you have in preproduction *will* become part of the sales package and will get used *all the way down the line.*

Which leads me to the second point: the marketing campaign. You have to have the marketing campaign and the one-sheet and the tagline and know who the audience is before you make the film. The synopsis and the one-line description of the film that you have in preproduction *will* become part of the sales package and will get used *all the way down the line.* Your marketing plan will help you sell your film and have more control eventually over how the film is marketed. I know a lot of filmmakers are not going to like to hear this because they are artists first, but if you don't know how to sell your film, it won't get seen.

What mistakes do filmmakers seeking distribution often make?

Not looking at alternative distribution models and being open-minded. I've seen a lot of situations where filmmakers are convinced that if they don't get a theatrical release that the film is a failure. Not true. I almost blew the release of *Super High Me*. Netflix wanted to try this experimental release where we basically gave the movie away to any group of people who wanted to see it. All they had to do was pay $2.99 shipping and handling to get a copy of the DVD. I put my foot down and said over my dead body. I just put two years of my life into this film and I'm not giving it away for nothing. Eventually, I realized the publicity and good word of mouth we would get by doing this would be worth any lost sales. And it turned out that the b-side free screening programs exceeded expectations dramatically. We got press all over the world and had one of the largest first-day audiences for a U.S. documentary, which in turn drove DVD and pay-per-view sales through the roof.

What red flags should filmmakers avoid in a distribution deal?

You need to have multiple bidders who all want the film after seeing it for the first time at a major festival. Otherwise, you can try to make a low or no-advance deal where you can split revenues. If you have an honest distributor (Netflix is the only company I have worked with who I would say falls in this category) you can make a good no-advance deal. However, I don't really recommend that approach, because most of the time the filmmakers will never see any money. Take the advance and try to get as much as you can up front because there will never be any profits. Just ask Peter Jackson, who had to sue New Line for his share of *The Lord of the Rings*.

Can self-distribution, kind of the last resort for an unsold film, ever work?

Self-distribution worked for *Loose Change* and it worked for *The Puffy Chair*. And there will be other examples in the future. If you have a good movie, people will see it. The problem is that most filmmakers are too close to their film and won't recognize that they might not have made a good film. And believe me, it is easy to make a bad film. I've done it more than once. A good picture will eventually get seen. Just be persistent.

Has playing many film festivals almost become like a minor theatrical release itself?

I would agree with this statement. You are getting the movie in front of an audience that wants to see it, and I think most filmmakers just want their work to be seen. Also, if you play enough festivals, you can build up a book of reviews and good press and use that to try and get a TV or DVD deal.

At the risk of death and being banned from the industry forever, what is it like dealing with the Weinsteins?

Harvey and Bob love movies. And everyone has their horror stories of working with them, but at the end of the day those guys are still doing

what they think is best for an individual movie. And I will take that every time over some corporate suit worrying over quarterly profits.

Other than making a great movie, what can a filmmaker do to increase his or her chances of success?

Get the best sales rep you can. You will need help navigating the shark-infested waters so you don't get eaten or, worse, ignored.

Don't make movies to make money. There are so many easier ways to make money. And I hope I haven't scared anyone off with my answers to these questions. I will close this interview by telling you the same thing that I told Darren Aronofsky and Miguel Arteta as they were trying to make their first features. Don't listen to anyone in Hollywood. They will all be afraid of your script. Just find a way to get your movie made and stick to your vision. Hollywood will come around if you pull it off. Just get your movie made by any means necessary.

HOLLY MOSHER
Producer

FILMS: *Hummingbird, Side Effects, Lady in the Box, Free For All!*
FESTIVAL EXPERIENCE: Screened films at CineVegas, SXSW, and forty others
DEALS: Sold *Side Effects* to Warner Bros. DVD, also self-distribution

"Follow your heart, and only make films that you are dying to make, because you will be married to that project for years."

Holly Mosher grew up in Milwaukee, Wisconsin. In high school, she developed a passion for both photography and philosophy, which led her to pursue filmmaking. In her college entrance paper, she cited British author George Orwell's idea that all art should be political and continues to use that concept to guide her work.

Holly Mosher

She graduated with honors from New York University's Tisch School of the Arts. After NYU, she spent two years in Brazil working as an assistant picture and sound editor on four feature films, including the Oscar-nominated films *O Quatrilho*, *Tieta do Agreste*, and *Pequeno Dicionario Amoroso*. Once back in the United States, Holly contributed to the PBS productions *Reading Rainbow* and *Puzzle Place*. Following her work for PBS, she went on to produce numerous commercials and feature films, including *Lady in the Box* and *Reeseville*.

Finally, with notable experience under her belt, Holly decided to return to her true passion, uniting political purpose with art. In 2004, she made her directorial debut with *Hummingbird*, an inspiring documentary about two nonprofits in Brazil that work with street children and women who suffer domestic violence. The film shows that one person truly can make a difference in the lives of others. *Hummingbird* won numerous awards, including Best Human Rights Documentary in Rome and Best Short for Children's Advocacy at the Artivist Film Festival. The film also appeared on PBS and has found a home on library shelves across the country.

Most recently, Holly produced two films about the dangerous and misleading tactics of the pharmaceutical industry. The films, *Side Effects* and *Money Talks: Profits Before Patient Safety*, received unprecedented international press attention and have been heralded for raising awareness about an important issue.

Holly talks about tackling social issues while remaining a financially responsible filmmaker.

Throughout your very consistent career as a producer, what methods have you found to be most effective when it comes to fundraising?

After moving to Los Angeles, for a while, all I'd hear from people was about making horror films because they wanted to make money on

foreign sales. But in my opinion it is not worth the years of my life that I will dedicate to making a film, and following it through distribution, for the tiny amount of money that you may make in that market. How much are two years of your life worth? Do you really need to make a horror film just to get your leg in the door, or are you trying to make a career of films that you wanted to make and believe in? Unless of course you are a horror fan—then go for it! But I say from experience—follow your heart and only make films that you are dying to make, because you will be married to that project for years.

> Raise the money making your investors believe in what you are bringing into the world and the value it will have regardless of whether it may be that long shot that actually hits.

Now that I have a track record of making socially conscious films, I feel more comfortable in the fundraising position. I try to do every project that I can as a nonprofit and ask people who will also believe in the project as an artistic vehicle for social change.

Filmmaking has often been compared to gambling in that it can be such a long shot. There is very little money in distribution unless you are a big studio and making most of your money on your blockbusters. So you raise the money making your investors believe in what you are bringing into the world and the value it will have regardless of whether it may be that long shot that actually hits.

How does investing in a film you're also producing change your view of the project?

I actually hate feeling responsible for other people's money. When I have worked with directors who brought in the financing, it's been a relief. I knew that I would do my best to give them what they wanted, but ultimately they were responsible for the bill. When I brought outside investors to the table, I found myself disagreeing with the director more, because I felt my role was to protect the investment and the investors. That often created a lot of tensions that I didn't previously have, which were not easy to navigate. I'd find myself thinking about marketability first and foremost, and the project would move away from being the director's piece.

After fighting so much with one of the directors I worked with (really, it did get nasty), I learned a lesson. If I have put some money into a project, I try not to be too heavy-handed in pushing my opinion, but I do gently guide the director with my past insights and hope that they will come to the same conclusions that I have come to.

One of the investors of the second thriller I made said to me that he was just excited to have been a part of the process—that it was fun for him. Now in these tight economic times, that might not be the case, but if people have money to throw around and they get to come to set and maybe hobnob with a star, the whole thing might be worth it for them, even if they don't ever see a dime. Hearing that was also a turning point for me and lifted that weight of the world from my shoulders, because until then I had been carrying around the idea that I somehow *had* to pay investors back. Having only lived in the film world, I didn't realize how many ventures these venture capitalists invest in actually fail. Although they may not be happy, they really are aware of the risks.

With the film I directed and that only had my money in (or fully donated money), it was such a relief to know that I was the only one responsible for the outcome and could run the show the way I wanted without any hesitation. For instance, I like to take away deadlines if they aren't necessary and just let the film happen at its own pace. Most people will want to work at a good clip and to the best of their ability anyway.

I prefer if people on the crew can make the film and balance it with other projects so that they aren't worried about paying their bills. This way, everyone continues to be in it because of the film's artistic value. Unfortunately, I know that it can't always be done this way, but it is really nice when it can.

> I prefer if people on the crew can make the film and balance it with other projects so that they aren't worried about paying their bills. This way, everyone continues to be in it because of the film's artistic value.

Also, if the funding is my own, I feel more willing to take bigger risks that I wouldn't necessarily take with other people's money. I am much more protective with other people's money, and I have seen other producers I've worked with who are the same way. I understand the idea in Hollywood of never putting your own money in a film. It usually will just put you into debt.

That said, it has often been worth it for the other gains—the lessons and life experiences you get out of it.

Having done both docs and narrative features, is the business behind the two any different?

Documentaries that have a cause are easier to raise funding for because people are used to supporting activism. Foundations often realize the value of getting behind a film that can educate people to the problems going on in the world around us. I think it is much harder to raise money for a narrative film as a nonprofit, although not impossible if you are passionate and believe in your project. Friends and family with access to funds are always helpful though.

Also, I think in spreading the word about the film afterward, you will have a much bigger built-in audience around a documentary because there will always be that core group who really care about the topic of your film. Unless, of course, you made a film about a relatively unknown subject that nobody but you seems fascinated by.

On the other hand, a documentary actually may have far fewer outlets on television. So it is a toss-up. If you make a really high quality narrative with great characters and a great story, you might get a much better release and more notoriety.

What ancillary markets exist for documentaries that do not for narrative films?

A lot of high schools and universities will screen documentaries for relevant classes, which is a market that is not open to narrative films. Also, more libraries will take independent documentaries versus independent narrative films. And as we all know, there are thousands of schools, universities, and libraries out there, so this can be a significant market. I know that is also how New Day [a member-owned distribution company comprising more than one hundred independent filmmakers] succeeds in helping filmmakers make some money on their films. It can also be a challenge, though, because some teachers will get the film on Amazon or rent it from Netflix and not abide by the public screening rates.

Filmmakers need to make it clear on their websites that when their films are screened in certain settings, public screening rates apply, and have a rate listed for that opportunity.

How did you secure the financing for your narrative film Side Effects?

Kathleen Slattery-Moschkau, the writer/director behind *Side Effects*, raised most of the funds herself (within a month) through private investors. She had successfully run a temporary staffing agency for pharmacists and also had ten years of sales and marketing experience behind her from her past career as a pharmaceutical sales rep. So people in Madison trusted that her filmmaking venture would also be a success. It was very hard for her, just as it had been for me in the past, to see the film not make the money back that she hoped for. We are still pushing ahead by securing different avenues of distribution, and we believe that it will make its money back, because we were really lucky to cast the up-and-coming Katherine Heigl. But even having one of the country's hottest stars does not guarantee money in your pocket in the very difficult-to-navigate waters of film distribution.

Did you begin with a festival strategy targeting larger film festivals?

I try to start out with bigger, more well-known festivals, but I don't sacrifice the quality of a film and rush the finished product just to make a festival deadline. Sometimes I have been happy with a Sundance rejection because I knew there would be no way we'd really have the film finished in the way it should be. I have been very happy premiering several of my films at Cinequest, which I have found to be the most helpful festival I've been in. I find that they are extremely well organized and really care about the community of filmmakers that come. I also saw this with the Florida Film Festival.

The panels at Cinequest brought in top-notch people from the industry, and the festival gave us the chance to spend time with distributors at the nightly gatherings. I have remained friends with so many people I met at that festival. It was also days after we premiered *Side Effects* at Cinequest

that our three-quarter-page article came out in *USA Today*. After playing at a top festival like that, I am happy to play anywhere else.

With my latest film, *Free For All!*, because of the timeliness of the subject matter, we felt we had to get the film out immediately and make it available online for free before the elections. Unfortunately, when you are covering a topic in a documentary that the mainstream media is ignoring, you have to forgo your aspirations of where the film could go in order to do a greater service to the public and get it as widely seen as possible as quickly as possible. I think as the mainstream media quality is declining, that kind of decision is being forced upon many documentary filmmakers, in order to do what is better for society.

What did you do to ensure your best chance for acceptance into your first festival?

I always put together a nice press kit with all the basic info that they all ask for. They will want to make sure you have good stills for their program, and they want to know that you will be easy to work with and help get them what they need so that they can do their jobs. You have to remember that putting together a festival is as crazy and hectic as making a film. And you need to respect their time.

You should find a film similar to yours that has played elsewhere and try to follow their steps. Apply to the festivals they were in, because if the programmers liked theirs and yours is similar, they will likely program your film as well. Or with a distributor, look to ones who have films like yours and will know what to do with it.

I try not to take any rejection personally. For example, *Hummingbird* was often compared to *Born into Brothels*, and I had the misfortune to be on the festival circuit at the same time as they were, so there were several festivals that said they couldn't play my film because they had already programmed *Born into Brothels*. One woman said she'd actually prefer to play mine because it would be a premiere. So if you are rejected, try to

> Find a film similar to yours that has played elsewhere and try to follow their steps. Apply to the festivals they were in, because if the programmers liked theirs and yours is similar, they will likely program your film as well.

get someone on the phone and find out what is going on. Also, if you're rejected, you might be able to get a copy of the comments of people judging your film.

In fact, with *Hummingbird*, I completely went back to the drawing board after I had screened it as *In the Eyes of a Child* at Cinequest. Luckily the programmers were honest enough with me to say that they liked it enough to program it but that some of the people on the panel thought it was too educational. At that point, I saw that the film was not hitting people the way I wanted, so I went back and started working on it from scratch with a new editor and spent another year having my editor work only two afternoons a week on it. For my first edit I had my editor working for only eight weeks. I thought she did a great job, but it was not enough for a documentary where you have to really finesse the footage to tell the story that first inspired me. I am so happy I went back and made the film I had always envisioned.

Because of that experience, when we made *Money Talks: Profits Before Patient Safety*, I knew it was very educational and so I didn't bother submitting it to festivals, because I knew that it wouldn't be a "festival piece." Instead, it went straight for library and educational sales.

When Side Effects *was rejected from the larger festivals, how did your strategy regarding selling the movie change?*

The first film I produced, *Lady in the Box*, started its festival run at CineVegas, where it unfortunately ended up playing at one in the morning. Luckily I had convinced enough people to stay for such a late screening and the programmer from Cinequest saw it and then asked us to screen there. So we were extremely lucky to play two such great festivals right off the bat. I also went to both festivals and spent time meeting as many people as possible and going to their panels to learn more about the whole film world. The festivals were my schooling on what to do with a finished film. In film school we were taught how to *make* a film, but I don't think they even offered any classes on what to do *after a film is finished*. Or if they did, I was oblivious to it all.

So for a while, I believed the stories I'd hear about not selling DVDs at festivals or not letting a distributor see a film outside of a festival.

Then I realized that there really are no hard-and-fast rules for any of this, and you have to think about what is really best for that particular film.

Sometimes lots of smaller festivals will really embrace your film, and you will rack up awards—whereas you would have been buried at a big festival.

There were smaller festivals where I just felt so embraced and appreciated and stood out. I loved the Eureka Springs Film Festival, the Black Point Film Festival, and the Raw Lifestyle Film Festival for these aspects. There are a few crunchy towns in areas of the country that are pockets of really lovely people. I am so happy I went to and sold DVDs there. I still keep in touch via e-mail with some of these people and in fact they have become very supportive of my future endeavors. So sometimes you have to look at the smaller festivals as opportunities to build audiences for your next projects. I keep growing my e-mail list with each festival I go to.

Did you set up distributor screenings?

Yes, with the fictional films and with *Free For All,* I set up screenings in both New York and L.A. and tried to get all the distributors to go and see them there. We usually got at least a handful of distributors interested in being our sales agents from these screenings.

What would you have done differently in preparing for your film's debut?

I wish I had a better handle on successful street team marketing. I think this can really make the difference in how a film is getting talked about and in filling seats. The people who I saw as most successful usually had a handful of people helping them to help spread the word. The more people are talking about your film, the more people might overhear others talking about the film, which can grow exponentially if you're lucky.

Also if you have a film about a topic with an interest group, I would recommend getting involved with the groups who have that interest early and have them ready and waiting to see the film. I often found myself trying to get in touch with them too late, so, while they've shown enthusiasm, they weren't able to get the approval or to make announcements soon

enough. People need advance warning to make the time to go see a film and support it.

Any advice you'd like to pass on to other filmmakers regarding the creation of hype?

At a festival, you have to be shameless and talk your film up from the moment you arrive to anyone and everyone who is going to the festival. Obviously not to the point of annoyance, but at least give a mention and have your pitch down as to why they will want to see your film. I came up with tag lines for each film and tried to keep them fresh.

Also, the gimmicky marketing tools—give them something to take home or to hang onto that they might talk about with friends. Try to make it something useful, so that it won't go straight in the garbage. With *Lady in the Box* we made key chains that were buoyant and went in all of the distributors mailings. With *Side Effects* we gave away mints in pill bottles. With *Free For All!* we made condoms that said *"Election Protection—Don't Get Screwed at the Polls."*

Did you have a sales strategy that included film festivals as promotion after a potential sale?

With *Hummingbird*, I started selling my DVDs at the first film festival, since I really thought the festivals might actually be my biggest market for the films. I am very happy I chose to do this, because as I started sending out the film, I got the responses that American television really doesn't embrace films with subtitles. I was shocked at first but then realized that I couldn't think of many that I had seen lately. So I was glad that I was selling DVDs directly at the festivals. Sometimes it would even cover the cost of my trip. I even sold sixty DVDs at one screening, which was a highlight.

What led you to the decision to choose self-distribution over selling the movie to a distributor?

It was interesting because we did have a couple of offers for *Side Effects*, but they just didn't seem like they made sense. One company wanted

to put us on five hundred screens, but the marketing budget they said they were going to put into it didn't seem adequate for what I thought it would take to be on five hundred screens. I was worried that they didn't really know what they were doing and were over-promising in hopes that they could just make money on DVD sales. Also because I had gotten a direct deal with Marcus Cinemas in the Midwest on previous films, I knew how much you needed to minimally advertise in a city to fill some of the seats.

It is here that the independent filmmaker is at a real disadvantage, because the studios get much better advertising rates. They are buying ads from newspapers and TV and radio stations weekly, whereas being a one-time buyer we had to pay higher rates if we couldn't get a really sympathetic ad sales person to give us the best deal.

I think since we were watching Katherine's [Heigl] career much more closely than the distributors were, we saw her true potential earlier. Also, because of the experiences of working with a company that had promised a wider release and then gone bankrupt, owing us money, I just felt that I knew that we would work harder and push the film more than any of them would. Unless it had been an initial offer from one of the bigger companies, I was just leery of trusting one of the smaller companies to do justice to our film at that point.

I understand now that distributors have to keep promising filmmakers that they can make them money because otherwise filmmakers would never sign over the rights to their film to them, just to see the film go a quarter of the places you think it will go. I see the DVD world falling apart, first because of Blockbuster making all the mom-and-pops go out of business, and then because of companies like Netflix giving Blockbuster a run for the money, and now because of the invention of Internet downloads, putting the whole idea of DVDs into big question. It is a quickly changing world, and everyone is wondering: Can you drive millions of people to your site to pay a quarter for your film? Maybe if they have heard good things about it, but how do you get millions of people talking about your film enough to get them to your site in the first place?

I think that the best lesson is to know that even as much as you learn on each new project, the marketplace will be evolving. Each film will be

different and times will be different, so you have to try to always think outside of the box and figure out what is best for you.

Any advice on the right approaches to self-distribution?

As you are making the film, you should already have in the back of your mind where you want the film to go. Think realistically about what will make you happy. Is it more important to try to recoup your money, or is the film a calling card for the distributors whom you might want to make a relationship with for a second film? Or do you want the most viewers possible? Prioritize what is important and know why.

> Is it more important to try to recoup your money, or is the film a calling card for the distributors whom you might want to make a relationship with for a second film?

We are in changing times, so there are no hard-and-fast rules. You can distribute on the Internet sometimes and then be in festivals. With *Free For All!* we were online first and then because of our topic many festivals are choosing to screen the film anyway. Many festivals are finally seeing that it isn't most important for them to be the premiere festival like a lot of them wanted to be in the past. Obviously the top-tier festivals can still demand this, but the others won't hold it against you. The way I see it, people still watch films from years ago on TV or will rent old movies, so the whole idea of having to be the first with anything, whether it was theatrical or with festivals, just doesn't fully add up. For them it is a marketing tool to say that they premiered a film. But you are not taking away from an audience just by it having played elsewhere.

Also, you will want to think about timing. When is it the right time to give the film to Netflix, if it might detract from your online DVD and download sales? If it is a documentary, do you want to give a window where it is only available at the higher price for educational sales? How long will you try to get a TV deal before you release it in other ways? It is easy to get swept up with what is happening at the moment and forget your bigger picture, so if you can, think through all the hypotheses ahead of time and know how you feel about things.

Eventually Side Effects *was picked up by a larger distributor (Warner Bros.). Do you feel the initial self-distribution push helped demonstrate to a larger distributor how the film might be marketed and sold?*

I feel like in our case, it actually helped in several ways. We did really well in our theatrical release within the context of our advertising budget. There was one opening weekend in Portland, where we were the number one film, beating out a Charlize Theron film without nearly the amount of ads that they had. We also sold out at the Museum of Modern Art in Boston. Originally they had been worried that we were too mainstream, but we had great feedback from the theater afterward saying how it was such a hit with the audience. It fed us to keep going on.

Although in the end I think Warner Bros. took *Side Effects* on the star quality of Katherine Heigl, I feel that the film has been a huge success with a first-time writer/director and with a very tight budget and shooting schedule.

The other thing that I think helped in the long run is that Katherine's star power actually rose considerably over the year that we were struggling distributing the film ourselves. So by the time we were ready to sign a DVD deal, she was huge. I still wish we were getting more up front than we did, and I actually think that WB should have considered releasing it theatrically again. *27 Dresses* grossed well over $70 million mostly on her name, so I would think that since we only played on one screen in ten cities back in 2005 before she was a household name, we barely made a dent in the theatrical potential. I think if they ran the type of advertising campaign that a major studio can afford to do, they could have made a windfall on a really low-budget film. But I am happy to see that it will at least be widely released as a DVD.

Is there a best time to get good press?

I think the timing with the press is important, but it is hard to control. Our mainstream press for *Side Effects* actually hit too early before the DVD was available, so we lost out on a lot of sales. If we had already had it available at that point, we might have done a lot better on our own.

I found that it is easier to get press in the smaller cities where we played because they are looking for news. In larger cities you are competing with so many things going on. Also I think it is good to partner with local groups so that they can be mentioned as hosting an event and getting their members out to the screenings. This takes a lot of time and legwork but is worth it.

> Partner with local groups so that they can be mentioned as hosting an event and getting their members out to the screenings. This takes a lot of time and legwork, but is worth it.

Always try to get to the press with enough lead time so that they can see the film and write about it. Get reporters to your film before it screens in a festival—they won't write about a festival after it's over. It is their job to tell their readers which films are worth seeing at the festival.

What was your best festival experience?

Probably my first festival. I learned so much from going to CineVegas, and I saw great films. I had actually never even been to a film festival before, so I had no idea what they were all about and what it could mean to a filmmaker. I stayed at the festival all week, I went to many discussions, and I talked to anyone and everyone about independent film. I became hooked on how great being a part of this community could be. In high school I loved going to art house films, and here was a whole week of it. It was like the best vacation ever. And then when you have your screening and people love the film that you just spent over a year of your life on and you have that live feedback of them laughing at the funny moments or jerking at something scary, it is amazing and extremely addictive.

What are the most important lessons new filmmakers should keep in mind when embarking on their festival experience?

You have to remember that the festivals are just a part of the promotion for a film. You are raising awareness and seeing if the film plays well with

audiences and if it will have legs. Depending on the response, it will either fuel you to want to take the film as far as possible or it may be the end of where you try to go with the film.

PAUL OSBORNE
Screenwriter, documentary filmmaker, producer, trailer editor

FILMS: *Ten 'til Noon, Official Rejection*
FESTIVAL EXPERIENCE: Screened films at deadCenter, San Francisco Independent, San Diego, Phoenix, Ft. Lauderdale

..........................

"What's most important in taking your film on the circuit is finding its audience."

Paul Osborne grew up writing scripts, putting on plays, and shooting Super 8 movies. As a high school senior, he won a statewide scriptwriting contest held by Denver's Gates Planetarium, and his winning entry was turned into a show.

Determined to go to film school, he ended up at the University of Miami in their motion picture program. After graduating he took the path many follow, working odd film jobs as a production assistant, second assistant director, props, camera assistant, or production manager. Paul moved to Los Angeles to pursue a career as a screenwriter and made a living as a film editor specializing in motion picture trailers. Through it all, he found the spare time to be the key creative force behind two indie features.

Paul talks about taking his screenwriting/ producing debut feature, *Ten 'til Noon*, on the B-festival circuit and his documentary that dispels myths about film festivals, *Official Rejection*.

Paul Osborne

Tell me about your role in Ten 'til Noon
and how the concept came about.

Ten 'til Noon was a spec script I wrote that was specifically crafted to be easy to make. The concept was that the entire film takes place within a single ten-minute time span, and sequences are presented in real-time intervals. I love playing with time as a writer because it's very freeing. A large part of storytelling is just information management—telling the audience what they need to know, when they need to know it, to maximize the effectiveness of the tale—so not being locked to a linear time increases that control.

The way you're supposed to conceive a script is to think of a story first and then come up with a clever way to tell it. What I did was ass-backwards—I came up with the clever device first and then conceived a story to fit within that construct. I was driving home one day and simply thought it would be cool to have a movie locked to one limited time span that would repeat over and over, each time in a different location with new people, until the whole thing came full circle. I was like, hmmm, one minute? No, too short. Thirty minutes? Nah, too long. Fifteen? Too irregular. How about ten? Yeah, ten'll work. By the time I'd gotten home, I'd already figured out most of the story. Then I wrote an outline and had the first ten pages by the next morning.

In my unsuccessful trials to mount a career as a Hollywood screenwriter, I'd become good friends with Scott Storm, a very talented director also not having much luck getting work. He read a script of mine called *All About Evelyn*, loved it, and we decided to team up and try to get it made. It was good enough to get into development in a few places, but then it routinely languished there. Finally, after a few years of this, I suggested we raise some money and make something smaller on our own. He agreed, and I gave him a stack of scripts, and out of those he selected *Ten 'til Noon*, which he felt was the most unique and easiest to make on a limited budget.

We formed a company and raised the money together, which made me a co-owner and "boss." It was an interesting position because Scott and I, serving as executive producers, lorded over everything. There was very

little money but so much control. It also meant every problem fell on our shoulders. Such is the tradeoff of going independent.

Ten 'til Noon came to life as a little indie flick with no big actors and a budget of under a hundred grand.

What did you do to ensure your best chance for Ten 'til Noon's acceptance into the festival?

It's boring to admit, but we didn't really do anything for Sundance beyond the straight application. Our sales rep, I think, did try to get the attention of Geoff Gilmore and a few others on our behalf, but we signed him about a month after applying and I'm sure by then the schedule was pretty much set. Our rep also worked the inside track at SXSW, where we apparently split the committee, but ultimately he didn't have enough juice to get us programmed there either.

There's a pretty good trick that a friend of mine, John Daniel Gavin, did when submitting his film *Johnny Montana* to different festivals, although it was a fairly risky one. He would send, as his screener, a fully labeled, blank DVD. John found that, if the festival was doing its job, when they discovered the DVD was blank, they would call him and let him know. Usually it was the programmer who would make the call, and so suddenly John would find himself on the phone with the person he most needed to impress. He would apologize for "accidentally" sending a blank DVD and then would get about thirty seconds to pitch and excite the programmer about his movie. This way, when the new DVD would get to the festival, it was no longer "just another movie on the stack" to the programmer. This technique also let him know which festivals took his application fee but never watched the movie. Apparently there were several.

What other festivals did you apply to?

We applied to fifty or sixty film festivals, total and were accepted to fourteen in the end. We hit up most of the biggies—Sundance, Slamdance, SXSW, Tribeca, Los Angeles, Cannes, Venice, plus a fair number of

regional festivals. I don't remember all of them, but there were a lot. We probably over-applied, and as the year went along we refined our criteria for which ones we should submit to.

Any advice to others on applying to festivals in general?

I think a good piece of advice is, honestly, if you have a little indie movie with no stars and no industry connections, to think carefully before applying to a major film festival, especially Sundance or Toronto. Not that I'm saying you shouldn't apply—far from it—but I think there are things that every filmmaker should consider before doing so.

First, you should take as unbiased a look at your movie as possible and ask yourself, how good is it, really? This is a tremendously difficult thing for a filmmaker to do, because it's nearly impossible to be objective about something you've been working for months or years to complete, but still, deep down inside of everyone there must be some measure of honesty that exists about your own film. Facts are facts: Most indie movies suck, so chances are, yours does, too. Your friends and family aren't going to be honest with you, and frankly, they may not even be capable of it. They've seen you slaving away tirelessly, and just the mere fact that you completed the film is enough for them. But the real world cares about quality, so take a good, hard look: Are the performances really up to snuff? Does the movie actually look like a real movie? Is the script you wrote, now fleshed out and on screen, compelling enough to support a feature-length running time? Try to look past the effort you've expended and see the film the way someone who'd never met you would. Does it compare to other movies you yourself have paid to see, or is it really just an okay first attempt with more promise than successful realization? Major festivals have the pick of the litter, so unless you've made a pretty damn good movie, your odds of getting programmed by Sundance or Toronto or SXSW aren't low, they're nonexistent.

> Ask yourself: Are the performances really up to snuff? Does the movie actually look like a real movie? Is the script you wrote, now fleshed out and on screen, compelling enough to support a feature-length running time?

Secondly, don't submit your film unless it's actually done. Just because the Sundance deadline is coming up doesn't mean you should

send whatever latest cut you happen to have to them. I've spoken to so many filmmakers who submitted a three-hour rough cut of their movie and hoped the festival would "see the great film inside the work in progress." Well, guess what—they won't. They've got several thousand completed works to consider. I read multiple interviews where Geoff Gilmore has echoed this exact sentiment. If your film isn't done, save your money.

Third, there are one's own personal finances to consider. Submitting to Sundance is like buying a lottery ticket, and the odds of "winning" are about the same, but the Sundance application doesn't cost a buck, it costs a hundred bucks. One should never gamble with the rent money, and if your budget for getting into festivals is super-tight, you might want to consider spending that fee on a more attainable festival, because chances are, all you'll get from a major film festival is a form letter. If you don't have cash to spare, save your money.

I'd like to add that these points to consider aren't just about one's own finances but are also about extending consideration to the other filmmakers out there. The fact is that programmers are overwhelmed with a crushing number of submissions, and good, deserving films can get lost in the shuffle. If there were fewer films submitted, the films that do apply would have better chances. One day you may find you've made a really good flick, and wouldn't you appreciate it if other filmmakers whose movies were not ready for prime time, for whatever reason, didn't distract and clog up the programming channels?

Were you concerned about applying to other festivals before you got word from Sundance?

We were only concerned with making sure we didn't apply to festivals that took place before Sundance and Slamdance. We knew Sundance was a long shot but, because Scott was a Slamdance alumni, we felt we had a great chance of getting a special screening slot there, which would have certainly been fine for our world premiere. It was pretty cocky and foolish on our part, frankly, but we figured anything after the Park City festivals would be safe to apply to. Of course, we didn't get into Slamdance either.

> What's really difficult when you have a tiny indie film with no big-name actors is figuring out how long to hold the door open for the major premiere festivals.

What's really difficult when you have a tiny indie film with no big-name actors is figuring out how long to hold the door open for the major premiere festivals. The fact is that, in today's indie landscape, Sundance, SXSW, Tribeca, Los Angeles, and Toronto are almost predisposed to reject the little films outright, so if you really just wait for one of them to bite you might never actually play anywhere.

In terms of *Ten 'til Noon*, we withheld committing to a premiere until SXSW rejected us, and then decided it was better to play where we were wanted rather than hold out further. Our sales rep was not at all thrilled, and it was a questionable decision, but in the end I still think it was the right one. We started a lengthy run of smaller regional festivals that got us in front of eager, receptive audiences.

Our premiere ended up being at the San Francisco Independent Film Festival, which is literally run out of a van. That said, they have a terrific relationship with their local audience, and if you play there it will be to packed theaters full of real indie film lovers. That festival has no real sponsors and stays afloat almost entirely through ticket sales. You won't get the Weinsteins to see your movie there, but you'll get a real audience.

How did you react once you knew that you were rejected?

When we got rejected from Sundance, I think it hit Scott harder than it hit me. Our cinematographer, Alice Brooks, had gone to Sundance for years and she was convinced we would get in because she felt *Ten 'til Noon* was significantly better than most of the stuff she'd seen there. I knew we had nearly zero chance. My reasoning was that Sundance has the pick of everything, so if they're showing movies inferior to ours, then quality isn't the only deciding factor for them, and therefore our quality wouldn't help us.

The very first festival to get back to us was the San Francisco Independent Film Festival, and they accepted us with a phone call on Thanksgiving Day. Then we got hit with a wave of about twenty to twenty-five solid rejections—Sundance, Slamdance, Sonoma Valley,

Palm Springs, SXSW, Cinequest, and so forth. Cannes rejected us within a few mere weeks of our submission, and just to be sure we got the message, they did it twice. We got two different rejection letters from them in multiple languages. It wasn't enough for them to say "no"— they really wanted to make it a clear "fuck no." Sundance sent us two letters as well, both allegedly signed by Geoff Gilmore, but each with different signatures.

How did you prepare for your first screening?

Our world premiere was white-knuckle time, because we felt we'd made such a concession by premiering at a smaller festival and therefore would forever be excluded by the major fests—the only thing that could redeem us would be to have great audience turnout. The "theater" they booked us in was in some odd building in a quiet residential area, so we took to the streets for a couple of days to promote the movie.

To get people into the theater we did everything we could think of, from papering the neighborhood around the venue with fliers and posters, and handing out cards and glad-handing passersby, to trying to get covered in the local media. I remember even buying a few tickets for people and giving them away if I felt the recipient would then encourage their friends to come along.

The festival cleverly made an arrangement with the local Apple store so filmmakers could do a presentation in the in-store theater. We participated in this and then in future festivals contacted Apple stores in other cities directly to find that most were willing to donate a timeslot to us. They need to fill that theater time, and letting us play our trailer and stuff was just fine with them.

What promotional elements did you create, and how did you pack the festival screenings?

We created the usual postcards and flyers, but the big thing we were armed with was full-sized one-sheets. Normally those big movie posters are really expensive—$60 to $80 per unit—and so filmmakers tend to only make a few at a time. But one of our producers made a connection

with a company that printed these in mass quantities and secured us a deal where we could print the posters for a dollar apiece, provided we ordered a minimum of one thousand. Finding a thousand bucks to make posters was difficult, but we knew over the course of our festival run we'd probably end up making twenty posters at the higher rate and spend more money overall.

As a result, we had way more posters than we could handle, so we would bring stacks of them to our screenings and give them to people in the audience at the Q&As. Folks were excited to get those posters and started asking us to autograph them, so we got in the habit of bringing silver Sharpies and several times found ourselves in marathon signing sessions with enthusiastic fans. It was, of course, a huge ego boost for us personally, but I think it really enhanced the festival experience for the audience because this was something they never got to do when they went to the movies normally.

We also created an electronic press kit, which was basically a master tape with our trailer, behind-the-scenes footage, and film clips on it. We had this available for festivals that received television coverage, because if a local station did a montage of movies at the festival, we wanted to be in it.

Paul Osborne (at left) and *Ten 'til Noon* director Scott Storm

In the end, though, the turnout at our screenings depended less on the work we did and much more on the individual festival's relationship with its own local audience. If a festival had built up an audience over the years, then generally those people would come see the movies they played, and our efforts were more just to steer them toward our specific film. However, if a festival didn't have much of a loyal local audience, then there was little we could do to convince people to forgo seeing the latest Tom Cruise movie and come to ours instead.

How helpful was the cast in promoting the movie?

We didn't have any big-name actors, so we couldn't trade on that, but whether they're famous or not, people still want to meet the onscreen talent, so whenever we could get them anywhere, it helped. The audiences liked seeing them at the Q&As, and the festival directors would usually give our film more attention if we could get them there. Of course, if we'd had big-name actors their presence would have carried even more weight.

Ten 'til Noon is an ensemble film, and we had a large cast, so as long as a festival wasn't too far from Los Angeles we could get at least a few actors there. They were generally pretty game and supportive of the movie. Some of them would get flakey about showing up, but that tends to be the nature of people in the business in general.

The trick is to be good to your cast and stay in close touch with them, e-mail them updates, and make them feel included. There's really no reason not to anyway. This keeps them invested in the movie and its fate, and they'll be more likely to come support it. You have to remember that you may have slaved over a film for the last year, but all their work was done during the very small window of production—say, two to four weeks—and for them this may be only one of several projects they've got coming out. Anything you can do to keep them involved and emotionally tied to the movie will increase the support they'll give it, and that will always benefit you in the long run.

The trick is to be good to your cast and stay in close touch with them, e-mail them updates, and make them feel included.

Did you hire a publicist, and if not, how did you do your own PR?

We didn't have the money to hire a publicist, but one of our producers, Brian, had a publicist friend and got her to agree to do some pro bono work for us. She wasn't specifically a film publicist, and the services she offered were limited—basically, if we wrote a press release, she would blast it as an e-mail to all the appropriate press in her address book, and

then if anyone responded wanting more information, she would pass the request on to us. We managed to get a little coverage in some trade magazines as a result.

With the festivals, though, we were on our own. If we could wrangle a local press list we would contact all the outlets ourselves and try to get coverage. Thing was, unless the press was already covering the festival, they usually didn't care, and often we would get the press list so late that there wasn't enough lead time for anyone to do a story on us even if they were interested.

The only outlet we really could make any headway with was the Internet, using sites like MySpace, which only generated mixed results, but at least we could usually pitch straight to our audience. A typical tactic would be to find a user group that was in the same city as a particular festival—something like "UCSD Alumni" in San Diego, for example. We would then send a friend request and e-mail to each individual in that group whose movie tastes, as detailed in their profile, made them seem like someone who might like *Ten 'til Noon*. For every hundred or so friend requests we'd probably get an average of five to accept, and for every hundred who accepted maybe two or three would actually come to a screening. But we did this in such volume that it helped goose our numbers, and it certainly did indeed spread the word about the movie.

Some festivals allowed us access to their own publicists, and when they did we'd get a lot more traction. The San Diego Film Festival, to use them as an example again, has a kick-ass PR firm behind them and managed to get us on three local morning television shows the day of our screening. We ended up being sold out with a line of people around the block waiting to get in.

Were you nervous at the first screening, and if so, how did you deal with it?

Our first screening was actually a cast-and-crew/family-and-friends screening of the film. We looked for a theater we could rent with high-end HD projection (*Ten 'til Noon* was mastered in HD) and wound up booking the Pacific Theatre in Hollywood, which seats 1,100. We then invited everyone we knew, because if we didn't come close to filling the

place, the screening would feel empty and lame. We ended up with about nine hundred people—pretty much everyone we'd ever met. So yeah, we were nervous. If the film didn't play, the only way we'd ever live it down would be to fake our own deaths.

Fortunately *Ten 'til Noon* played through the roof at the Pacific, but of course I realized a simple truth afterward: Every film's cast-and-crew/family-and-friends screening plays great. It doesn't matter if it's the best or worst movie ever made; the audience is already predisposed to love it, and that will undoubtedly be the best screening a film ever has. That said, when we had our first public screening, which was our world premiere at the San Francisco Independent Film Festival, we had to go through the fear of our movie's playability all over again.

What did you learn from that first screening?

We learned that *Ten 'til Noon* did play much the way that we'd hoped with an audience of people we'd never met, that the moments we wanted the audience to have strong reactions to did evoke those reactions. There was never any impulse to change anything in the movie. We also learned there were moments they responded to which we never thought they would, laughs in spots we felt there weren't.

We were fortunate that was the audience to pop our cherry. This was, again, the San Francisco Independent Film Festival, so it was a liberal, indie-friendly, open-minded bunch who received our R-rated, edgy, violent, sex romp with open arms. We experienced varied results in different cities with their specific local tastes, and over time you realize that no two audiences are alike.

The polar opposite of the San Francisco audience attended our opening screening at the Phoenix Film Festival. We'd gotten a four-star review in the local newspaper, and our first showing was on a weekday morning. So what kind of people like the arts, read the paper, and don't usually work during the week? Why, that would be retirees. Never mind the review warned readers the movie contained extreme violence, language, and sexual content— it was a four-star review, and having seen it an army of the elderly eagerly poured into the theater to watch our film.

They were dead silent during the entire thing.

Once it was over, there was a massive bailout, and the few that stayed for the Q&A did so because they were upset. Arizona is a relatively conservative state, and the over-seventy set tend to be the most conservative of that group. One woman physically cornered me, demanding to know why I felt the need to write dialogue with so much profanity.

In defense of the elderly, we had another screening largely populated by retirees at the Fort Lauderdale International Film Festival, and they were very much into it. They were loud during the movie and complete geeks at the Q&A. And for the record, our other two screenings in Phoenix went over really well.

Were you prepared for the questions from the audience?

I didn't think I would be, but I actually was, because most of the questions were things people I knew personally had been asking about the film while we finished it. The only questions you aren't prepared for are the ones to which there are no answers, which is really just members of the audience voicing their opinion in the form of a question, for better or worse. "Do you know how awesome this film is?" Or conversely, "Did you really need to make it so confusing?" There's no real reply to those.

> If someone doesn't like your movie and expresses it to you, you have to respect their opinion, acknowledge the film isn't for everyone, and move on.

One thing you learn quickly is not to defend the work. If someone doesn't like your movie and expresses it to you, you have to respect their opinion, acknowledge the film isn't for everyone, and move on. What's great in our case is our film is very polarizing, with some people loving it and others hating it. Those who hated it would usually leave before the Q&A, and those who loved it would tend to stay. So when a hater would get up and tell us off, it was quite easy to be gracious, because all the lovers in the audience, greatly outnumbering the haters, would first jump to our defense, then heap praise on us.

*What other fests did you play, and can you recount
some of the more memorable moments?*

We played a total of fourteen film festivals all over North America. Some
had great relationships with the local audiences and media outlets, and
we'd get a lot of exposure. Some didn't, but their hearts were in the
right place and if they continue to grow will one day probably be
successful festivals. Others, and these were very few, were basically just
people trying to make a buck with the submission fees and putting as
little effort into the festival itself as possible.

The best festival we played was, in my opinion, the Phoenix Film
Festival. It's run by filmmakers and, as such, is extremely filmmaker
friendly. The festival takes place in one location—all its parties, screenings,
panels, and events are at the Harkins multiplex theater in Scottsdale. The
result is that, once you arrive, you're constantly plugged into the festival.
They get big crowds so even the weekday screenings tend to be full, and
the local press covers everything thoroughly. The only drawback is the
lack of distributors in attendance, but my understanding is that may be
changing.

Some other festivals we played that really had their acts together were,
in no particular order, the deadCenter Film Festival in Oklahoma City, the
San Diego Film Festival, the Newport Beach Film Festival, the Asheville
Film Festival, and the Fort Lauderdale International Film Festival. Fort
Lauderdale runs their movies in this awesome theater called the Cinema
Paradiso, which was once a church and now has an open bar in the lobby.
It's far and away the coolest venue I've ever set foot in.

What did you do to get distributors into your screenings?

If we were playing a festival where there was a distributor presence, our
sales rep, Chris Pizzo, would invariably invite the appropriate parties.
We didn't play a lot of "market festivals," though, so these tended to be
smaller labels.

The only time we got major distributors into a screening was when
we screened the film at the SAG Foundation in Los Angeles, at the

suggestion of then-program director Bob Nuchow. We asked our rep to target all the "Indiewood" majors, like Focus and Fox Searchlight, and some of them did indeed show up. We didn't get the main acquisitions folks to come—they sent assistants—but they were actually there. Nuchow even allowed us to use the SAG Foundation offices to host a wine-and-cheese reception for the distributors prior to the screening.

Our sales rep did the negotiations for us, along with our lawyer, Arthur Stashower. Radio London Films, who ended up being our distributor, was very slow in responding to us once we got to the contract stage, so much so that our rep, Chris, assumed we were trying to somehow stonewall the deal, because it was unfathomable to him that a distributor would take that long during final negotiations. I think it took six months to iron out the paperwork. Chris would call me and exclaim that I was "fucking up the deal" by dragging things out, and I'd invariably have to explain that we were the ones waiting for their reply.

Were there things you asked for that were unusual?

We asked for the right to use unlimited clips from *Ten 'til Noon* in our documentary about film festivals, *Official Rejection*. That was pretty odd for them. And I don't know how unusual it is to retain merchandizing rights, but we asked for that as well. They had never thought about merchandising—it's not something indic films tend to deal with too often—but once we asked for it they got nervous and wanted to take those rights. We ended up sharing the merchandizing with them, but we control it and would make the majority of the income from it. Of course, after all that, there's been no merchandizing done for *Ten 'til Noon*. Yet.

We also had an unusual theatrical deal, which led to us retaining our theatrical rights but with our distributor paying for the theatrical release.

Essentially, Radio London wanted to put the film in theaters to widen potential DVD sales and told us they would pay for the release, but they asked us to do all the work. Their rationale was that they'd never released a movie theatrically before and wanted to learn by watching us, their

test case. Of course, we'd never done it before either, so I think the real reason was, by having us do all the labor, they'd save staff costs.

Personally, I was fine with that because I figured we would care a hell of a lot more about our movie than they would, seeing as how we only had one, which was our labor of love, and they had eight or ten, which they looked at as "product." But we were adamant that if we did the work, we would be in full control of every aspect of the theatrical run. They could consult so the marketing would be consistent from theaters to DVD, but we didn't want to be hampered by having to get approval from them for everything. We asked to retain theatrical rights so we would technically be the theatrical distributor. Radio London would finance the theatrical release in one lump sum, and in exchange we'd put their logo on the theatrical marketing materials.

It was an unusual deal, but we got a theatrical release out of it, which we fully controlled, followed by a nationwide DVD release, in which Radio London did the heavy lifting. And we got to learn how to put a movie in theaters, which was undeniably a terrific bit of education, should we ever need to do it again.

What was the most important thing in determining what distributor was right for you?

Sad to say, it was probably money, but that's only because the other offers we got were so horribly, staggeringly low. Not that Radio London offered us a mint. Far from it—it certainly wasn't enough to cover our negative costs. But in today's market, with so many films looking for a home, unless you've got a big ticket, big-star-filled flick that's played a major festival, the advances you get are pretty tiny—and that's if you can get an advance at all. Radio London offered us twice what the next highest bid was.

But there were other factors—Radio London was willing do to a small theatrical, and others were not. They valued our input into marketing and the creation of bonus features for the DVD, and the others did not. We liked the fact that Radio London was a new company and didn't quite regard us as "just another movie." They were buying films they not

only thought they could sell but felt they could believe in. They were still naive enough to be idealistic. Over the course of our dealings with them, though, we watched that aspect of their character erode and pretty much die.

How did the deal come about?

Our sales rep, Chris Pizzo, did a mass mailing of screeners, and I believe Radio London was on the list. They were a hungry, relatively aggressive new company and bought a couple of his films. We did get some attention from distributors at the festivals, but, in the end, it was essentially our agent doing a mailing that got us the deal.

The best advice is not to put too much faith in the first offers you get, one way or the other. Don't jump on the first offer just because you're afraid there won't be others, and don't be too downhearted if the first offer isn't very good.

Also, I'd like to say it's very helpful to get a sales representative, because it was for us, but we were very fortunate to get an honest one, and many are not. Of course, every filmmaker should try to get their film to the big ones—John Sloss, Jeff Dowd, etc.—but unless you've got stars in your film, they will likely pass. That doesn't mean there aren't good second- and third-tier sales reps, but make sure you do your research before signing with one. Find out what other films they've handled that have been distributed and get in touch with those filmmakers. The Internet makes this so easy to do. See if the people they've handled are happy or not. That will tell you volumes.

Chris Pizzo, who ended up representing us, also represented Joe Swanberg, who has since become the pseudo-famous filmmaker at the center of the whole "mumblecore" movement. I cold-e-mailed Joe on his movie's website, he vouched for Chris, and we ended up with an honest guy handling us.

Also, beware any rep who asks for significant money up front. A rep is essentially an agent for the film, and they will make their money on commission from the sale. If they ask for a few bucks to ease mailing and cell phone costs, that's one thing, but if they ask for a $5,000 retainer, you're being had. Think about it—how hard are they going to work to

get you a good deal if they've already been so well paid there's no more money they can make on it?

Are there any things you would have done differently?

We took the best deal we were offered and got as much mileage out of it as we could, and I feel, by and large, we made the best decisions possible. We got as much up-front cash as we could, because we all know that, with Hollywood's "creative accounting," one rarely if ever sees back-end money. We got the film out as widely as we could. I don't really feel like we made any missteps with what there was available.

The deal was primarily for DVD and TV, but as I've mentioned it included a limited theatrical release. The financials of the deal were that, for DVD, we would receive half of what Radio London brought in after they recouped their expenses, and what they could claim as expenses was itemized in the contract. For TV I think we got a larger percentage.

We did receive an advance, which wasn't nearly enough to put us in the black, but it did pay off all of our actors and some of our crew. And, not surprisingly, that was the last money we received from our distributor.

How are you expected to handle supporting the release of the film?

I think they knew, and expected, that we would be as involved as possible in the DVD release just because of who we were and what we'd already done. Scott and I both have day jobs in film marketing (indie filmmakers generally do need day jobs), and long before any distributor got near us we had done a significant amount of marketing on *Ten 'til Noon*. It was mostly Web-based, but we'd done three different trailers, which were linked on dozens of sites, been a MySpace "featured film," and had tens of thousands of trailer views there. I know that the marketing we'd already done was a huge selling point for Radio London—they wouldn't have to start at zero with our film. With the DVD they called the shots and relegated us to consulting in terms of key art, posters, etc., but they still assumed we would get out and push the movie on the Internet and with the press and festival connections we made. And we did. They didn't even have to ask.

Theatrical was a little disappointing because it's hard to get people to the theater, and although we had a little money we were horribly underfunded. Radio London didn't have a realistic notion of the expenses involved and didn't want to stick their necks out too far on what they sort of considered an experiment. The producers all pulled out a lot of favors to really stretch that money, but in the end we couldn't afford nearly as much advertising as we'd have liked, and that hurt the revenues. Most of our money was spent in Los Angeles, and our engagement there was the most successful. Still, we understood that the theatrical release was really about making enough noise to help push the eventual DVD, and we were satisfied we'd done that.

In terms of the home video release, we were relatively pleased with the overall marketing and subsequent sales, but the film didn't go as wide as we'd been lead to believe it would. The day it came out Scott and I ran to Best Buy, where we were told it would be on shelves, and, well, it wasn't. We weren't aware of how precious shelf-space has become in stores. Apparently now, with every major release coming out in both Blu-ray and DVD, and often with multiple editions (wide-screen, full-screen, two-disc collectors), there's precious little space left for indies. *Ten 'til Noon* eventually did get on those shelves, but it took a few months of decent Internet sales to do it.

There were other market realities that limited the DVD release. Hollywood Video nearly went under and couldn't pay for the copies they ordered, so our distributor didn't give them any. And Blockbuster said they didn't want the film because it was too sexy and violent for them. Apparently they had a fairly conservative executive in charge of what they picked up, and it violated his Christian beliefs. Of course, they acquired mass quantities of *Sin City*, which was ten times more sexy and violent than *Ten 'til Noon*, but hey, that was a big movie they knew would make money. So Blockbuster's got morals, but they're for sale.

What led to your next project, Official Rejection, *a documentary about* Ten 'til Noon's *festival tour?*

As we were getting ready to go on the festival circuit, and discovering all these unwritten rules and political angles that were in the way of us

just showing people our little movie, I realized I should probably educate myself so I'd know better what I was in for. We were jamming, trying to get everything ready, so I didn't want to take the time to read a book, but I figured there had to be a documentary somewhere covering this topic, which would be preferable anyway because I could then see and hear what the festival experience was like. I did a little digging, and guess what—there weren't any films about film festivals. Sure, there were a few IFC specials about ten years out-of-date that only covered name filmmakers at Sundance, but there was nothing current, nothing outside of Park City, and certainly nothing dealing in realistic terms with the ground-level, rank-and-file filmmaker.

Then it struck me: I could shoot our own experiences on the circuit and make a documentary like this myself. It was kind of a horrible revelation, because I felt it was such a good idea that I couldn't pass up doing it, but I was exhausted having spent the last two years working to bring *Ten 'til Noon* to life. It took a lot of effort to grab the camera and start shooting *Official Rejection*, and it was often an awkward thing to explain while trying to participate in the festivals

Official Rejection logo

I attended, but in the end I'm extremely happy with the documentary. I'm glad I didn't talk myself out of making it.

When we started we'd only been accepted to one festival and had played one screening at UCLA. We weren't sure we'd have enough material for a full feature. But once we started shooting and word got out about what we were doing, people wanted to be onboard and talk to us on camera, and within a few weeks we knew we were gonna have more than enough stuff to create a full-length film. Frankly, we could make ten movies on the subject and never repeat ourselves.

What do you think audiences seeing Official Rejection *will learn about festivals that will surprise them?*

I think for those who haven't been on the circuit before, the amount of work required to get your film out there, and to really maximize the

festival experience, will shock them. It'll also open people's eyes to the fact that the festival circuit is as socially stratified as high school, and with as many cliques. There's a perception that festivals are somehow a level playing field, and if you just have talent, you can be recognized. But festivals are as much about commerce as they are art and as much about who you know as how good your film might be.

Official Rejection definitely isn't anti–film festival—the festival circuit is the main lifeline for independent film, and thank goodness for it. We're just trying to give the festival world a reality check, for the benefit of all. Hopefully, after seeing it, filmmakers will make better choices and take more responsibility for themselves, instead of holding festivals up to some impossible standard of being able to accept every single movie with some morsel of worth. And festivals will become more accountable for some of the choices they make.

So many filmmakers get rejected by the big boys and become instantly jaded and bitter, but they shouldn't. There are so many ways to get a film out there, festivals and otherwise. It's important to patiently find the way that works best for your film, not to put an inordinate amount of value on the acceptance of the bigger festivals, and to never, ever, give up. If your film is good, and you can get it to the public, it will eventually connect with its audience.

What promotional materials have you used to promote Official Rejection?

When we were shooting in Park City we brought about a hundred baseball hats with us, and those became hot items very, very quickly. Our logo, which displays the words *Official Rejection* in the festival laurel leaves (the way one would normally see "Official Selection" displayed), is immediately eye-catching, and people thought it was hilarious just by itself. We were wearing the hats and gave away all of our extras in about an hour. For the whole rest of the festival you could look down Main Street and see those hats bopping about, and more and more people would come up and be like, "Where's everybody getting those—I want one!" If we'd known they were gonna be that popular we'd have made a lot more. So wherever we play *Official Rejection*, you know we'll have a ton of those hats.

Is there a right and a wrong way to present your movie?

I think a mistake some filmmakers make is being a little too eager to show their movie to whomever will watch it. There's something to be said about being a little withholding. When I would go to a festival, if I couldn't make it to someone's screening, the filmmaker would often give me a DVD to watch. This always felt like a desperate act to me. I feel it's better to create a sense of "event" around your movie. If someone can't make the screening, they can't see the film. Period.

Now, with regard to press and programmers, of course you should provide whatever screeners they require. But as often as possible I think it's prudent to withhold the movie and build up demand and interest around your screenings. I made my own father wait over a year to see *Ten 'til Noon* because I wanted him to watch it in a theater and refused to send him a DVD. He missed all the festival screenings, but when we were theatrically released he was first in line.

Additionally, here's a tip I hope no one else has given: Don't dismiss shooting your movie on actual film.

With rare exception, every independent filmmaker now shoots in either HD, or DVCAM, or some new high-end, "film-like" video format. But if you've got a decent budget of $50,000 or more, consider shooting in either Super 16mm or 35mm.

> If you've got a decent budget of $50,000 or more, consider shooting in either Super 16mm or 35mm.

First of all, it can be less expensive than shooting in HD. HD cameras and equipment are fairly new, and are in high demand, so rental houses can charge a premium. But film cameras have been around forever, and rental houses have tons of them they can't move. You can negotiate terrific equipment deals, as you can with the film labs who don't get enough work developing and processing and the companies that make and sell the raw stock. Film is also easier to light and more forgiving, so you may be able to shoot faster.

Once you've shot your movie you can transfer your footage to HD and complete postproduction in the easier digital realm, and if it was photographed on actual film it's pretty much guaranteed to look like a "real movie." It also tends to hide the budget, because there's still this

perception that film is more expensive. Your movie will appear to be higher end, and just because it was obviously made on film it'll get taken more seriously in mainstream arenas.

We shot *Ten 'til Noon* on Super 16mm, and people always assumed the movie cost significantly more than it did. We also got a better distribution deal and better press coverage than most of our HD-lensed counterparts.

So when planning the next movie, one might do well to keep in mind the old-school approach of shooting on film.

JOE SWANBERG
Filmmaker, director, writer, actor, et al.

FILMS: *Alexander the Last, Hannah Takes the Stairs, LOL, Kissing on the Mouth*

FESTIVAL EXPERIENCE: Screened films at SXSW and many others

DEALS: *Hannah Takes the Stairs* picked up by IFC Films

"Making a film for no money with your friends is the perfect no-stress way to work, and it allows you to enjoy the experience of festivals. There is plenty of time to be stressed out when you've made a film with someone else's money and people are counting on a distribution deal."

Joe Swanberg

Joe Swanberg worked in a video store during high school and fell asleep in class every day because he was up late watching movies. He went to film school at Southern Illinois University, where he was exposed to mostly experimental and documentary film.

After film school Joe got a seasonal job working for the Chicago International Film Festival and began to think about making his own film. When the festival ended in mid-October, he started saving money for a feature.

In February of 2004, he and two friends started shooting *Kissing on the Mouth* with his then-girlfriend, who later became his wife. *Kissing* premiered at the SXSW Film Festival, and following that he made *LOL*, which also premiered at SXSW, and then *Hannah Takes the Stairs*, which also played SXSW.

Joe talks about his unique filmmaking style, the evolution of "mumblecore," and his SXSW connection.

What led to your inspired approach for your first indie feature?

I was frustrated with a lot of films I was seeing about young people at the time. I didn't feel that our lives were being accurately represented or that filmmakers were taking enough risks in the way they depicted adults. A lot of things seemed taboo, especially sex and nudity, and that seemed silly to me. I wanted to make a film that was natural and funny and truthful and didn't shy away from anything that my friends and I talked about or did in our lives.

Kris and I had been dating for four years by then, and she was very supportive of the idea and said she would act in the film and do anything she could to help, so we started working on the story together. We asked our friend Kate Winterich to play the lead in the film. Kate went to film school with us and was living with Kris at the time. I had seen her in a friend's film and thought she was very good, but I didn't know if she would be willing to do sex scenes and be naked on camera. We talked about it and she said that she trusted us and was willing to take a chance on the film. Kevin Pittman, a friend of mine from high school, agreed to play the other part in the film. He is a cinematographer who had never acted before but thought it sounded like an interesting challenge.

Kris made a Super 8 film at school called *Ex* that was the basis for the idea. She interviewed friends of ours about their most recent breakups and played the audio underneath abstract images of a couple doing typical relationship things. I admired the film and wanted to borrow the concept of the audio interviews but incorporate them into a narrative story. The four of us developed the story together and used aspects of our own lives and friends' lives to shape the characters.

I wanted to forgo a script altogether, but the others encouraged me to write as much as possible. Because they were willing to be so brave and trusting of me with the sex and nudity, I wanted to do everything I could to make them comfortable. I wrote a forty-five-page script with some dialogue and some scenes as merely outlines.

We improvised most of the dialogue in the film, and over the course of five months we put it together, shooting whenever we had time. We were all working day jobs, so we had to coordinate schedules, but the downtime between shoots gave me time to edit the footage and get new ideas. I have gotten rid of the script for subsequent films (they are now fully improvised), but I still use this method of editing while I shoot in order to understand the film better.

How did you secure the financing for Kissing on the Mouth?

I made the film with my own money, for about $1,200. I never considered outside financing. It wasn't necessary, but I also wanted total control over the project and I knew that meant using my own money. I was very realistic about the slim chances of the film finding distribution, and I knew the sexual aspect of the project would keep us out of mainstream theaters, so it didn't make sense to me to try and approach anyone. We shot on DVCAM, with the Sony PD-150, which I already owned, and I edited on Final Cut Pro. The money went mostly to food, gas, and tape stock. We used our own apartments, clothes, cars, etc. We relied on natural and available light. Kevin built a softbox out of foam core, some light bulbs, and a piece of diffusion. It worked really well when we needed some extra exposure and was pretty much the only piece of "equipment" we used, other than the camera and a shotgun microphone.

Because there were only four of us, we could move quickly and get a lot done. We probably shot for about twenty days, but it was spread out over several months. I didn't make a budget ahead of time. I just spent money whenever it was necessary. I only had a few thousand dollars anyway, so it wasn't like I had much of a choice.

*Did you begin with a festival strategy
targeting larger film festivals?*

We didn't think much about festivals while we were making the film.
AJ Schnack was serving as a mentor of sorts for me. We met in Los Angeles
a few years before and stayed in touch. He was extremely supportive and
generous with his time and talked with me throughout the production.
He watched cuts of the film as I was editing and encouraged me to submit
to festivals.

How did you go about submitting to festivals?

Believe it or not, I never actually submitted the film to the festival where
it premiered. Through an extremely lucky chain of events, it ended up in
the hands of Matt Dentler at the SXSW Film Festival. While I was working
on the film I was spending a lot of time on Roger Avary's website, where
there was a very active message board. At one point I posted a ten-minute
clip from the film for people on the board to check out. I didn't realize
that one of the regular posters was Austin filmmaker Dan Brown, who
had done the trailers for SXSW and was friends with Matt. Dan sent Matt
the link to my ten-minute clip and told him to check it out. A month
or two later, when I had a cut of the film, I sent a copy to Dan to get his
feedback. He liked the film, and the next time he had lunch with Matt,
he gave him the DVD.

 I was at my parent's house for Thanksgiving and I had forgotten about
the whole thing. I was on the computer and I got an e-mail from someone
named Matt Dentler. The name sounded familiar, but it wasn't until I
opened it that I remembered who Matt was. My heart started beating
really fast and I was afraid to read it. The e-mail, dated 11/24/04, said:

> *Joe-*
> *Hey. This is Matt Dentler with Austin's SXSW Film Festival. Dan
> Brown passed along your DVD. What are your plans for KISSING
> ON THE MOUTH? Festivals? Would you be interested in playing it
> at SXSW in March? Would it be a premiere?*

Thanks for your time. I look forward to hearing from you.
All my best,
Matt

I told him that we wanted to play festivals, and that the film hadn't premiered. And then I didn't hear back from him for five excruciating days. When his name showed up in my inbox again, my heart started beating really fast and I was afraid to read it. It was only a few sentences, but he invited the film. I immediately accepted the invitation and called Kris, Kate, and Kevin. I couldn't believe it. To this day, I consider Dan Brown and Matt Dentler my film guardian angels. Dan went out of his way to help, with nothing to gain personally, and Matt took a huge chance on the film, and on me.

How did you prepare for your first festival screening?

There were technical aspects of getting ready, like finishing the sound mix of the film and getting it on the right video format for the screening. I am a procrastinator by nature, so I waited longer than I should have and finished everything at the last minute, but it was a great learning experience. It's all second nature to me now, but at the time I had to figure out where to get a DigiBeta dub made and how much it would cost and how much time it would take.

I found a postproduction facility near the office of the Web company I was working at and I walked over there one afternoon during my lunch break. I told them my film had been accepted to SXSW and I needed a DigiBeta screening copy but that I had no money. I asked them if they would do it for free if I provided the tape stock and gave them a "special thanks" credit in the film. They were very nice and told me it wouldn't be a problem. There's something very liberating about being young and poor, and I found throughout the experience that people were very friendly and helpful.

When the lineup was announced, I got a few e-mails from sales agents wanting to see the film to consider representing it. I mostly ignored these, figuring no sales agent would want to get involved with such a small film.

They were mostly form letters and easy to dismiss. The only person who kept writing back was Chris Pizzo from Carmichael Films. I e-mailed Matt Dentler to see if Seth Carmichael was a good guy and Matt said he was, so I sent them a copy of the film.

They liked the film and wanted to represent it. I figured I had nothing to lose, and that it would be a good experience to have a sales rep and see what the process was like, so we figured out all the contracts and they took on the film. No money traded hands, and they only profited if the film sold, so I felt safe with the deal. Chris Pizzo represented the film and Seth Carmichael did some free publicity work for us just because he liked the film. Both guys were very nice and helpful.

How did you do your own publicity?

There are plenty of opportunities to get press at SXSW. We sent out screeners and got in touch with people before the festival. Once we arrived in Austin, we talked to other filmmakers and asked them what they did that day, and often they could help put us in touch with people who had interviewed them or written about their films.

It's not a bad idea to spend a few afternoons hanging around the Filmmaker Lounge, which is conveniently located very near the Press Lounge. Stay visible, and spend some time walking between the two places, seeing who you can bump into. Sometimes press will be conducting interviews with other filmmakers in the Press Lounge, and you can piggyback and do an interview after they are finished. We got some good coverage just from being in the right place at the right time, but the right place was almost always somewhere near the Press Lounge.

The Filmmaker Lounge has a few computers with Internet access, so you can keep up with e-mail and try and arrange coverage from there, but keep in mind that there are a lot of filmmakers all trying to use only four or five computers, so it can be frustrating sometimes.

If you are concerned about getting press coverage, you shouldn't plan on seeing very many films during the first half of the festival while the Filmmaker Lounge and Press Lounge are operating. Spend that time arranging interviews and talking to other filmmakers. During the second

half of the festival, when the music takes over, you will have plenty of time to catch up and see lots of movies, but during the first weekend especially, you should hustle to get attention while you still can.

Always have plenty of postcards with you at all times, because you never know when you might come across a good place to set some down. Also, make sure to have some DVDs of your film with you, because you might run into a critic who doesn't have time to attend one of your screenings but still wants to see your film. It's good to have some copies, just in case you need them.

What was the festival premiere like?

I was very nervous. Our sales rep, Chris Pizzo, was there to greet any distributors who might show up, but we had an afternoon time slot at the Dobie, which is fairly out of the way, so there were no distributors in attendance. I was pretty realistic about the fact that we weren't going to have a bidding war or sell the film at the festival, but it was a little bit of a letdown to realize that we weren't even going to have any distributors interested in the film because none had seen it.

I was momentarily bummed out, but I seem to remember Kris snapping me back into reality and reminding me of all the reasons why I should be overcome with joy. We had a lot of new friends in attendance and it was a great screening. It was fun for us to watch the film with an audience for the first time. To this day I have not had a better learning experience as a filmmaker than that first screening. I watched my film in a much more detached, critical way. It made me a better filmmaker, and I have been able to see my own work more clearly since then.

What would you have done differently in preparing for your film's debut?

I would have been less concerned about distributors and press and more involved in the moment. Making a film for no money with your friends is the perfect no-stress way to work, and it allows you to enjoy the experience of festivals. There is plenty of time to be stressed out when

you've made a film with someone else's money and people are counting on a distribution deal.

What unique marketing tools did you use to promote?

We knew we only had money to make postcards and posters, but we wanted to stand out, so I hired an artist friend, Ethan Hayes-Chute, to make handmade, screen-printed posters. They were more expensive than regular posters, and we could only make a limited number of them, but they looked really great and had a lot of people talking. I knew it was the right decision when I heard that people were stealing our posters and fighting over who would get to keep them when the festival ended. I still have a few of them, and they are all hand-numbered and signed by the artist.

Kissing on the Mouth *was the beginning of what has been dubbed "mumblecore" by much of the press— or did you come up with that?*

This all started at SXSW in 2005. The term "mumblecore" was a joke that the sound mixer of *Mutual Appreciation* came up with to categorize that film, *KOTM*, *The Puffy Chair*, and *Four Eyed Monsters*. People around the festival were talking about the similarities between those four films and Andrew Bujalski made the mistake of using the word "mumblecore" in an interview. For some reason that name stuck, and none of us has been able to shake it since then. It has been really positive insofar as the films have all received more attention as a group than they would have individually, but it has also resulted in a backlash and a dismissive tone from a lot of critics.

To set the record straight, none of us knew each other before SXSW 2005. I had e-mailed with Andrew a few times, because I had seen his previous film, but I met the Duplass brothers and Aaron and Susan in Austin. There was no movement, or any master plan. It was just a coincidence of a few filmmakers in different parts of the country all making films about themselves and their friends. I met Frank Ross a few months later, and the following year at SXSW I met Aaron Katz and all of us were making films in our own style before we even knew the others existed.

The idea of a "movement" started to come into the picture a year or so later when we started to work on each others' films, but I think it's

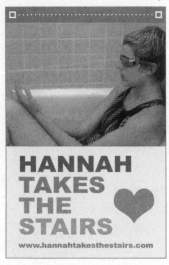

natural that because we like to work with friends, and because all of us had become friends through the festival circuit, that we would work with each other.

Any advice on handling press?

First-time filmmakers should enjoy the attention and excitement of press while they can. I have grown more wary of press with each film. I also get sick of my own voice a lot quicker these days and I don't have as much energy to get out there and promote the work.

Hannah Takes the Stairs poster art

You are particularly good at festival Q&As by remaining honest. Any advice on working a festival crowd?

I spend all of my time, energy, and money making these movies, so I have plenty to say about them once they're finished. Q&As are therapeutic for me, because they help me remember why I made the films in the first place, and they solidify my ideas about them. They let me know what works about the film and what doesn't.

I try to start each Q&A with a general discussion about the technical aspects, such as the camera we used, how long it took to make, and what the budget was. Filmmakers in the audience are usually curious about this stuff, so I like to get it out of the way in the beginning and move on to more interesting questions. My work is very personal, and I encourage the audience to ask personal questions.

As a festival veteran, do you still have to go through the application process? Can't you just, you know, make a call and get in?

I can't make a call and get in, but I can usually make a call and at least get someone to watch the film without having to pay an entry fee.

Sometimes a festival will reach out to me and request a screener of my film, which is really nice. I am often rejected from these festivals, but the rejection doesn't hurt as bad when I haven't paid an entry fee or gone too far out of my way.

How is it different being a veteran on the festival circuit?

When I first started playing festivals, I put a lot of pressure on myself to promote the film and get exposure, but I'm much happier now hanging out with friends and exploring the cities that I'm visiting. Festivals are a wonderful opportunity to travel and meet interesting people, and I would hate to miss that because I was too busy thinking about the business aspect of it.

SXSW 2005 was my best festival experience. Everything seemed magical. We had nothing to lose and everything to gain. To this day I am still working with people who I met at that festival. There was such a strong sense of community that year. We often joke about how it was all downhill from there.

Actress Greta Gerwig and Joe Swanberg in *Nights and Weekends*

Is it easier to navigate the festival circuit having done it before?

Getting the films ready for festivals and distribution is much easier now than it was the first time. Once you go through the experience, you know what is necessary and what isn't, and you can prepare for everything in advance. You also make connections with people who can help out in various ways, from postproduction to promotion.

The hardest thing about playing festivals on a regular basis is spending so much time away from my wife and my apartment. I get homesick a lot more now than I used to, so each year it gets a little more difficult to pack up my suitcase and head to the airport. The festivals usually pay for my travel and hotel room, but my wife and I don't have enough money for her to travel with me, so

she can only come every so often. At first it was really fun to go to parties all the time and stay in hotel rooms, but after a while I started missing my own bed. I am more selective now about the festivals I attend.

> Filmmakers often spend too much time on the festival circuit before they get to work on new projects.

I think filmmakers often spend too much time on the festival circuit before they get to work on new projects. It can be very tempting to keep partying and traveling, and some filmmakers can stretch it into two or three years with one project.

As you make more films and you see yourself grow as a filmmaker, what lesson has surprised you most?

I'm only really happy when I'm making small projects, with my friends, that I have total control over. I was surprised to discover how easy it is for me to turn down money and larger projects, even when I'm struggling to pay rent. My wife teaches high school and makes ice cream and I make enough money from my films and Web shows that we're able to eke out a living. As long as that continues, I'm really uninterested in making films for a paycheck.

Is there a secret to all your festival accolades and success?

There is no secret. I'm just lucky. I happened to be born at the right time, when video technology was emerging, so that by the time I got to film school it was readily available and I could make films cheaply. And Matt Dentler took a chance on me. Without the SXSW premiere for *Kissing on the Mouth*, I think I would still be making websites for a living and doing film stuff on the side.

I'm enjoying the attention that my films are receiving now, but I'm prepared for that attention to disappear. Festivals are trendy and my films will go out of fashion just as suddenly as they got popular. All I can do is keep working and try to forget about that fact.

DAN MIRVISH
Filmmaker, Slamdance Film Festival Founder, Hat Enthusiast

FILMS: Open House, Omaha (The Movie)

FESTIVAL EXPERIENCE: Screened films at Slamdance, Maryland, Oldenburg, Austin, and too many others to list

DEALS: Sold Open House to Miramax

"Many films fall into the trap of trying to be too mainstream but not with big actors. Being a low-budget movie doesn't make it a festival film. It's got to have that undefinable indie or festival feel to it."

Dan Mirvish grew up in Omaha, Nebraska, and from there things got weird. He worked in D.C. for a couple of years as a Senate speechwriter and journalist and then went to graduate film school at USC, where he did his first feature, *Omaha (The Movie)*, which was mentored by Robert Altman. *Omaha* did not get into Sundance, so he teamed up with other rejected filmmakers and founded Slamdance. Dan wound up self-distributing *Omaha* in thirty-five cities, and the DVD eventually was included for a time with every Pioneer DVD player sold in North America as a free sample, putting 350,000 copies into the marketplace. Dan eventually made the real estate musical *Open House*, which found distribution with the Weinstein Company. *Open House* became a cult fave on DVD and even resulted in a video game; there's even talk about turning it into a play.

Dan Mirvish

Dan has a unique perspective, having traveled to more than fifty festivals worldwide as a filmmaker, programmer, panelist, or juror.

*What do movies that get accepted into a
major festival all have in common?*

Originality. Name actors or experienced directors don't hurt for the
bigger festivals, but for Slamdance especially, that's not an issue. The
common mistake is that they try to copy last year's hot indie film. Or
worse, the hot indie film from three years ago. Strangely, though, the
hot indie film of *seven* years ago might work.

What are the reasons why films get rejected?

If it's a genre that's not supported by the festival. For example, submitting
a Southern-gothic-horror-comedy to a British-transgendered-Jewish
festival. Also, many films fall into the trap of trying to be too
mainstream but not with big actors. Unfortunately, those films don't
work for festivals. Being a low-budget movie in and of itself doesn't
make it a festival film. It's got to have that undefinable *indie* or *festival*
feel to it.

*Do you see anything wrong with festivals
supporting their own alumni?*

Some is good—it can create a community of filmmakers and a
connection between alumni and new filmmakers. But too much and
you get cronyism. One of the reasons we started Slamdance is that
Sundance had fallen into that trap by the mid-nineties. They had all
these great second-time directors they wanted to showcase, and that
left behind a whole wave of new filmmakers who had been inspired by
that first group. In 1995, Sundance rejected all ninety of the completed
features that showed at the IFFM (aka IFP Market) in New York. The
trick—and I think Slamdance has done this as well as anyone—is to
focus on, or at least have a section for, first-time directors, but still have
a separate (in our case, out-of-competition) section for seasoned or
alumni directors.

MEET THE FESTIVAL VETERANS: DAN MIRVISH

What is the best way to get a film accepted?

Bribery. The hard part is knowing whom to bribe. Short of that, I would say either apply really early or really late. Either way, you'll get to know the programmers. Note: Applying really late is not recommended. Usually, they won't let you in at all.

Is it advisable to bother people on the festival staff to find out if one's film will get accepted?

It makes sense to make a call to verify that your film got there and everything's all right. And it's okay to make one or two other calls to update your film info (like if you just got into another fest, or if you're playing two festival premieres against each other).

What really is the best way to communicate with a very busy festival staff?

I always use the phone. Go in person if you can. E-mail is impersonal. If you're in a competitive premiere situation, then yes, you may need to force an answer. It may not be the answer you want, but at least you'll know.

How can filmmakers work best with a festival staff to get a good program slot, like a Friday night?

Just be grateful you got in, and make the best of any screening time. And sometimes what you think is a bad screening time is actually very good, and vice versa. At some festivals, a Friday night slot may seem great, but you get there, and everyone's at the opening party across town. But another festival could be different. It always pays to talk to other filmmakers who were at that festival the year before and get as much intel as you can.

At Slamdance, we've definitely had the odd filmmaker—on average, one a year—who's so uptight about their screening, and a pain in the

277

ass for the projectionists, that it all becomes very unpleasant. More often than not, though, it's not the directors who become the problem but rather the entourage of producers, agents, actors, etc. A festival screening situation is rarely as good technically as when the director last saw his film in a pristine mix room at lab or on his computer in his quiet home.

What is the most effective way for a filmmaker to make his or her movie the must-see?

The tricky part here is you have to fill the theater with a willing audience, but if you overhype it, you run the risk of raising expectations beyond the level that the film can fulfill. One easy way to make the screening a must-see is to require a ticket to go to your exclusive afterparty featuring Perry Farrell DJ-ing at a secret undisclosed condo. Only tell people the secret location during your Q&A. They'll have to sit through your movie.

Remember, a screening is an experience from the moment the audience waits in line and buys a ticket till they go to sleep the night of your screening. The movie itself might only be a very small part of that. What that means is to promise something spectacular (a surprise guest! giveaways! sexual favors to the first fifteen people!), do a cool introduction (even if you find a celebrity who has nothing to do with the film, like when we had Carl Lewis intro a documentary about wrestling), or give the audience goodies—either when they buy their tickets or at the screening itself. Booze, chocolate, hats—whatever it takes.

Make sure the screening goes smoothly—communicate with the projectionist, and if it doesn't go well, be prepared to pop up, tell some jokes, maybe even do the Q&A in the middle of the screening if a projector breaks. Remember, people are now very used to directors' commentaries for movies, so if there's a sound problem, just do a live commentary! Just don't panic, and whatever you do, don't let anyone leave the room. (I once got a bloody nose when a woman tried to leave one of my screenings and started to slam open the door. Not on my watch, she didn't!)

At the end, bring up your stars, do a good Q&A (practice your quips, war stories, and jokes), and if you have any musicians in the audience,

have them perform a song. And afterward, throw a big bash or an intimate hot tub party where you invite selected press and distributors to "join in" with your leading actress.

What unique marketing methods have you seen that most impressed you?

Curtis Hannum dressed up like God to promote *The Real Old Testament* at Slamdance one year. People are still talking about the film! Some guys showed up at our annual Sled-Off and came down the mountain with a parachute—I think it had something to do with their film. There was a guy dressed up like a chicken one year. The Russo Brothers brought fifty of their Cleveland family all in matching hats with the name of their film, *Pieces*, and they dragged Steven Soderbergh to the screening. He launched their career; three features and an Emmy for directing *Arrested Development* later, and they're very proud of their hats.

The marketing attempt has to match the tenor and tone of the film. Dressing like a chicken for a serious Holocaust documentary might not work. On the other hand, who would have thought that having Tipper Gore come to your documentary about the Wu Tang Clan would have been a good idea?

How did you go about raising money for Open House?

First, you've got to set up your corporate structure and bank account before you can take a dime. My co-writer, Larry Maddox, and I first sent the script out as a spec to Hollywood companies. They said it was too small. We tried the indie companies. They said it was too mainstream. Then 9/11 happened and we realized that in times of crisis, America loves to sing. So we said, "Nuts, if we're going to make it ourselves on a shoestring, let's at least have some fun with it." So we wrote some songs and turned it into a musical.

I tried to get big real estate companies to invest. At one point, Century 21 said they'd put in $200,000. That got the ball rolling with casting and crew, and more important, in my own mind, I knew we'd be able to make the movie. But those yellow-jacket bastards reneged, and I was down

to $10,000 in the bank. Half of which came from an actor friend who invests in my films if I give him a nice little part—I always do—and half from my generous wife if I promised to procreate again. I asked one rich producer friend who was constantly trying to prove how gay he was to invest. He had to. Just to save face. Right before we started shooting, one of my just-graduated-college-in-Indiana PAs said he could maybe raise money from his roommate. His roommate? No way. Turns out his roommate had a lucrative job on L.A.'s local NBC affiliate as the weekend weather guy. So that was another $5,000! The lesson: Take every lead seriously, no matter where it comes from.

We barely had enough to shoot the film, then quickly cut a trailer together and had a party in Park City where we tried to raise finishing money. Amazingly, it worked, and we raised another $15,000.

After we'd finished the film, I was already on the festival circuit and trying to get distribution when we came up with a cockamamie scheme to get an Oscar nomination. Turns out there was an obscure dormant Oscar category called Best Original Musical, and *Open House* was eligible. If there were five eligible films in one year, then three would get nominated. Not bad odds, even for a no-budget indie. But we only found three other films that year that met the arcane qualification rules. So I teamed up with one of my actors, Robert Peters, headed to the Oldenburg Festival in Germany, and in ten days, we shot another feature musical. While Robert finished off that film, I headed back on the festival circuit with *Open House*. But I figured I needed to raise an additional $10,000 to do even a minor Oscar campaign, which would consist of a qualifying run in L.A., a couple of ads, and postage for screeners.

So going back to the original real estate idea, I contacted every real estate agent in Austin, where we were playing a week later at the Austin Film Festival, and the Hamptons, where we were playing the next week. I got a Realtor in each city to invest $5,000 in exchange for taking a shot of their "open house" signs and inserting it into our title montage of flags and signs. It was the quickest $10,000 I ever made, and it proved a couple things: It's never too late for product placement, and yes, you can earn money at a festival even if you don't win a prize. It also told me that if you wave a good Oscar possibility in front of people, that's a lot sexier than saying the old cliché, "I'm making an obscure independent film that's going to

go to *Sundance!*" People just don't buy that anymore. In the end, the Oscar campaign didn't cost as much as I'd feared and we were able to pay off some of our credit card debt. So it also proved that

It's never too late for product placement, and yes, you can earn money at a festival even if you don't win a prize.

indeed you can make money off an Oscar campaign for a film that nobody saw, in a category that doesn't exist.

What unique marketing tool did you use to promote Open House?

On the festival circuit, I made finger sandwiches at every one of my screenings. It's relatively cheap, memorable, and everyone loves to eat a snack at a screening. More important, it guaranteed an extra laugh every time finger sandwiches are seen in the movie.

When it came time for the DVD release of *Open House*, I was a parasite off of *Rent*. We were lucky in that one of our lead actors was Anthony Rapp, who after shooting *Open House* went off and shot the $40 million budget, big-screen version of *Rent* (Anthony had been in the play on Broadway). It worked out that our DVD release came out about the same time as *Rent* came out theatrically. *Rent* bombed in Hollywood terms, but its core audience of *Rent*-heads loved it. And they were equally fanatical about Anthony. So I came up with the slogan "Why Rent, when you can own . . . *Open House!*" Sony— *Rent*'s distributor—had spent a ton of money on their MySpace page—one of the first Hollywood films to really tap into that world just as MySpace was getting big. I cut together clips of Anthony comparing the two films and posted them on our own MySpace page. Then I just poached some of *Rent*'s sixty thousand-odd "friends." The interesting thing was that while Anthony was the initial draw, it turned out that the core *Rent* audience of sixteen-year-old girls, and seventeen-year-old boys who don't know they're gay yet, were actually becoming big fans of *Open House* completely in its own right.

We did some fun interactive things with photo contests, *Open House* parties, video podcasting from our fans. I had kids make finger sandwiches and bring them to every one of Anthony's concerts or book signings.

One of my MySpace fans suggested doing a video game . . . so we did! I found a couple of young idealistic game designers at Slamdance and told them, "If big-budget movies can have big-budget games, then why can't low-budget movies have low-budget games?" They loved the idea and came up with an awesome little flash game we put on our website. Kids also started to talk about turning the movie into a play at their high schools, and that led to some pretty serious discussions with Broadway producers and the Weinstein Company about turning it into a live theatrical production. The trick with all of this is that it was all *fun*! Marketing should not be a chore. It's a great way to connect with an audience and dig deeper into your film and your own creativity.

Oh, and I also propagated the national trend of "house humping"— sex in an open house—which got written up in *GQ* magazine, among other places. When people read about it, they knew that the frenzied real estate market had jumped the shark. It may have single-handedly burst the real estate bubble, leading to the subprime mortgage collapse and the worst financial crisis in world history. Oops.

> Marketing should not be a chore. It's a great way to connect with an audience and dig deeper into your film and your own creativity.

How did you pull together such an amazing cast on such a low-budget indie?

All actors love to sing. It's axiomatic. And they rarely get a chance to. So if you say you're making a musical, you can get actors who you wouldn't otherwise be able to touch. Also, my casting director, Liz Jereski, and I had a good approach with the agencies. We played the New York offices against the L.A. ones, and we found a willing talent-covering agent at all the midsized agencies to be our fans. Then we asked them who *they* thought would be good for the movie—we didn't come with any preconceived ideas or lists. The agents felt more vested in the creative process, and they really did come up with some people we never would have thought of, like Sally Kellerman, who was suggested by her agent, Thomas Cushing at Innovative.

*Did it make it any easier, having worked
on a festival, to do a festival tour?*

I knew what to expect, and I was much more selective about which festivals to apply to. I didn't go to nearly as many festivals with *Open House* as I had with *Omaha (The Movie)*. Part of it is I have kids now, so I couldn't just get up and travel the world for a year.

*How did you go about doing your own
distribution deal for* Open House?

We did a couple of distributor screenings—one in L.A., and one in New York. The New York one turned out to be much smaller, but it was packed with more distributors. Then I just called and sent out screeners and kept on doing our Oscar campaign and hoped that a distributor would go from "I like it, but . . ." to "Okay!" It was pretty depressing, actually. Then almost six months later, I was in Park City and ran into a dude at the Kodak party at the Riverhorse (you know, the annual party with the lame cover band?). He tells me he'd just talked to an acquisitions guy in New York the week before about my film. So the next day, I called the guy, who was at Wellspring, and he said, "Oh yeah, we'd like to distribute your film." Simple as that. But a year later, I ran into another distributor in Park City at a restaurant. He said that they'd actually loved my film and would have picked it up but assumed I was getting a bigger deal from Wellspring. When I told them what it was, they just laughed: "Oh God, we would have doubled that!" It proves that you can't follow up enough with distributors who go to your screenings and with all the screeners you send out. Until you have a definitive, "Goddammit, I said no! And stop calling me!" written down in your notes (and do keep scrupulous notes), then you can't stop calling.

What mistakes do filmmakers seeking distribution often make?

1. Being too pushy.
2. Not being pushy enough.

3. Being too picky or demanding.

4. Listening to your investors, and not to your ego. It doesn't matter if you get a big advance, as the director, you want it to get exposure and help *your* career, right?

How can filmmakers put their movie in position to get the best deal possible?

Big stars—and the right kind of stars.

It's a given you're going to get screwed; the trick is finding out how. So talk to other filmmakers who have been with the same company.

> Always try to get the biggest advance versus a high percentage cut on the back end.

Always try to get the biggest advance versus a high percentage cut on the back end. There is no back end. You'll never see another dime past the advance, so make your deal there.

Is self-distribution ever recommended?

Especially now with DVD, there are easier ways to do it, without the hassles of fulfillment and heading down to the post office every day. There are a lot of pseudo-self-distribution models, too. In short, though, self-distribution will always cost either a lot of time or money. Though not necessarily both. If you know that going in, and are clear in your own mind what your specific goals are, it can be a good way to go.

Has playing many film festivals almost become like a minor theatrical release itself?

If you want to have your film seen by audiences and get reviews, then the festival circuit is a perfectly valid means of fulfilling those goals. If your aim is to make money, then doing a DVD release may be the best way to go.

Are all types of independent films good for the festival circuit? Or is it just a matter of connecting the right film with the right festival?

A couple years ago, I made a short called *A Message from the President of Iran*. I made it for three dollars in two hours standing on one leg. Literally. As soon as I finished it, I showed it around to a couple of online and TV people. There was a bidding war, and I sold it to CurrentTV for $750. I never even bothered to apply to festivals with it. It got national airplay, I made money, and then later I put it onto YouTube, where over ten thousand more people saw it.

Similar story with a short I did with Eitan Gorlin, called *Sheldon*. We had conceived of it as a short but called it a "short pilot"—being the basis for a possible TV or Web series. So we got it into the HBO Comedy Arts Festival in Aspen (sadly, the last edition of that festival). We knew that, unlike Sundance or Slamdance, Aspen was deluged by TV industry people, not film people. A much different audience, and a crowd that didn't really know us, for better or for worse. We played it next at the Montreal Just for Laughs festival—the biggest comedy festival in North America—for the same reason. We never bothered to send it in to any of the "traditional" festivals.

Ultimately, we wound up posting it online anonymously, couched as one in a series of fake Rudolph Giuliani primary campaign ads. All told, those shorts had over a hundred thousand viewers and were written about in the *New York Times*, on ABC News, and in *USA Today*. That never would have happened even if it had been the opening night short at Sundance or Cannes.

Eventually, our anonymous online efforts led to the creation of the pundit character Martin Eisenstadt—which included shooting several more shorts (including the faux BBC documentary *The Last Republican*) that were posted pseudonymously online. Hundreds of thousands of hits later, after a glowing profile in the *New York Times*, interviews with AP, *Variety*, CNN, BBC, NPR, and *eXtra*, our names in virtually every newspaper in the world, a book deal from a prestigious New York publisher, and representation from Endeavor—one of the top agencies in Hollywood—and I'd say we did better than going on the festival circuit.

At some point, festivals—especially the small and midsized ones—are going to see fewer people apply and fork over the forty or fifty bucks a pop just for the probability of getting rejected. One solution that my pal Adrian Belic and I proposed to a room full of dumbfounded festival directors last year is to only charge the admission fee if you get accepted into the festival. Another is to lower the fees, or do away with them altogether, as is the practice in many European festivals. But also, festivals need to find exciting, interesting, and unique things to do at the festivals that will make filmmakers say, "Wow! That sounds cooler than YouTube!" For example, at Slamdance, I host an annual Sled-Off

Dan Mirvish poses with the author in Park City.

again Sundance (since we take over an active ski slope, someone usually gets injured, but it's an incredible bonding experience for all the filmmakers). We also have a hot tub party—usually as a way for new filmmakers to meet successful alumni . . . or celebrities like Chris Gore! Other festivals do similar things: The Maryland Festival takes filmmakers to an Orioles game. The Florida one has free passes to Universal Studios. LAFF has a great program introducing filmmakers to Hollywood industry people. The Oldenburg festival flies you to Germany and has "friendly" volunteers!

But more important—and perhaps more relevant for our times—you also have to ask if the festival circuit is even right for you. There's always been the notion that if you make a kickboxing movie in the Philippines (like *American Kickboxer 2*, the first movie I worked on!) then your best bet is to hang out at the American Film Market and just try to sell the thing to Sri Lankan pay-per-view. But now the question is being asked and answered by short film filmmakers (and some feature film folk) who wonder if it isn't best to just put your movie on the Internet in some capacity and forgo the festival world altogether.

A related notion is that there is now a generation of filmmakers who *only* conceive of exhibition and distribution in terms of posting their work onto YouTube. Most of these people don't even think of

themselves as "filmmakers"—much less, filmmakers worthy of festival play. But of course, many of them are. And a lot of YouTube videos are just as good as shorts that play at Sundance and Cannes.

If you get five thousand people watching your short on YouTube, that's a hell of a lot more people than would see it at Sundance. And conceivably, you may be able to make more money on an online deal you get directly than bothering to sell it at a festival.

FINAL FESTIVAL FRONTIERS

"This business, this life we've chosen, this fantastic, stressful path we're on, isn't a sprint—it's a marathon. And every step along the way counts."

—MORGAN SPURLOCK,
filmmaker

The most difficult challenge in the quest to forge a career as an independent filmmaker is attempting to keep two vitally important things in balance: creative and business concerns.

Once you've used all of your artistic reserves to complete your project, you are tasked with taking your film to a festival and then using all of your acquired business skills to find the movie a proper home. And, in addition, perhaps building a career for yourself working in the industry. You can overthink any decision, whether it be the poster-trailer-marketing campaign or the festival in which you choose to premiere. No matter what choices you face on any given day, I guarantee that each one involves some level of both commercial and creative concern. This is probably the reason that the job of filmmaker is the most difficult among all artists—it requires so much responsibility when it comes to money, often the downfall of creative types in general.

Reducing a project, in which blood may often have been literally shed, down to a monetary figure is not easy for those more comfortable making imaginative choices about dialogue or wardrobe. Choosing the best festivals and the path for your film is, in a way, not unlike what a parent may struggle with when sending a child on his or her way to school and out of the house . . . only perhaps more painful. You've lived with this project for too long to see it abused and mistreated. So finding just the right routes to travel along this seemingly endless road is as important as making the film itself. It's all a matter of achieving some level of peace within the battle happening in your filmmaking brain: the boldly creative side versus the logically business-minded side. Doing whatever it takes to find the balance between the two is what will separate the serious filmmakers who are discovered from those merely seeking attention, excitement, or a hobby.

Unfortunately, it pains me to admit that the most successful filmmakers are not always the ones who are most creative. I can't tell you how often I've seen an incredibly innovative movie on the festival circuit that never really went anywhere. On the other hand, those possessing talents in the ways of business don't always make it either. It truly requires an equal amount of creativity and business acumen to make the whole package work. The most passionate and inspired filmmakers may lack skills

with numbers, but you can bet that there are people behind them who excel at the complex math required to close a deal.

At the end of the day, filmmaking is a team sport. And while much of the focus is often on the director, many other important roles make up a winning team. That is why not everyone has to be a psychotic creative-business drone to do it all. In fact, it's better that not be the case. Able filmmakers tend to be creative obsessives, so if your business skills are lacking, then add members to your team who can fill those roles absent from your roster.

I've been there and learned hard lessons firsthand with my own projects. I can tell you that while it may not have been easy for me, the high that comes from the whole experience has made me want to do it all over again. I hope you don't allow temporary setbacks to stop you in your tracks. I know you can't have things go your way all the time or control the outcome of every situation. You may have a good or a bad screening. Or a deal on the table or no deal at all. Or a positive review or a review that tears your film to shreds. All of this is going to happen—they're the ups and downs that come with the film business. You can only control how you react to these situations as they arise.

Smiling, in spite of all the adversity, really helps a lot. As does an open bar at the closing night of the film festival.

See you at a festival soon. You'll know where to find me—I'm pretty much always where the fun can be had.

INDEX

W

Waterfront Film Festival, 10
Website (festival), 5, 33, 119–120, 294
Website (your/movie)
 animation bells and whistles, 90
 building, 89–90
 creating content, 87
 designing, 88
 dos and don'ts, 90–91
 flow chart, 88
 importance of, 86
 interacting with audience on, 90
 registering URL name, 87
 simplicity of, 90
 steps for creating, 87–90
 updating, 90–91
 using dot-com name on
 everything, 86

Weinstein, Harvey and Bob, 228–229
West Virginia Film Festival, 10
*Where in the World Is Osama Bin
 Laden?*, 7, 11, 150, 151
White, Connie, 166–167
Williams, David E. quote, 96–97
Wlnterich, Kate, 265, 268
Winters, Heather, 156

Y

Yamagata International Documentary
 Film Festival, 135

Z

Zagreb World Festival of Animated
 Films, 133

ABOUT THE AUTHOR

CHRIS GORE is perhaps best described as a "nerdlebrity."

He is a filmmaker, television personality, and writer who has built a solid reputation as an outspoken voice in the film world. As a teenager, he founded the brutally honest magazine *Film Threat*, which has been named one of the top five movie sites on the Web by the *Wall Street Journal*. He has traveled the world to over a hundred different festivals, having attended his first at the age of twelve. He was the program director for the Sonoma Valley Film Festival for two years and serves on the advisory board for other festivals, such as Ann Arbor. Chris was also the keynote speaker at the very first International Film Festival Summit and named one of the twenty-five most influential people in independent film by *Film Festival Today* magazine.

Chris co-wrote and produced the feature comedy *My Big Fat Independent Movie* (Anchor Bay DVD), which played over forty film festivals worldwide and can be seen on Showtime and the Sundance Channel.

He has appeared on MSNBC, E!, and Reelz Channel and has also hosted shows on the FX Network, Starz, IFC, and G4TV, where he is the film expert on the smash hit cable series *Attack of the Show*. Chris's stories have appeared in magazines, online, and trade publications such as the *New York Times*, the *Hollywood Reporter, Variety, Video Business, Spin, Details, China Shop*, and www.suicidegirls.com.

His other books include *The Fifty Greatest Movies Never Made* (St. Martin's Press) and, with Paul Salamoff, *The Complete DVD Book* (Michael Wiese Productions).

He lives in Los Angeles, and his home on the Web is www.chrisgore.com.

ultimate
FILM FEST

Go Beyond the Book and Discover . . .

www.UltimateFilmFest.com

Your book purchase grants you admission to the only official website affiliated with Chris Gore's Ultimate Film Festival Survival Guide. You'll join a community of filmmakers and festivals dedicated to sharing information to help guide you along the festival circuit.

1. Go to: **www.UltimateFilmFest.com**
2. Enter the serial number: **UFFSG-42K9-M4G4-6556-2327-A443**
3. Sign up for your account.

You will need your copy of the book to access all of the features and to log in. Upon completing registration on www.UltimateFilmFest.com, you will be given an all-access pass to a complete film festival database, exclusive filmmaker resources, and continuing support for your project from a network of independent filmmakers and festivals. In addition, special offers will give registered users discounts. Content from past editions of the book will be available, and the site will host online events with key figures from the world of independent film, including author Chris Gore.

Neither Watson-Guptill Publications nor Random House, Inc. is responsible for the operation and maintenance of this website, and any technical difficulties you experience should be addressed to the systems administrator.